EARLY NEW ENGLAND GRAVESTONE RUBBINGS

by Edmund Vincent Gillon, Jr.

Dover Publications, Inc., New York

Published in Canada by General Publishing
Company, Ltd., 30 Lesmill Road, Don Mills,
Toronto, Ontario.

Published in the United Kingdom by Constable and
Company, Ltd., 10 Orange Street, London W. C. 2.

International Standard Book Number: 0-486-21380-3
Library of Congress Catalog Card Number: 66-14555

Manufactured in the United States of America
Dover Publications, Inc.
180 Varick Street
New York, N. Y. 10014

PREFACE

The purpose of this book is one of pictorial documentation rather than the presentation of a scholarly text. I wish merely to call attention to the remarkable variety of early New England gravestones, the originality of the men who carved them, and the quality of their work. However, in the interest of scholarship I have prepared an appendix of notes on the plates in which I try to explain some of the symbols that appear on the slabs, make stylistic identifications and, in a few instances, attribute workmanship to particular stonecutters. The rubbings reproduced here were made over a period of years, and my notes covering this work are unfortunately incomplete, but where such information is available I have also given the location of the stone and the date, if no date appears on the rubbing itself.

Since virtually all the rubbings had to be greatly reduced for the format of this book, I have also prepared a table of the widths of the actual rubbings at their widest point, so that the reader will perhaps be able to visualize the true size of the stones depicted.

The reader whose interest in early New England gravestones goes beyond the scope of this book is referred to Harriette M. Forbes' authoritative study, *Gravestones of Early New England* (Boston, 1927), a work which contains a wealth of information about the actual men who carved the stones.

hi♡

CONTENTS

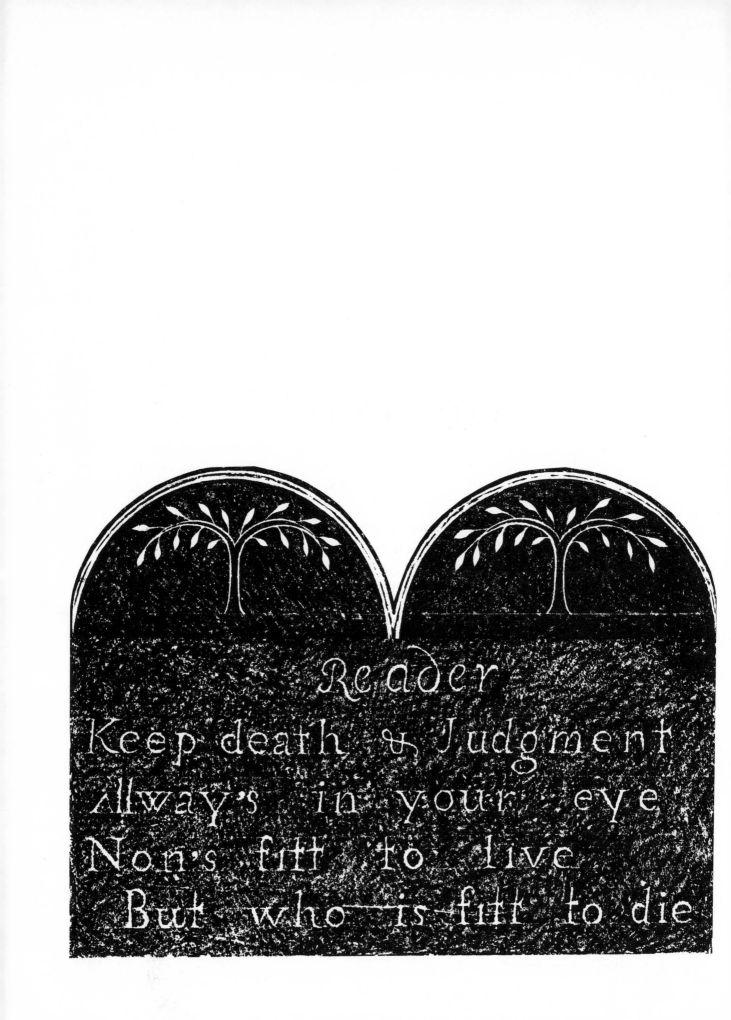

INTRODUCTION

In the early burying grounds of New England a unique expression of primitive art exists, which has received scant recognition by the art historian and has gone relatively unnoticed by a public familiar with most other aspects of our national heritage. This unheralded wealth of material is to be found in the carved designs on the tombstones, which stand not only as monuments to the individuality of the deceased, but also as testimonials to the innate sense of design and excellent craftsmanship of the stonecutters who produced them. These stone slabs with their brooding death's-heads, winged cherubs, stylized portraits, and willows and urns, are reflections of the religious beliefs, philosophy, and fashion of their time. Our appreciation of them may be heightened by a basic knowledge of the spirit in which they were created.

The earliest markers erected by the Puritans reflected an attitude toward death which differed considerably from that of later generations. To a people who suffered the rigors of a severe climate, famine, and epidemics, death was a fearsome prospect. So it is not surprising to see carved on their stones images of the grim reaper snuffing out the candle of life, or hollow-eyed grinning skulls beckoning to the passerby with the popular epitaph:

> AS YOU ARE NOW,
> SO ONCE WAS I;
> AS I AM NOW,
> SO YOU MUST BE.
> SO PREPARE FOR DEATH
> AND FOLLOW ME.

Only the world beyond the grave held the promise of a more comfortable life. Thus, the perpendicular stone borders of this early period were carved with motifs symbolizing heavenly rewards: figs and pomegranates denoted prosperity and happiness, the rope expressed eternity, and the rising sun was a symbol of the soul's resurrection. The graveyard, especially when it was in proximity to the meeting house, served as a place of contemplation and instruction during the recess between the morning and afternoon sermons of the Sabbath. In an age when illiteracy was not uncommon, the monuments of this period relied heavily on such symbolism to convey their messages of the mortality of man and the blessings of Heaven.

In the eighteenth century, when the sternness of the Puritan faith lessened somewhat, the tombstones were embellished with less formidable motifs. The skulls and crossbones, full skeletons and empty hourglasses became less ubiquitous and were slowly supplanted by winged cherubs, a subject which evolved into angels and finally into a stylized type of portraiture. In the depiction of the angel it is often difficult to determine whether the portrayal is actually meant to be an angel or a representation of the deceased. The early portrait stones frequently record details of costume and indicate the station in life or occupation of the deceased.

The last important development in the three centuries of early gravestone design was the influence of the architectural motifs of the Federal and Greek Revival periods. This influence was reflected in delicate classical urns, medallions, and graceful swags, subjects which adorned fences and mantels of the region's more elaborate buildings. The most popular mortuary decoration was the willow tree, introduced into America in the first half of the eighteenth century. The stonecutter often depicted the willow and urn on full entablatures supported by Doric, Corinthian, Ionic, or Tuscan pilasters. There was a rather free interpretation of these orders, and the capitals were often handled with distinct originality.

The last period of early tombstone design ended with a decline in craftsmanship and a taste for the eclectic. Consequently, it is at this juncture that it seems esthetically appropriate to terminate this brief history of the art of of New England's gravestones.

The Stonecutters

Having established that religious philosophy and fashion influenced the design of New England's early gravestones, the question then arises who the men were who carved them. Because the region's early population was relatively sparse, the business of stonecutting could hardly have provided anyone with a sufficient source of income. Therefore an artisan engaged in such an enterprise would of necessity be compelled to ply other trades, such as masonry or the slating of roofs. Another craftsman so engaged might have been the cordwainer, who not only made and repaired shoes, but also produced more ornamental leather items such as wallets, powder pouches, saddles, and chair seats. These required fine tooled work, and it is not unlikely that the details of design used on them were borrowed for the decoration of tombstones. The brazier and woodcarver most probably found himself recruited as a stonecutter, and the influences of these crafts are evident in the stones created.

With the growth of population the business of providing gravestones became a trade in which men could become exclusively engaged for a livelihood. As a result of the apprenticeship system practiced at that time, there emerged throughout the New England area families of stonecutters whose craft was plied through several generations. Deeds, probate records, inventory accounts, sometimes signatures on the stones themselves, reveal some of the names of men who actively engaged in this craft. Even the work of stonecutters whose names are still anonymous has been tabulated on the basis of stylistic configurations. But whether these men be known to us or not, their stones display a rich variety of design and a remarkable degree of originality.

The Rubbings

The method chosen to best illustrate the strong graphic quality of New England gravestones is a technique referred to as rubbing. There are various ways of making rubbings, but I will describe only the method I have found to be most satisfactory in

terms of faithful reproduction, simplicity and speed. This method also allows one to strengthen weak rubbings and, frequently, to complete rubbings taken from stones that are chipped or partially defaced.

It is hoped that anyone who admires the striking designs of early tombstones and cares enough to acquire his own collection of rubbings will be helped in doing so by the following suggestions.

The required materials are few and may be purchased at any art supply store: a roll of masking tape, a large pad or roll of strong bond paper, and a box of black lumber-marking wax crayons.

The first step in making a rubbing is to clean the stone of lichen, dirt and other foreign matter. Next, carefully tape the paper to the stone, making sure that the paper clings tightly, since the slightest shift will cause a blurring of the design. Finally, remove the wrapper from the crayon and lightly rub the broad edge of the crayon over the entire surface of the paper, thus establishing the over-all pattern. That part of the stone which touches the underside of the paper will be recorded in black, and that part which is recessed—the incised design—will be represented by the white areas.

Once the over-all design areas have been established, it is necessary to rub again with a firmer pressure, this time working in from the edges which separate the surface of the stone from the depressed background.

The character of the rubbing depends partly on the texture of the stone. Slate yields the greatest contrast in the image, whereas sandstone produces the coarsest texture. Schist and marble prove the least satisfactory.

A weak contrast in a rubbing due to the rough texture of the stone may be corrected after the removal of the paper by touching up the black areas with a crayon. This procedure is effected with a smoother stone surface, such as a piece of slate, under the paper. In this way an almost imperceptible design can be made to stand out clearly.

The Photographs

Gravestone decoration represents one of the most difficult and subtle forms of sculpture, that of low relief carving. The sculptor, confined to a working depth of a fraction of an inch, is challenged with the carving of forms that not only capture the spiritual quality of the subject, but also create the illusion of lifelike full-bodied round-ness. Many designs owe part of their success to the optical phenomenon created by light striking the oblique incision at a different angle than the parent surface, thus causing the incision to appear nearly white against the darker surface. When low relief sculpture is reproduced in the form of a rubbing, the result is strikingly unlike the subject that it is taken from. The most dramatic difference is that embossed areas become divorced from the background, creating a design that is no longer linear but rather one consisting of broad patterns.

The selection of photographs at the end of this volume will give the reader a more exact idea of what the gravestones actually look like, and will also perhaps illustrate better than do the rubbings the tactile qualities and surface textures of early New England grave-stones. A comparison between a rubbing and a photograph (Plates 44 and 179, bottom) reveals the marked difference in the nature of the two mediums. A number of interesting stones which are too fully sculptured to be rubbed are also illustrated in this section.

Death's-Heads,
Angels
& Portraits

Plate 1

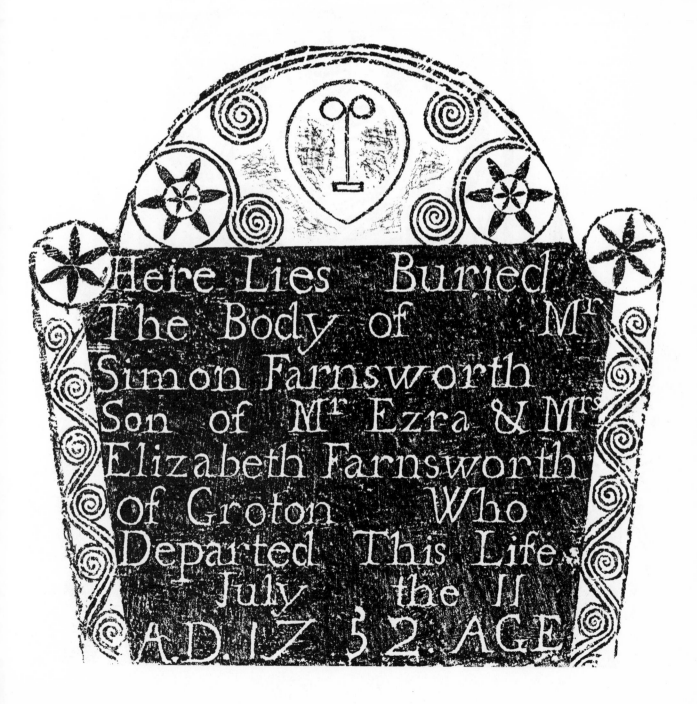

Plate 2

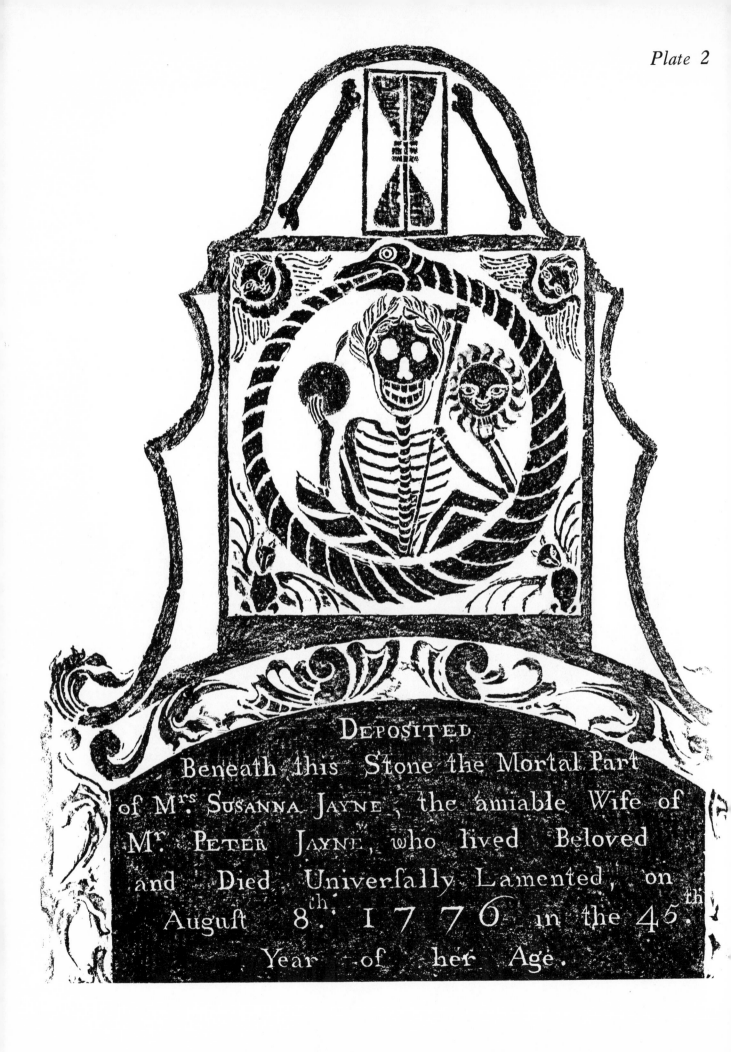

DEPOSITED
Beneath this Stone the Mortal Part
of M:rs Susanna Jayne, the amiable Wife of
M:r Peter Jayne, who lived Beloved
and Died Universally Lamented, on
August 8:th 1776 in the 45:th
Year of her Age.

Plate 3

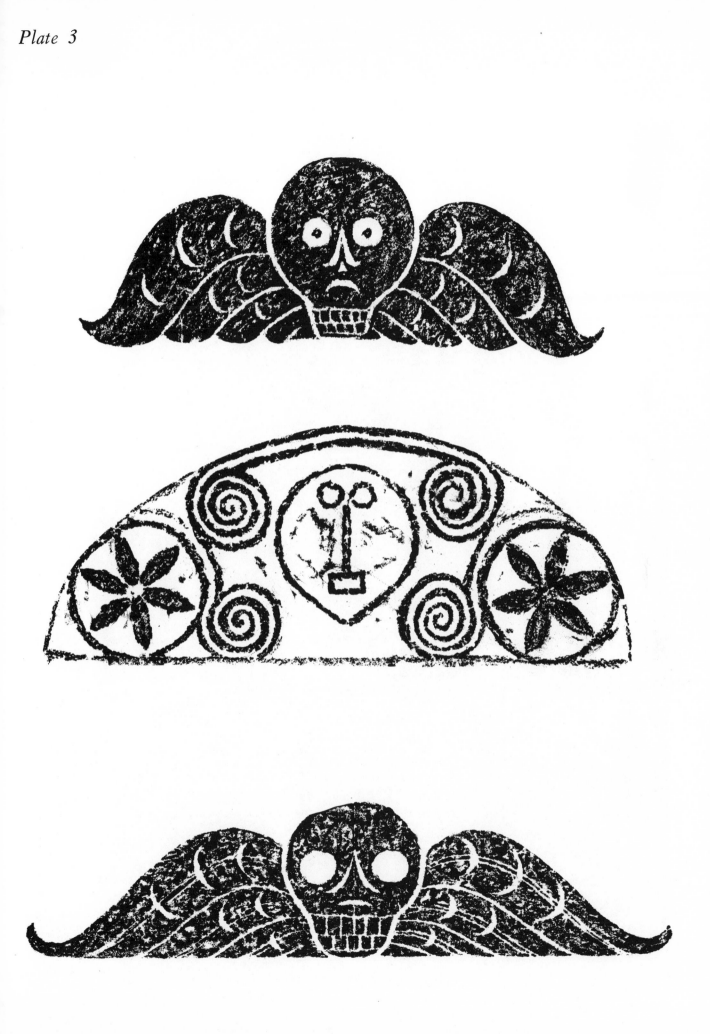

Plate 4

HERE LYES BURIED
THE BODY OF
M^rs DORCAS WORTH WIFE
TO JOHN WORTH ESq^r
DEC^d AUG^t Y^4^d 1730
IN THE 33 YEAR
OF HER AGE

Plate 5

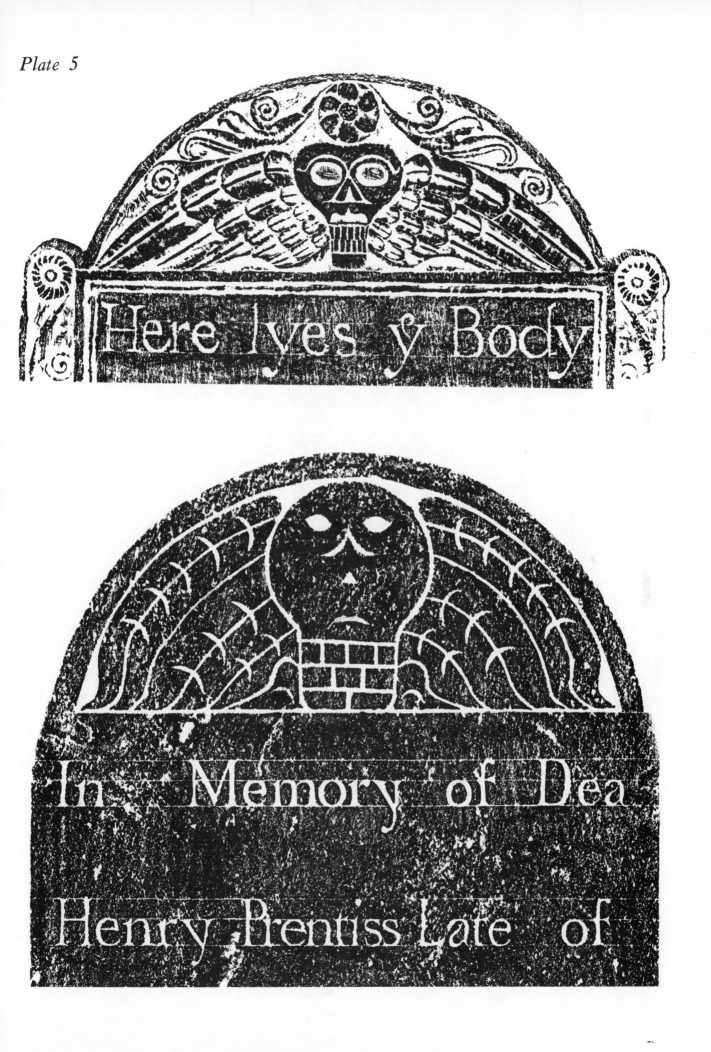

Plate 6

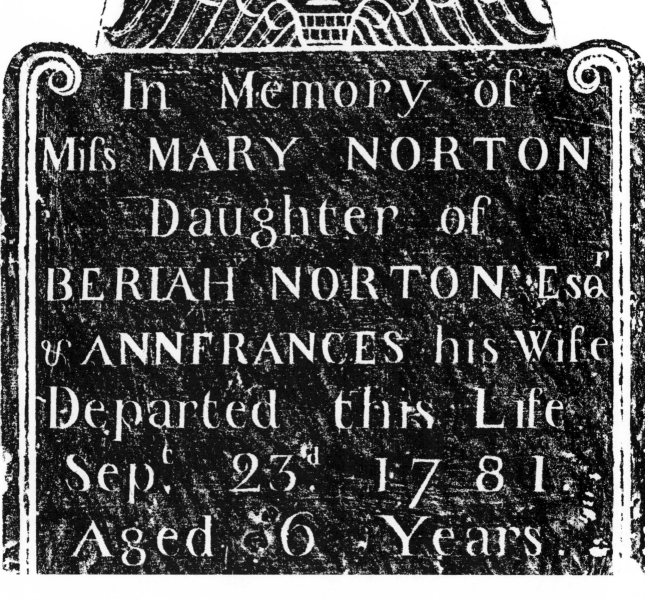

Plate 7

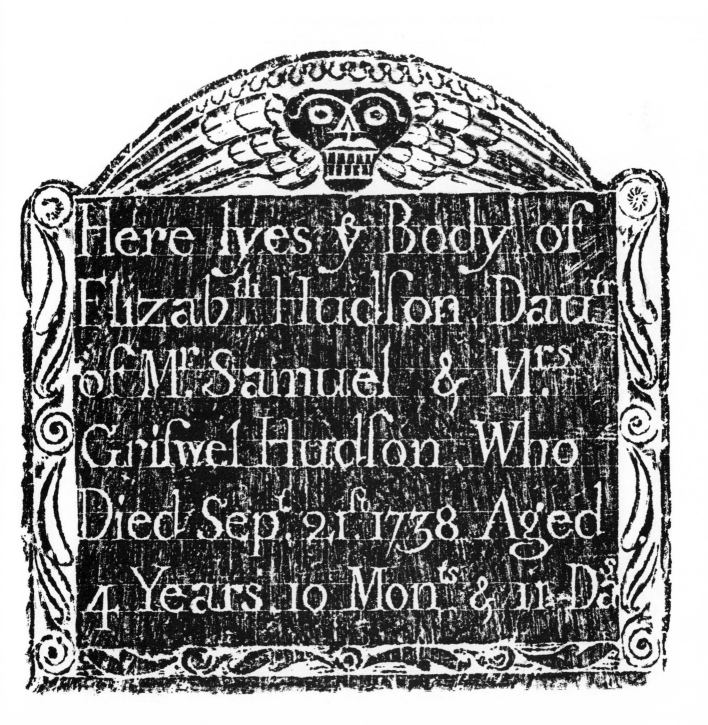

Plate 8

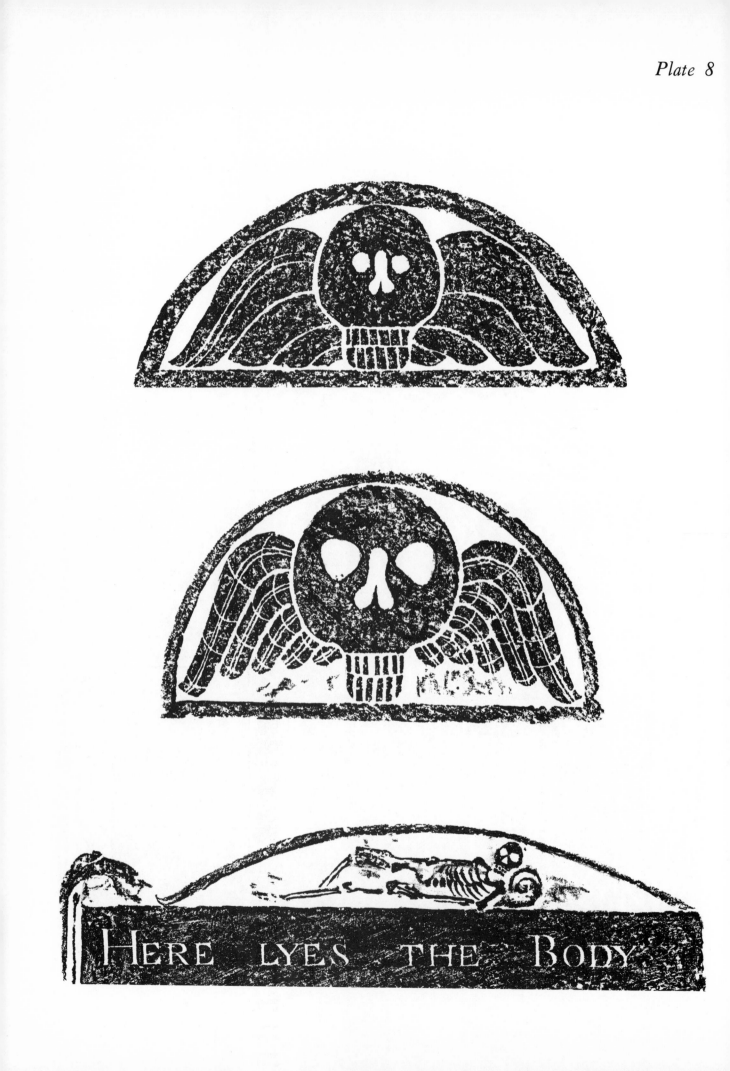

Plate 9

Plate 10

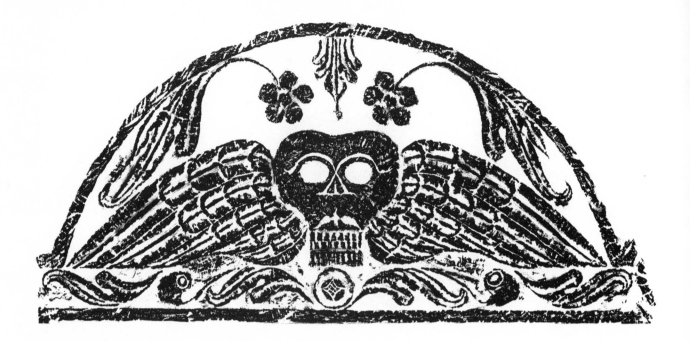

Plate 11

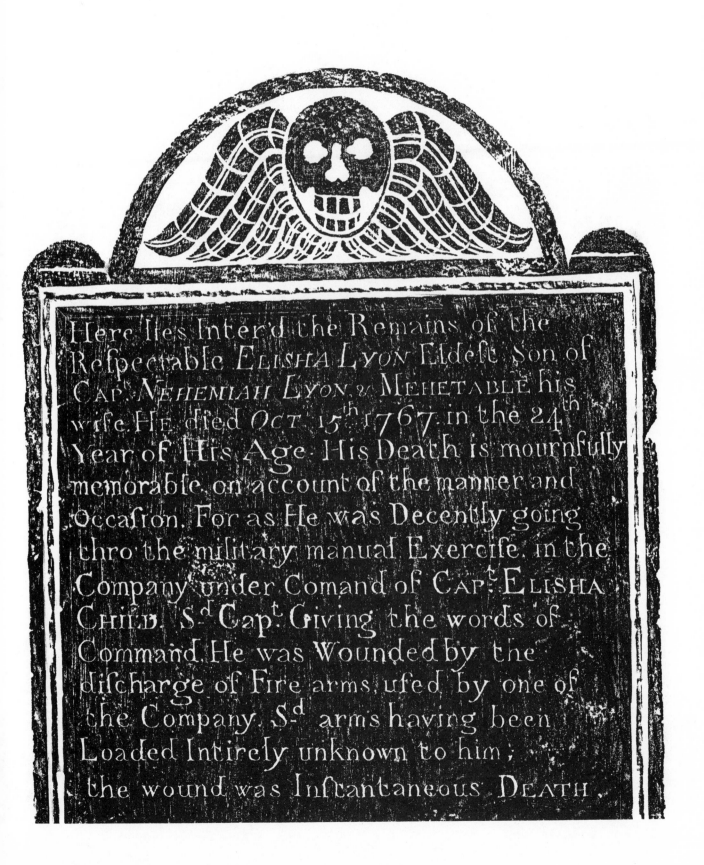

Here lies Inter'd the Remains of the
Respectable *ELISHA LYON* Eldest Son of
Cap^t *NEHEMIAH LYON* & MEHETABLE his
wife He died *OCT* 15^th 1767. in the 24^th
Year of His Age. His Death is mournfully
memorable. on account of the manner and
Occasion. For as He was Decently going
thro the military manual Exercise. in the
Company under Comand of Cap^t ELISHA
CHILD. S^d Cap^t Giving the words of
Command. He was Wounded by the
discharge of Fire arms. used by one of
the Company. S^d arms having been
Loaded Intirely unknown to him;
the wound was Instantaneous DEATH

Plate 12

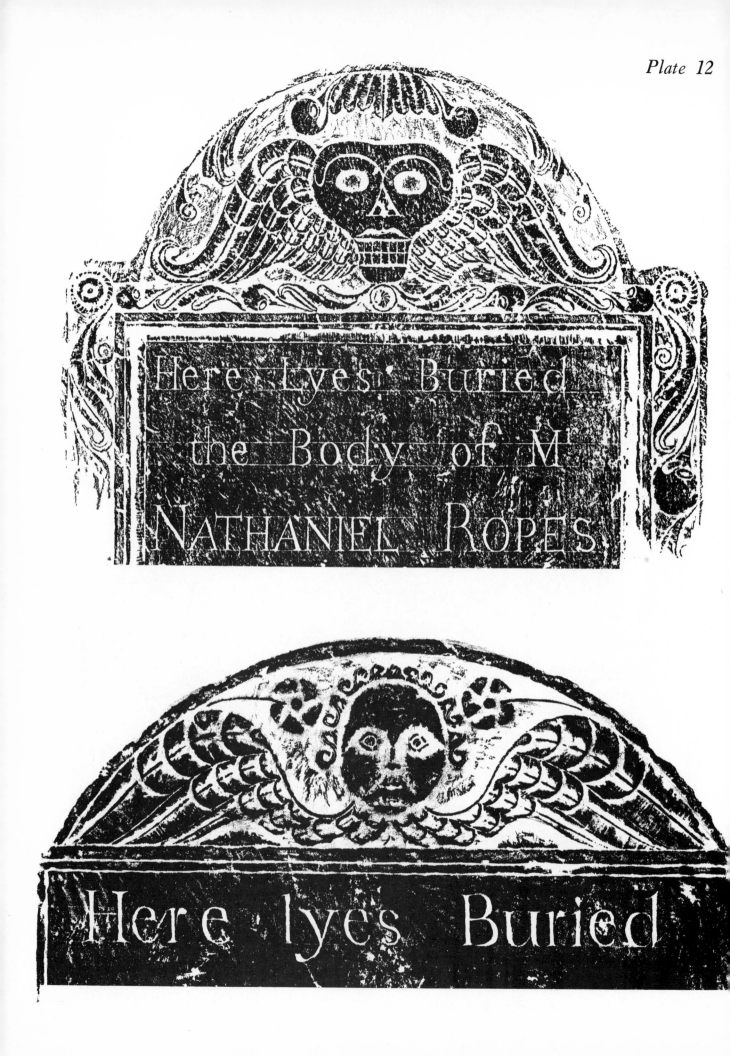

Plate 13

Here lies the Remains of
Mᵗˢ SARAH BEACH wife to the
Revᵈ Mʳ JOHN BEACH, who after
having been a dutiful Child; a
loving Sifter, an amiable & faithful
Wife, a tender & careful mother, a moft
devout Chriftian, exchanged this
Life for Immortality AUGᵗ 1ˢᵗ 1756.

Plate 14

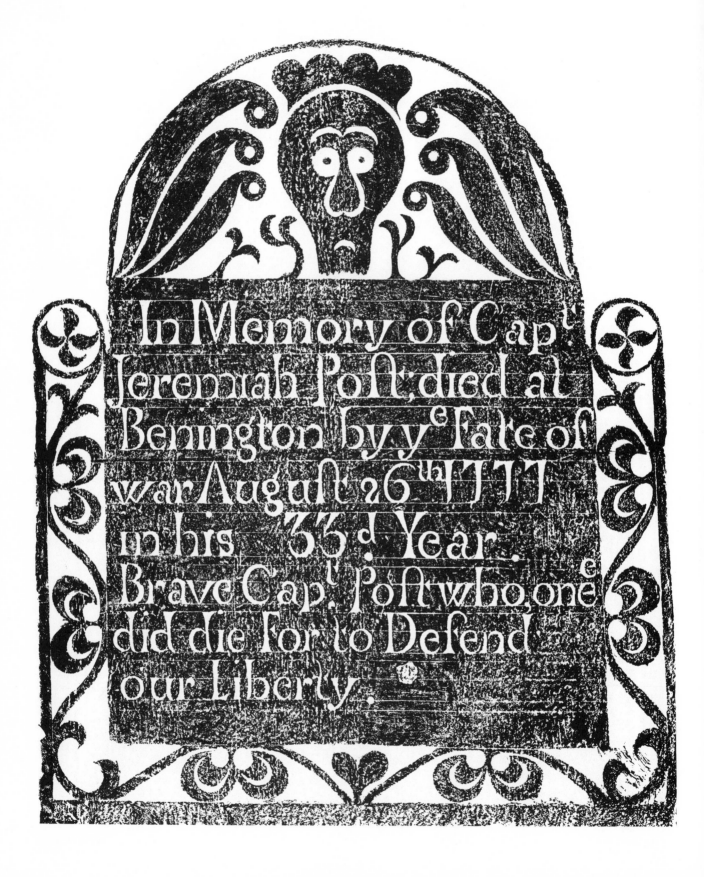

Plate 15

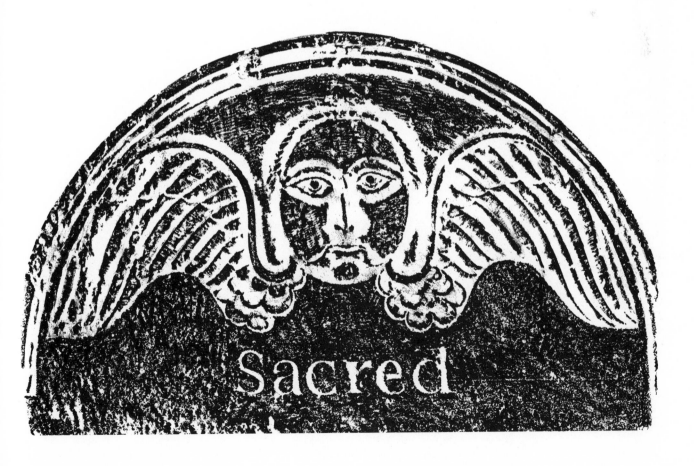

Plate 16

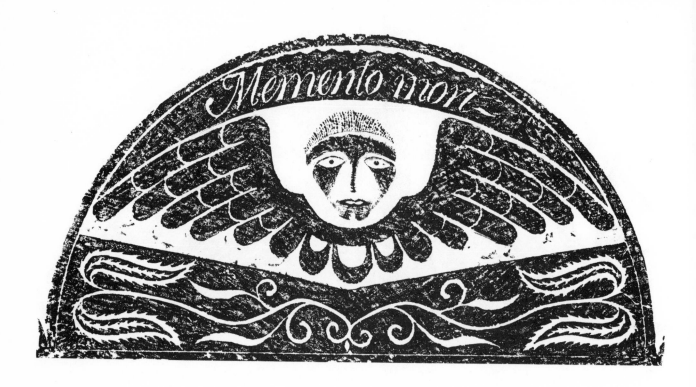

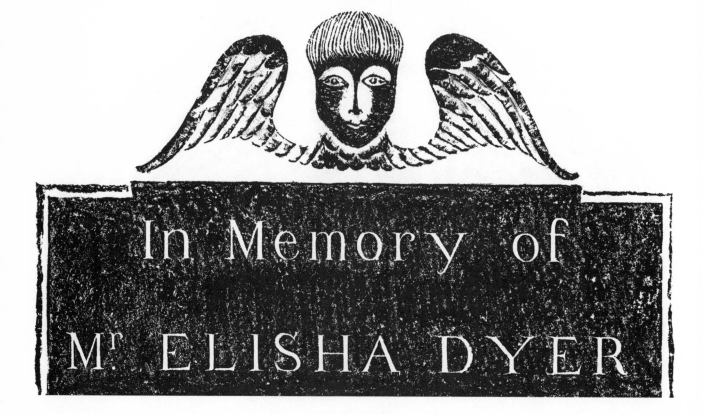

Plate 17

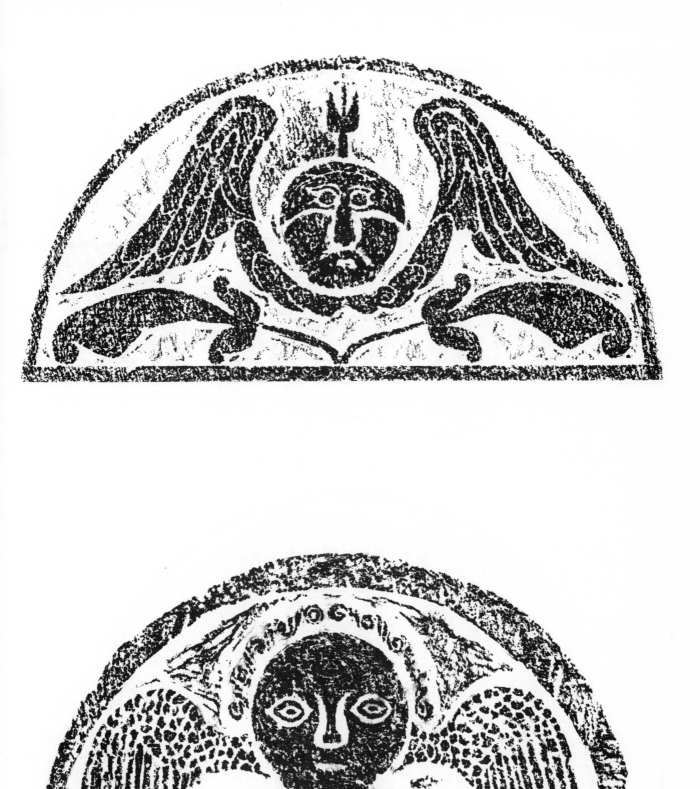

Plate 18

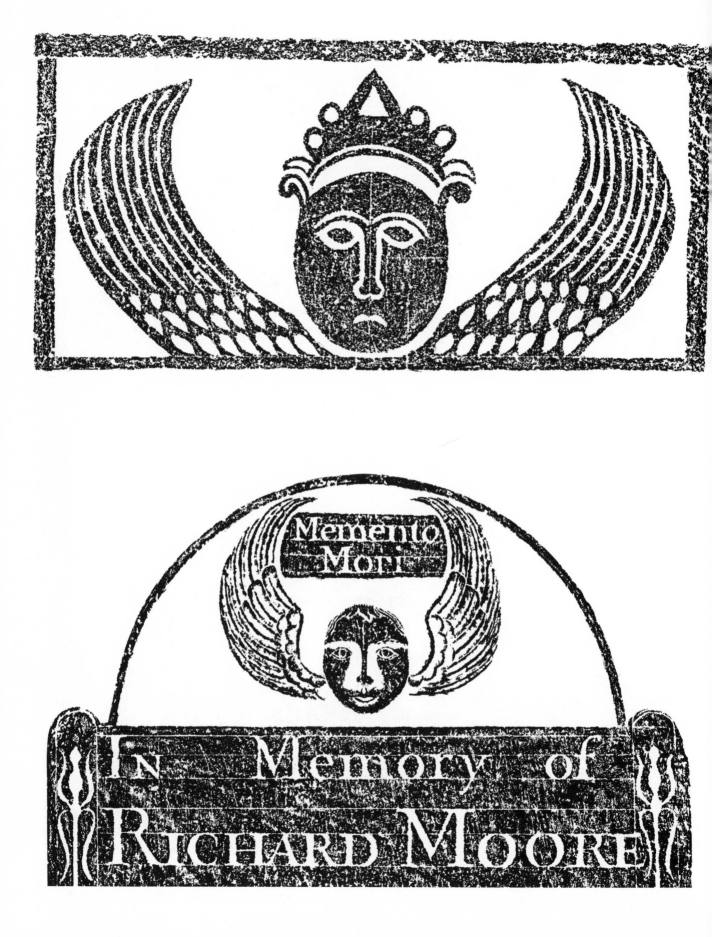

Plate 19

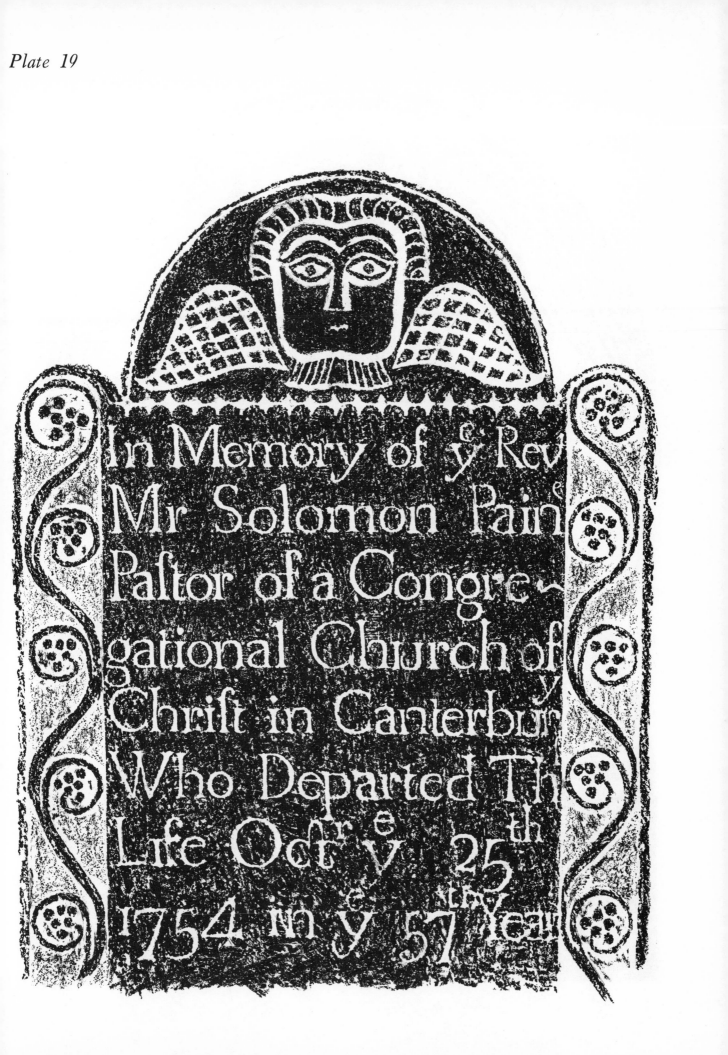

Plate 20

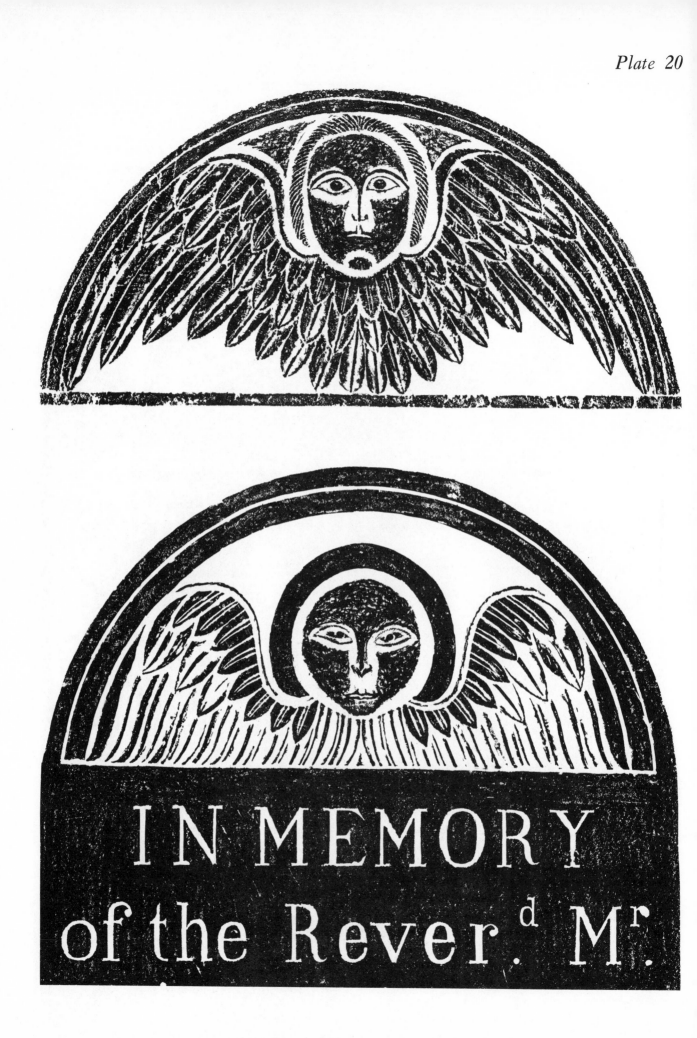

Plate 21

HERE LIES THE BODY OF
M.rs ELIZABETH BARNARD,
THE WIFE OF
M.r EBENEZER BARNARD;
SHE DIED AUGUST 4.th
1753: IN ye 59th YEAR
OF HER AGE.

Plate 22

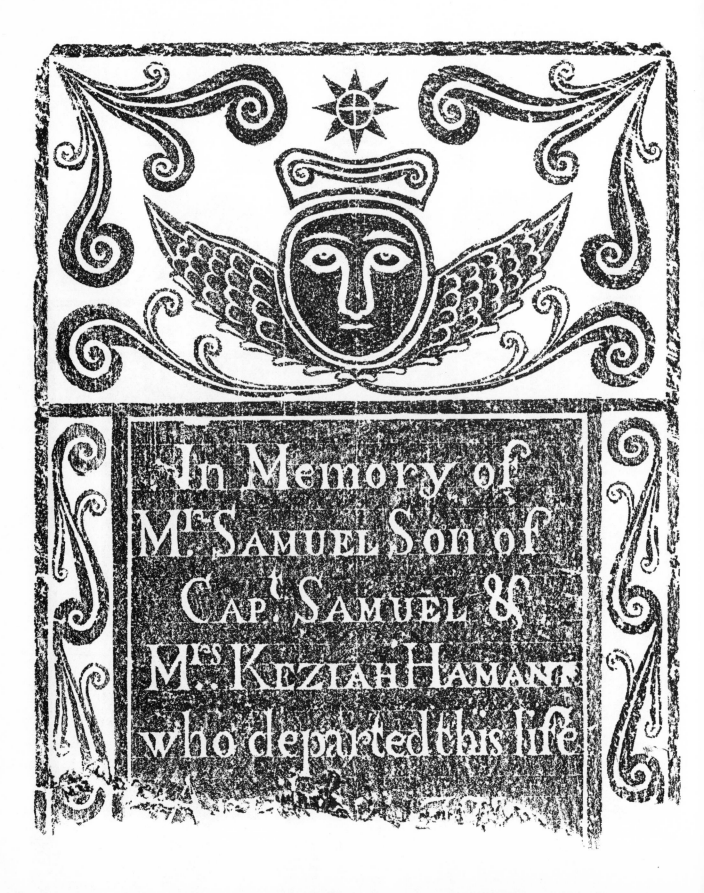

Plate 23

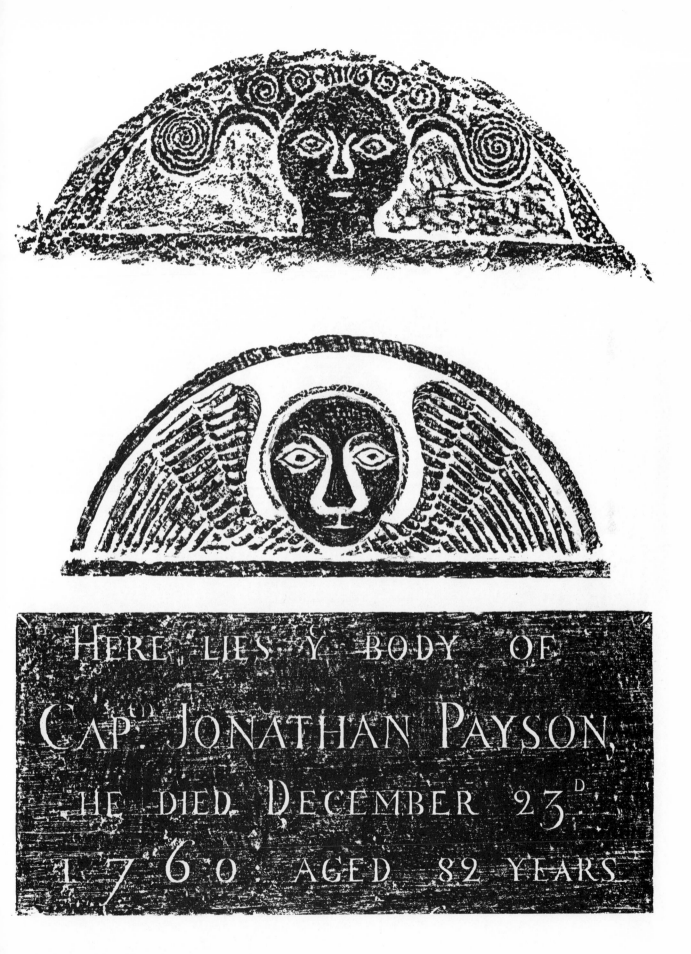

Plate 24

Sacred to the memory
OF Mrs TEMPERANCE WILLIAMS
Confort of Mr ISRAEL WILLIAMS
And Daughter of
Dr DAVID HOLMES & TEMPERANCE his Wife

Adding lusture to an amiable character
By sustaining her last illnefs
With Christian refignation
She departed this life
March 20th J795
Ætat. XXI

The scythe of Time "cuts down
The fairest bloom of sublunary blifs."

Young

Plate 25

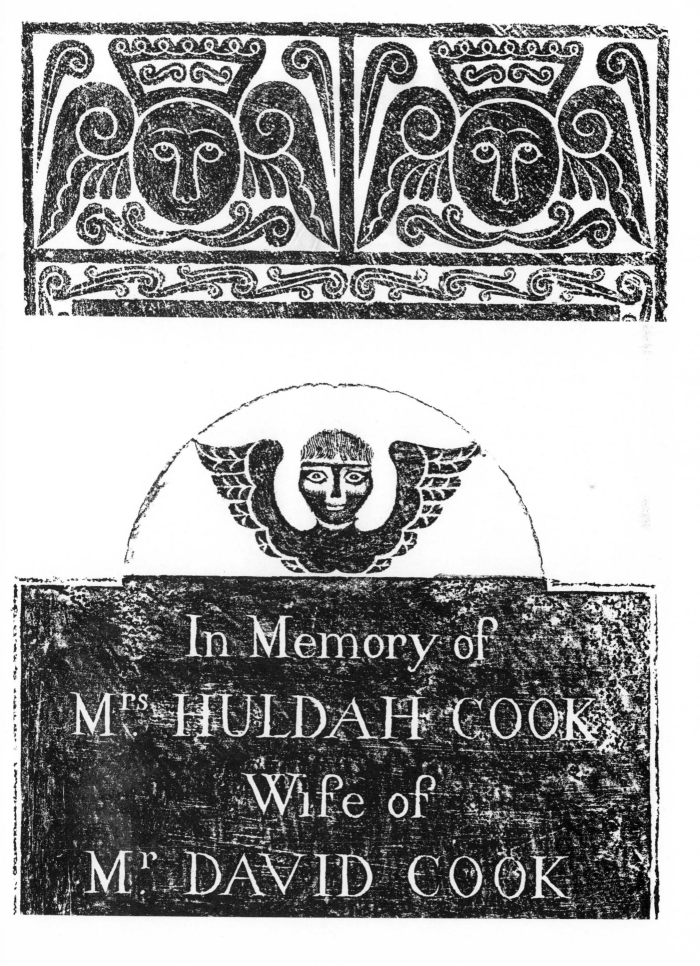

In Memory of
Mrs HULDAH COOK
Wife of
Mr DAVID COOK

Plate 26

In memory of
Miſs Eunice Dean dau[r]
of Mr. Simeon Dean,
& Tameſin his wife
who died March 1800
In her 24th Year

Affliction ſore, long time I bore,
Phyſicians ſkill was vain,
Till God was pleaſ'd to give me eaſe,
And free me from my pain.

Plate 27

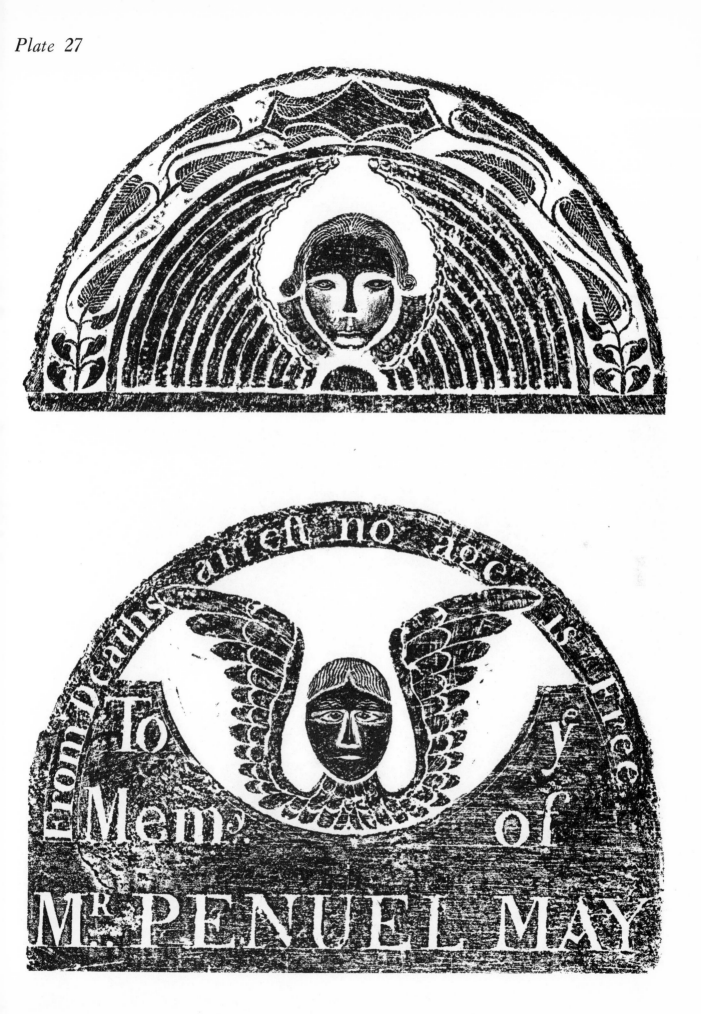

Plate 28

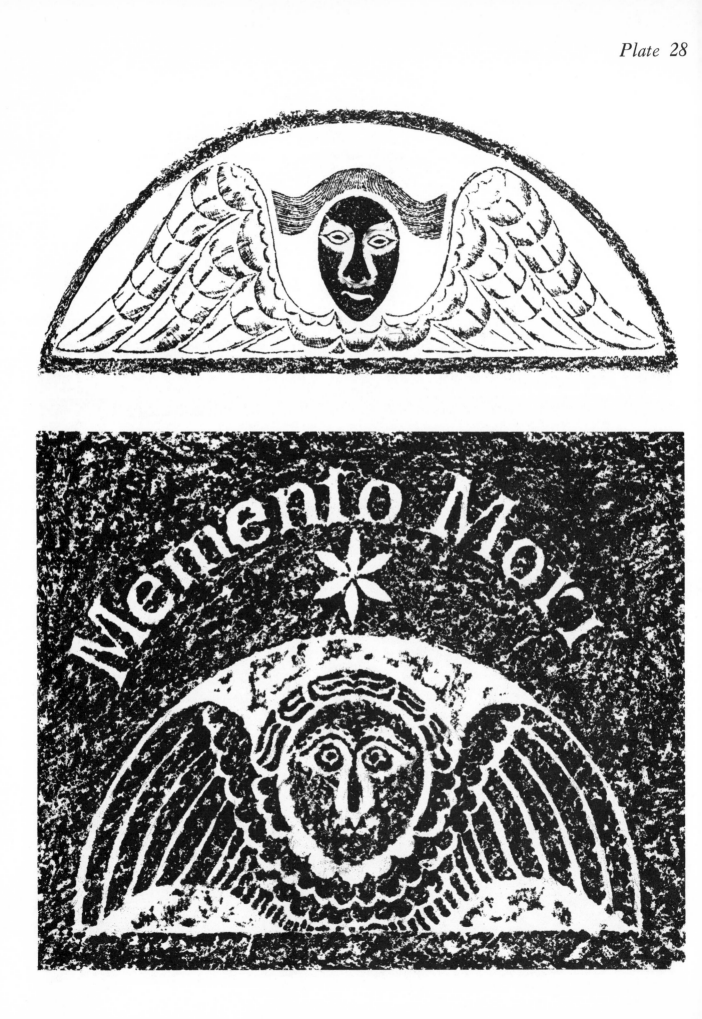

Plate 29

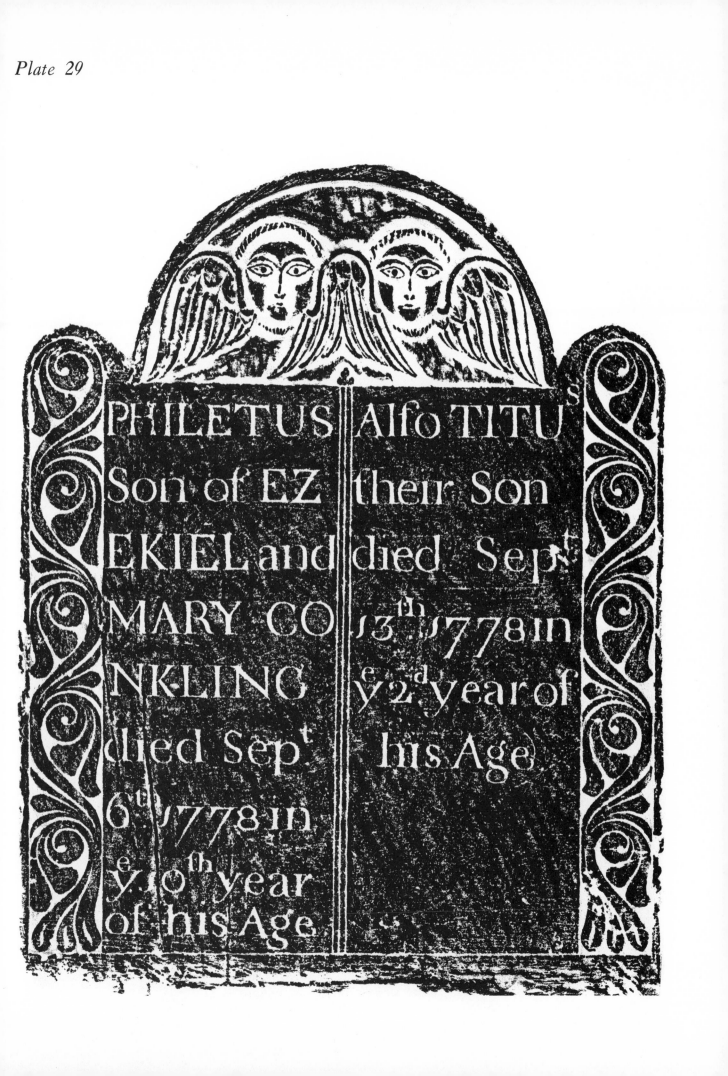

Plate 30

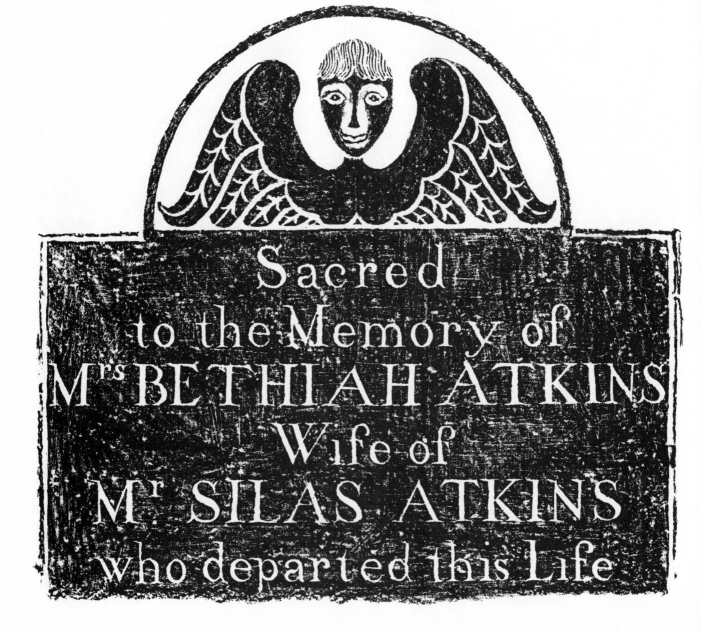

Plate 31

Here lyes y Body of
Mary-Ann Fofdick Daugᵗʰ
of Mᵗ Thomas & Mᵗˢ Anna
Fofdick Who Died Jan. II. 174⁴ᵗʰ
Aged 10 Months & 12 Days.

Som frutlefs tears & weep no more
This Babe's not loft but gone before
......

Plate 32

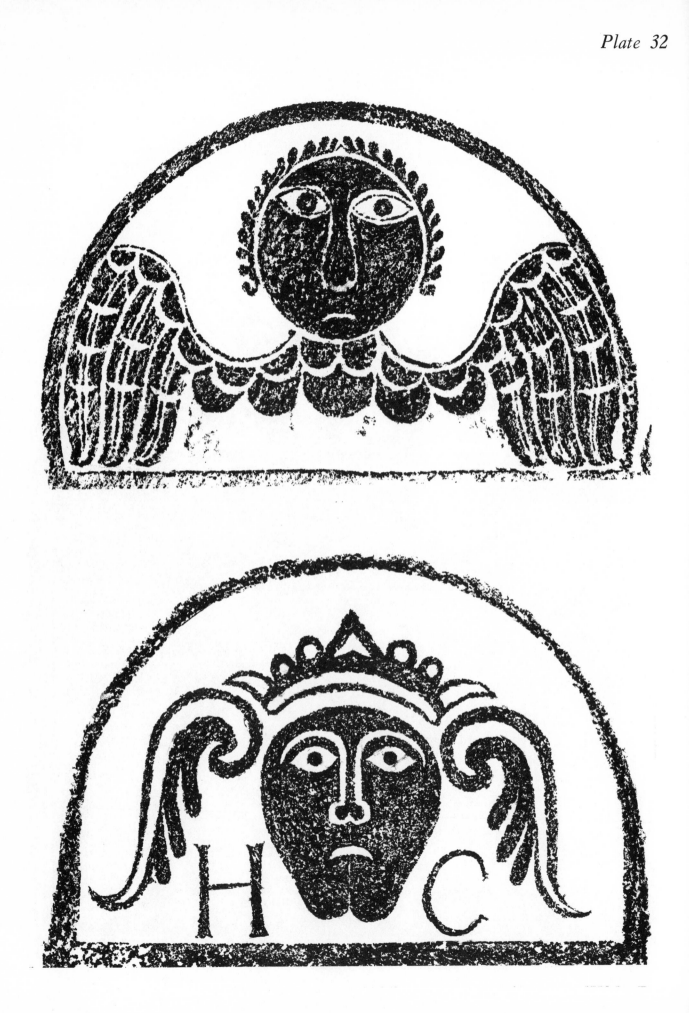

Plate 33

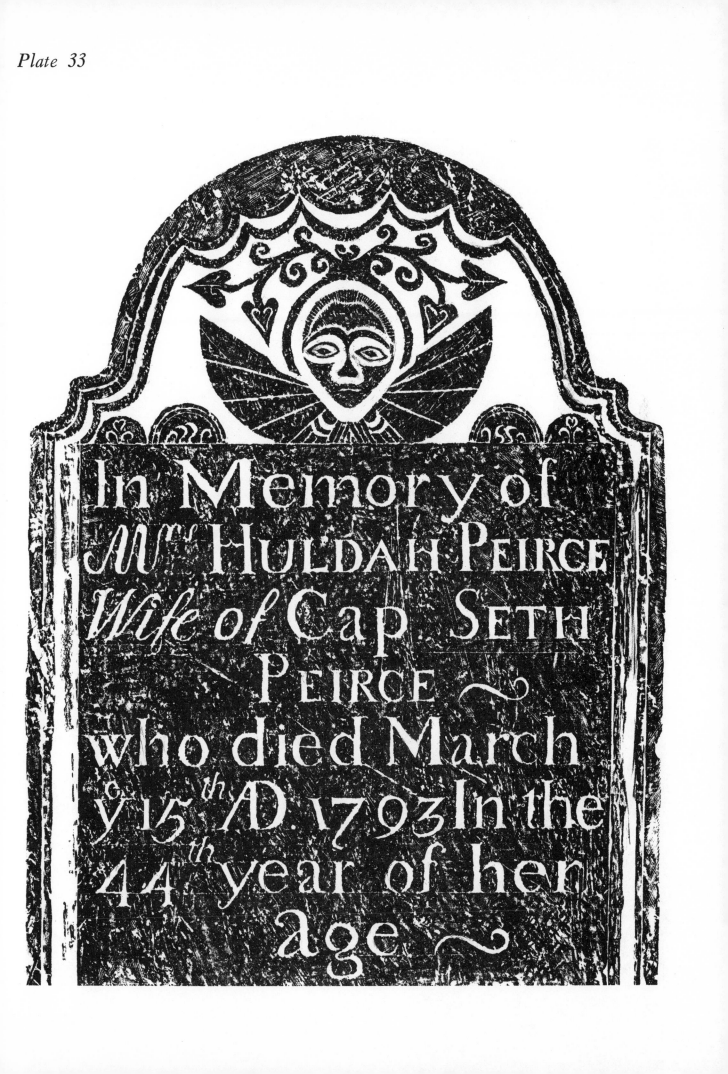

Plate 34

Plate 35

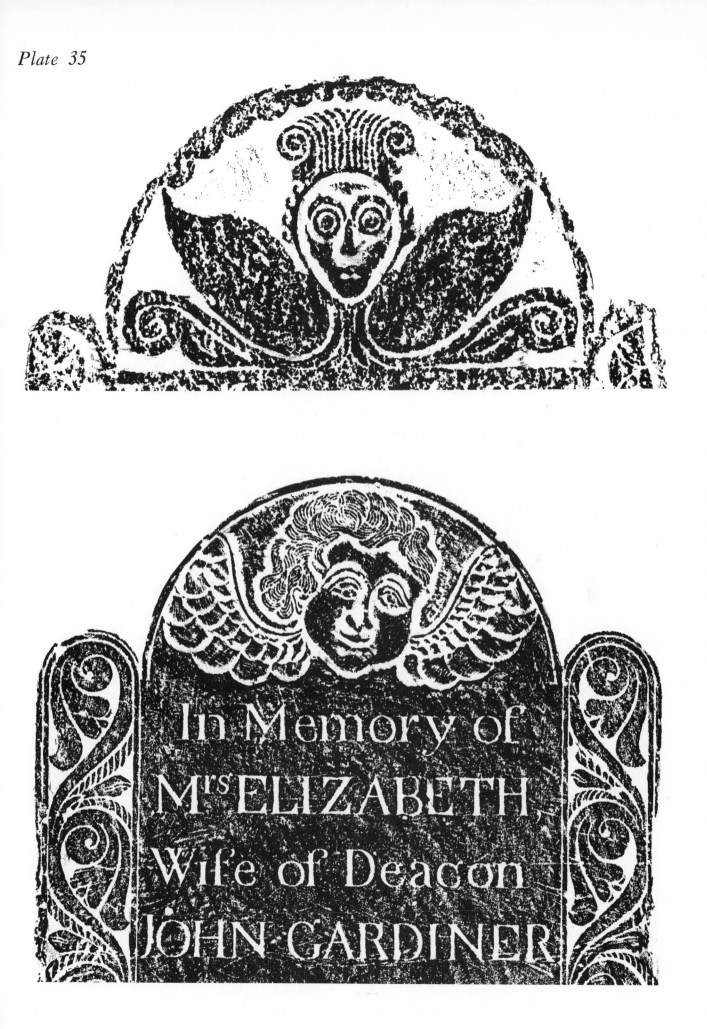

Plate 36

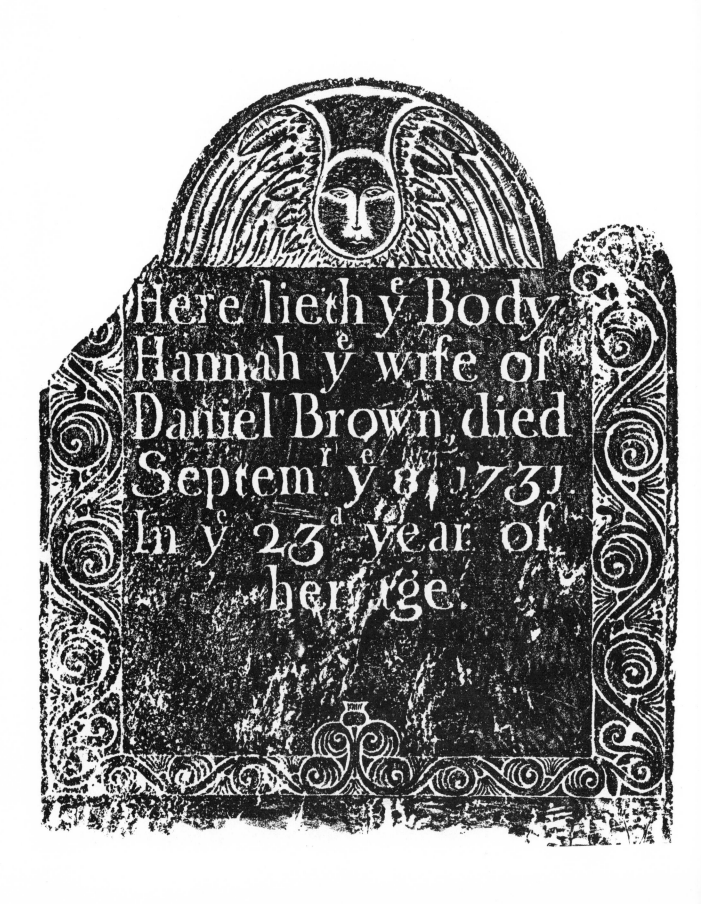

Plate 37

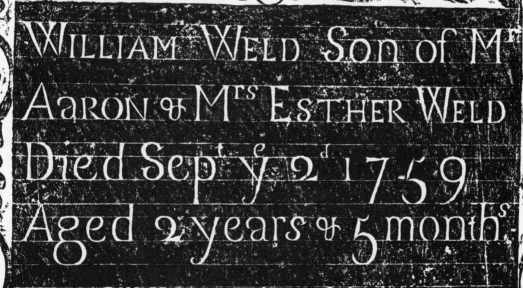

WILLIAM WELD Son of Mr
Aaron & Mrs ESTHER WELD
Died Sept y 2d 1759
Aged 2 years & 5 months

Mournfull Parents here I ly
As you are now so once was I
As I am now so you must be

Plate 38

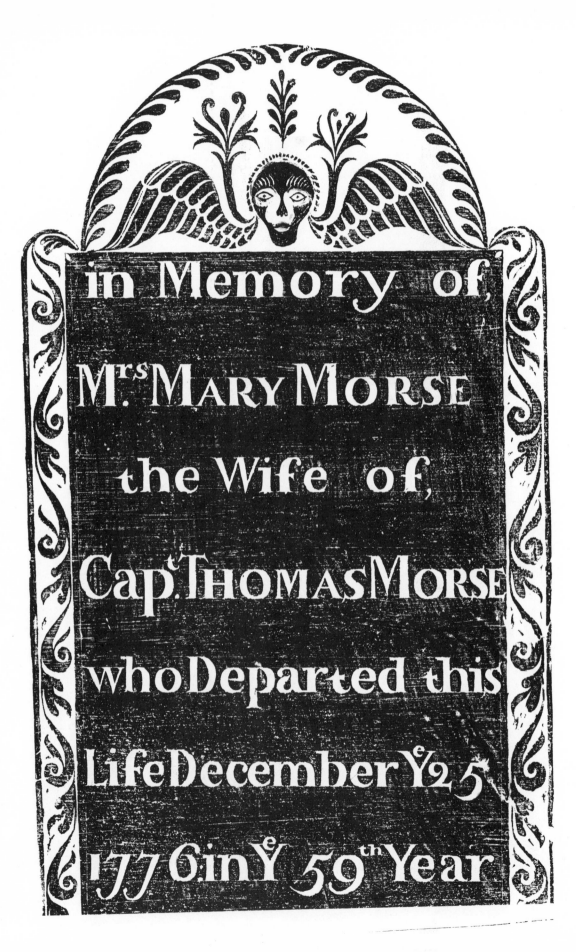

Plate 39

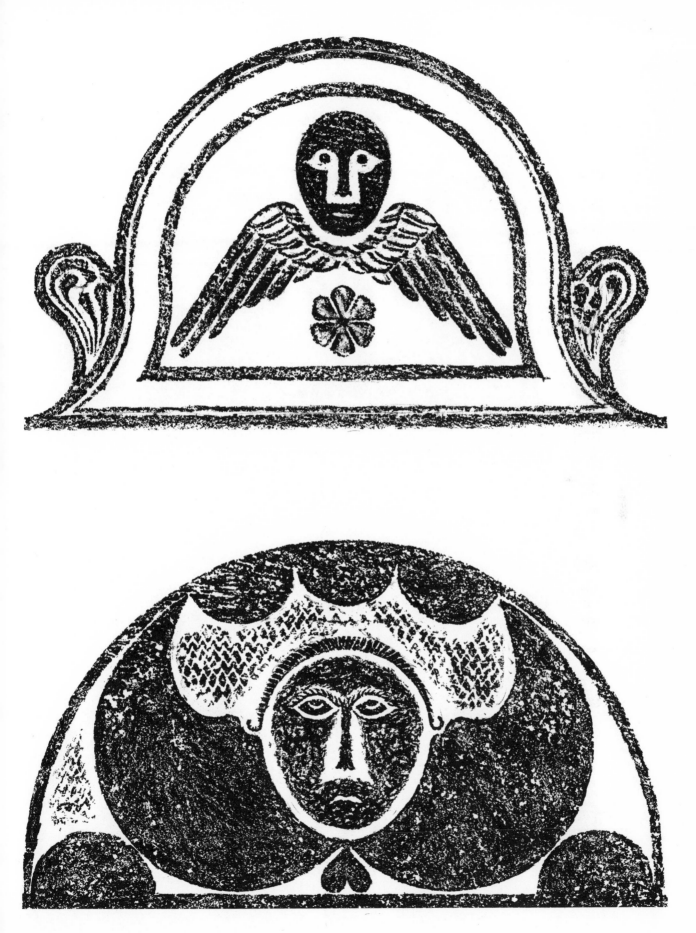

Plate 40

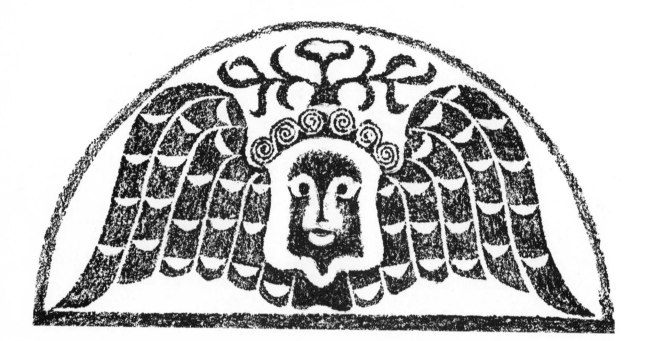

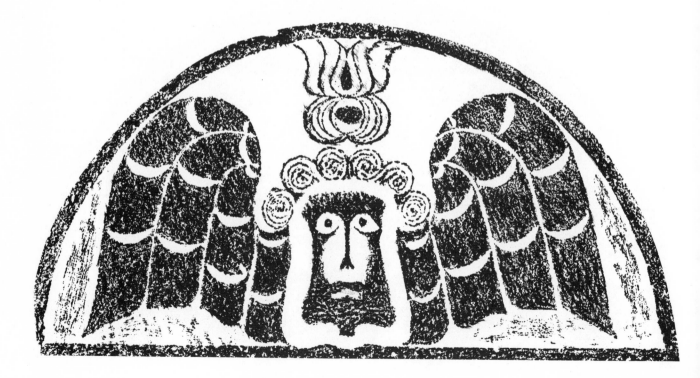

Plate 41

SACRED

to the memory of,

Mr. TIMOTHY HARTSHORN

who died

July 13th 1800,

Aged 70 Years.

If virtue, honesty, and truth, could save,
He lives in realms of bliss, far, far! beyond
the Grave.

Plate 42

In Memory of Benjamin, Son of Doc.^tr Thomas & Mr.^s Sarah Wells; he Died March y.^e 28^th 1746 in the 16^th Year of his Age

Plate 43

MARCIA GIBBS, Daught of Henry and Mercy Gibbs died Nov. 17th 1791. Aged 4 Years & 2 Weeks.

HENRY GIBBS eldest Son of Henry and Mercy Gibbs died Dec 14th 1791. Aged 8 Years & 7 Months.

Insatiate Archer! could not one suffice?
Thy shaft flew twice, & twice my peace was slain;
And twice, ere twice yon moon had fill'd her horn.

Young.

Plate 44

In Memory of
the widow Sarah
Littlefield, who
died Nov. ye
1794 in

Plate 45

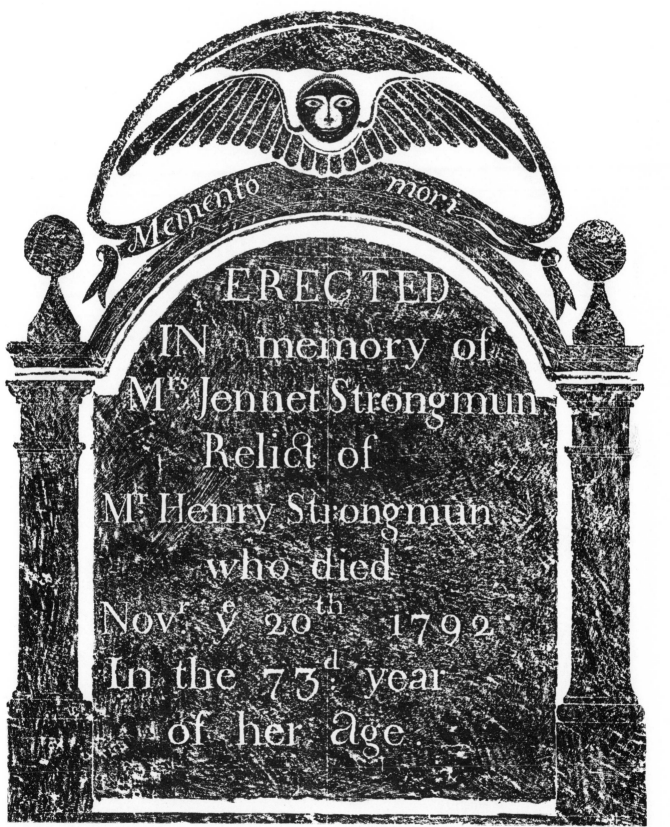

Plate 46

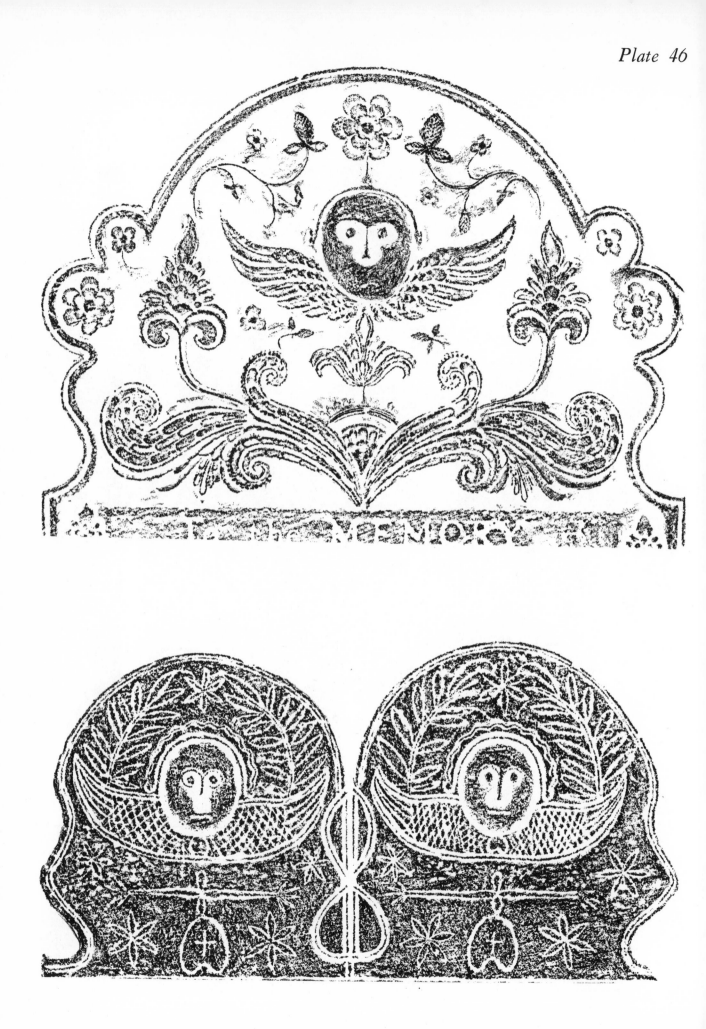

Plate 47

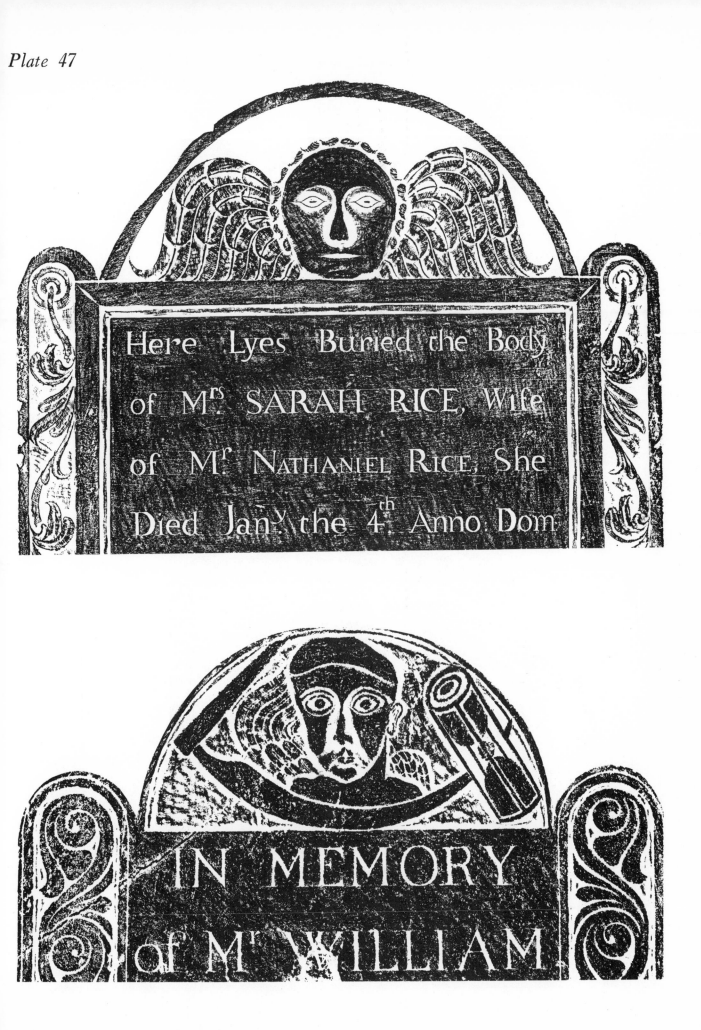

Plate 48

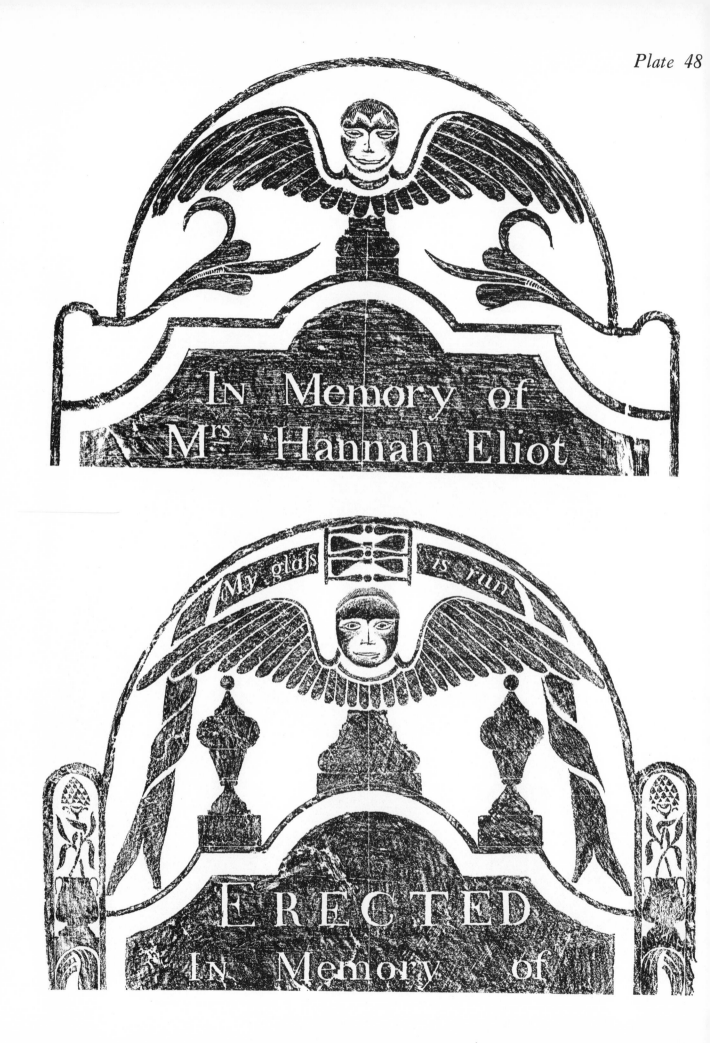

Plate 49

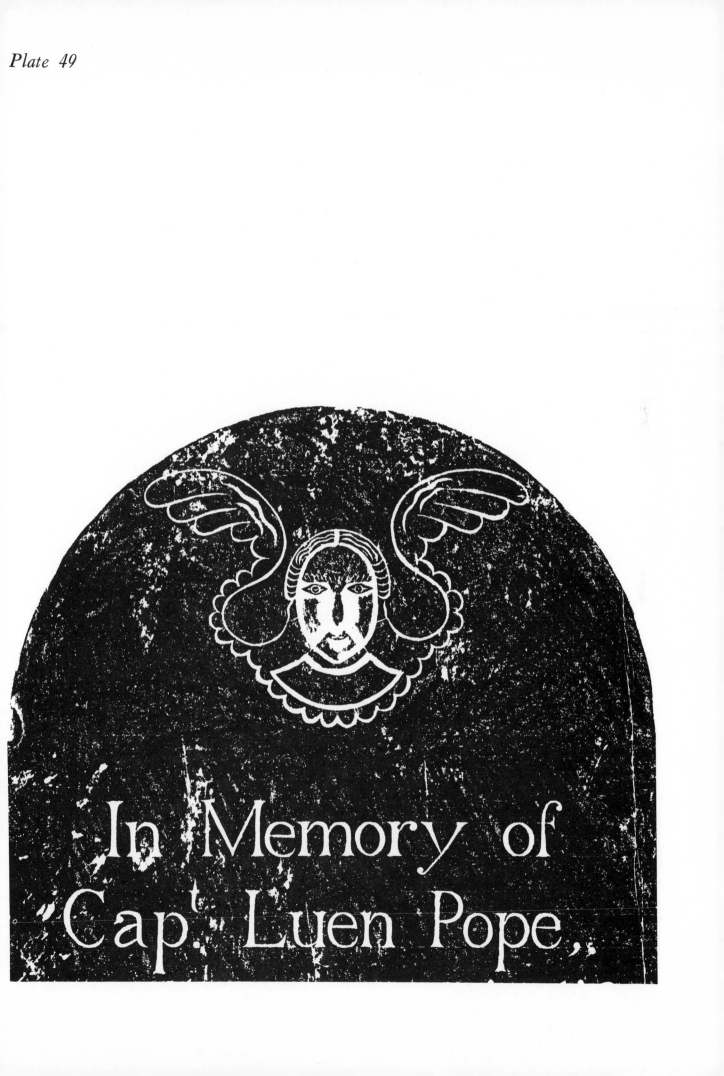

Plate 50

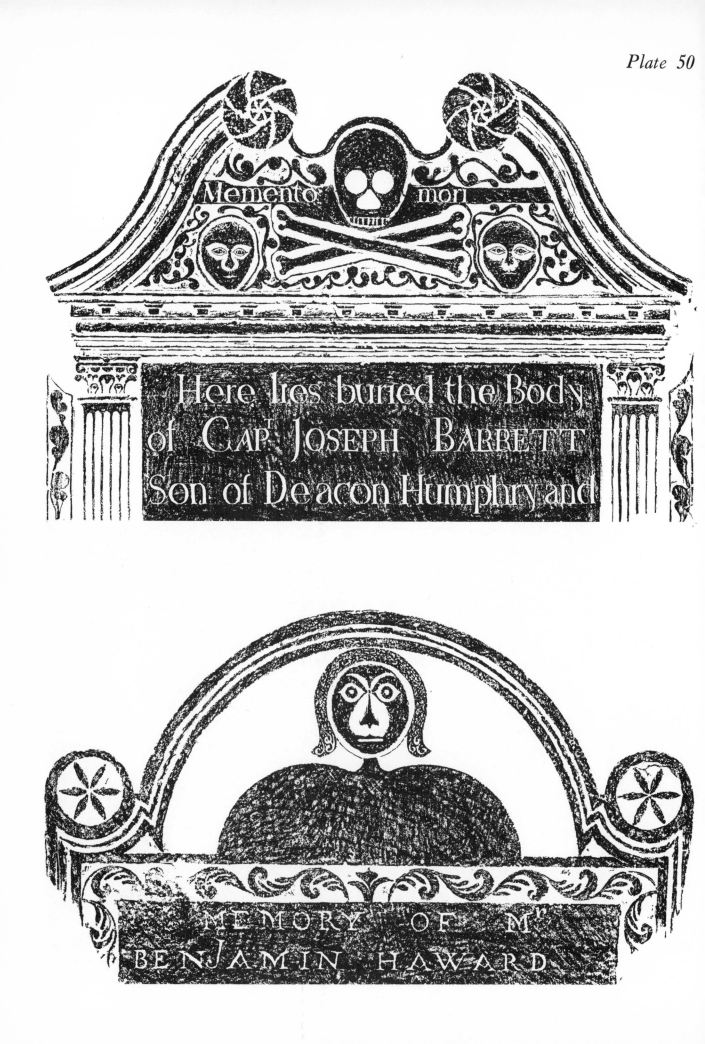

Plate 51

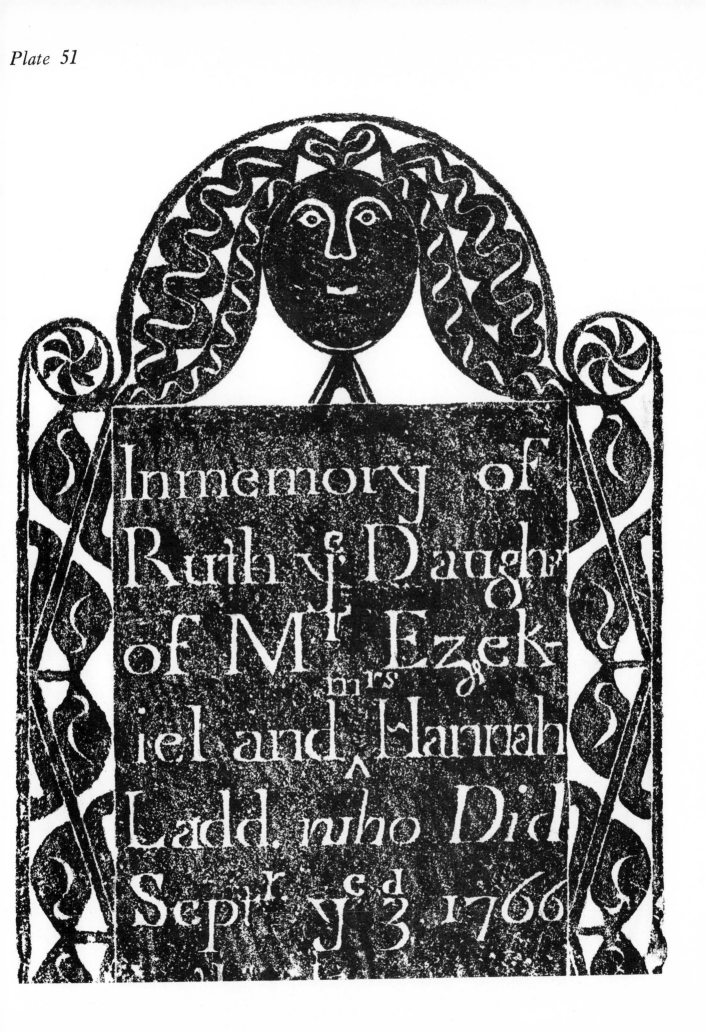

Plate 52

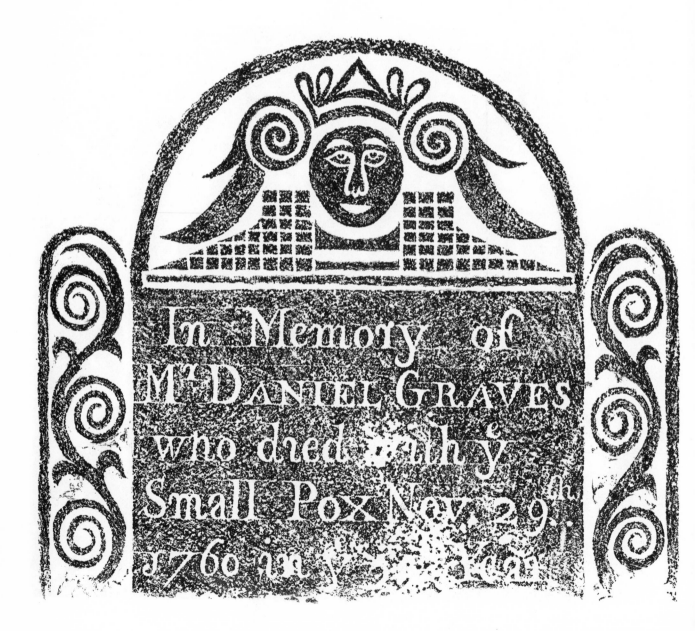

Plate 53

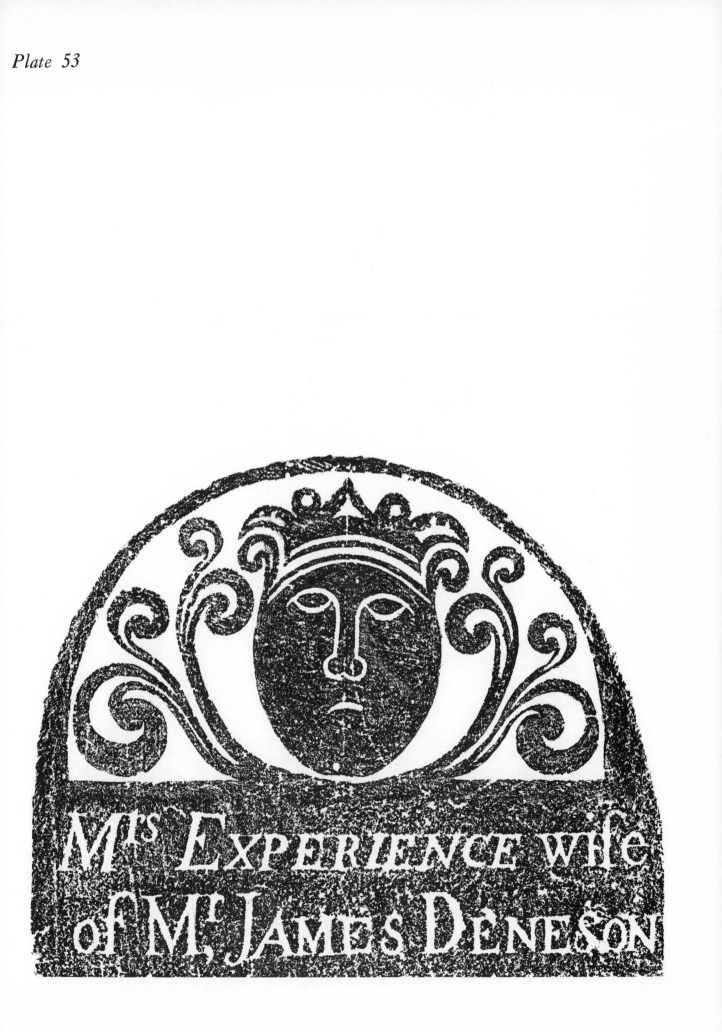

Plate 54

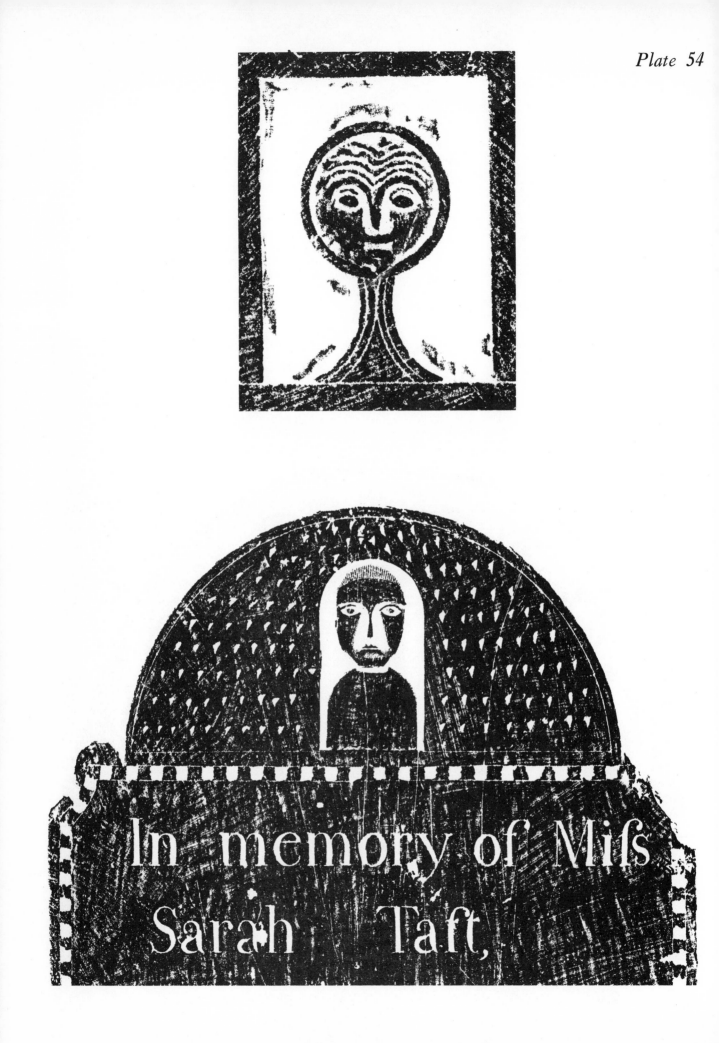

Plate 55

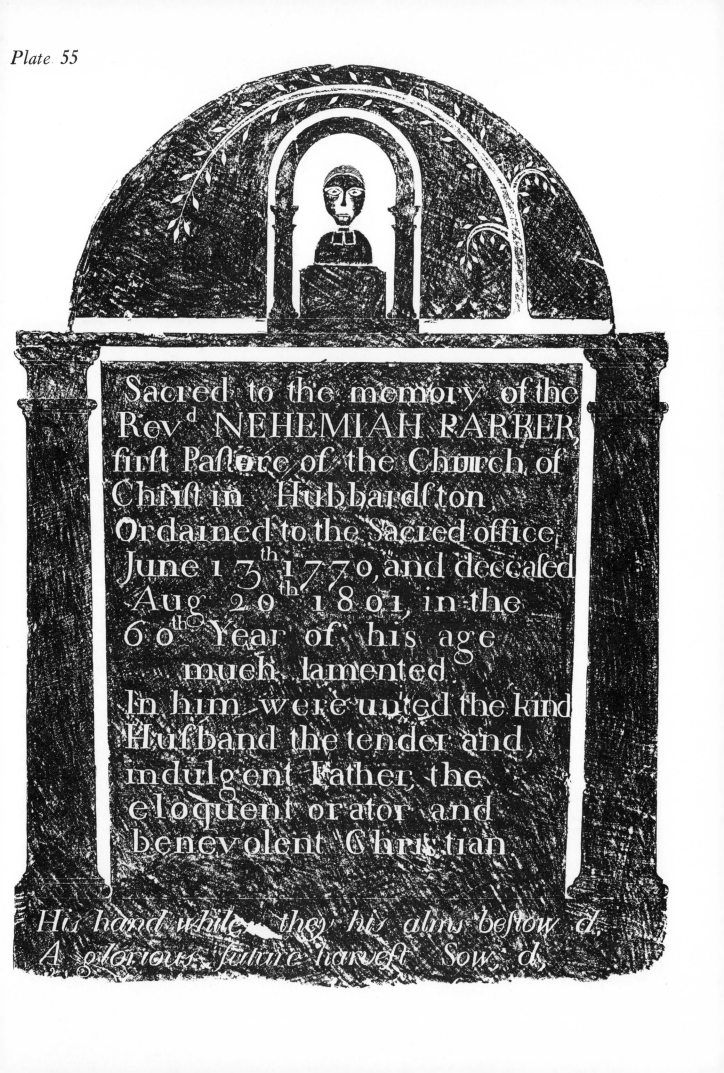

Plate 56

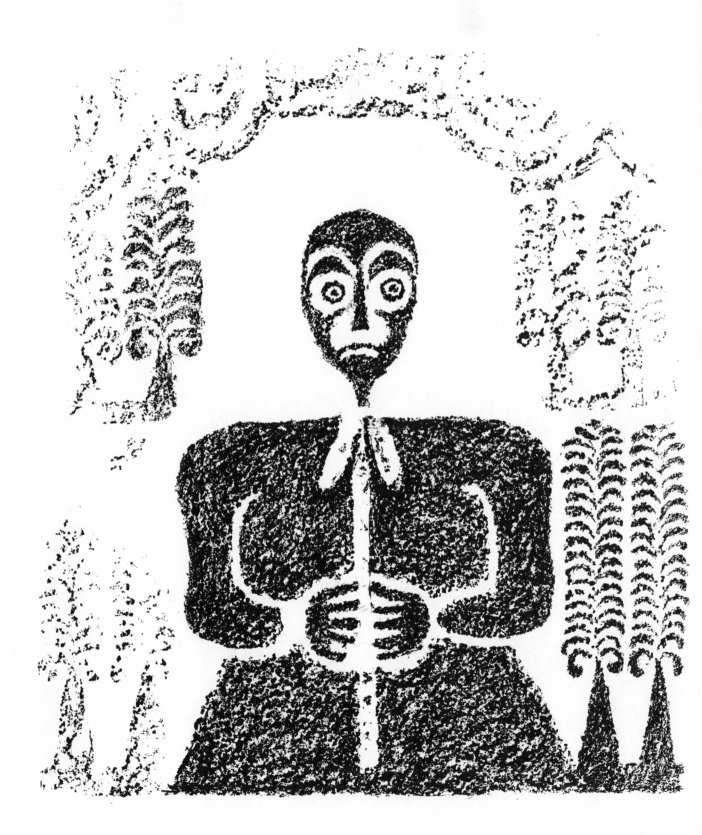

Plate 57

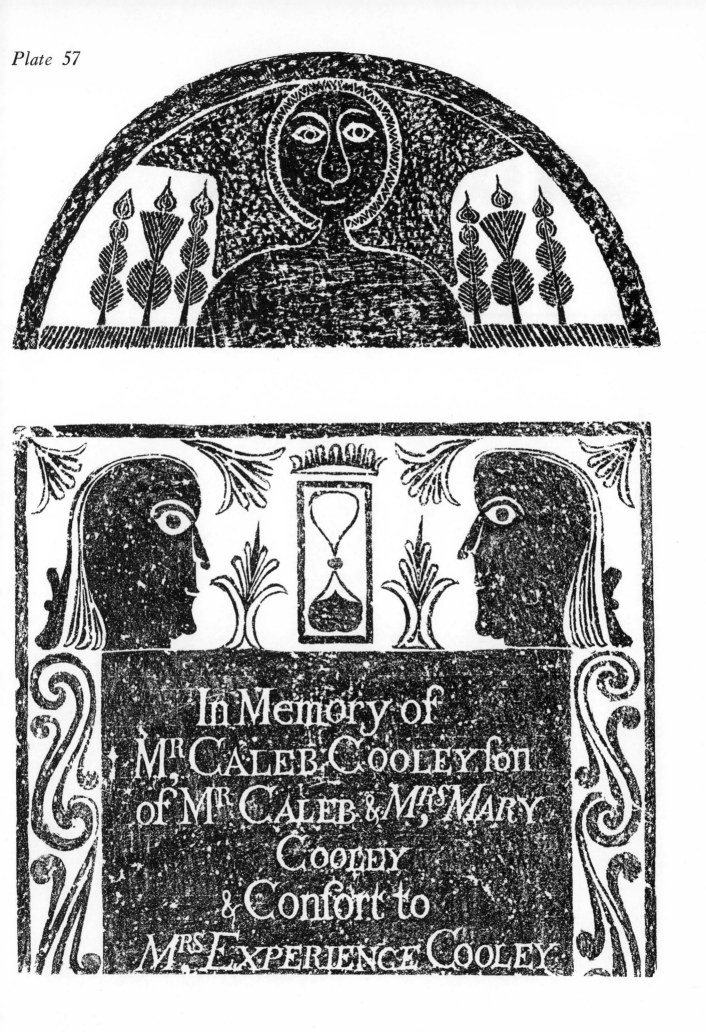

Plate 58

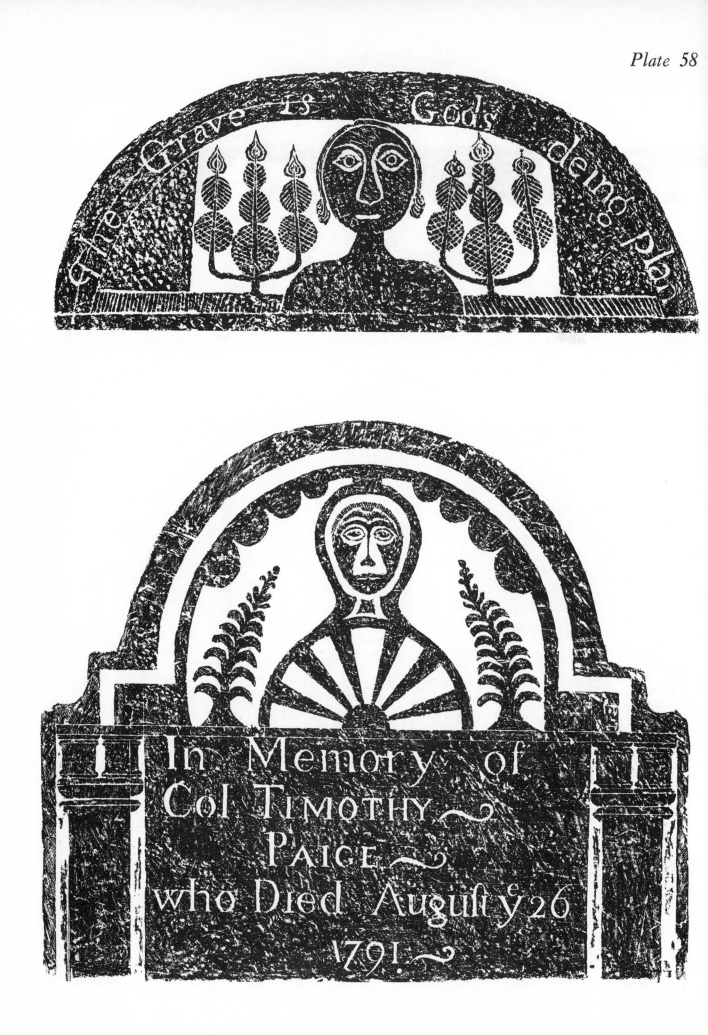

Plate 59

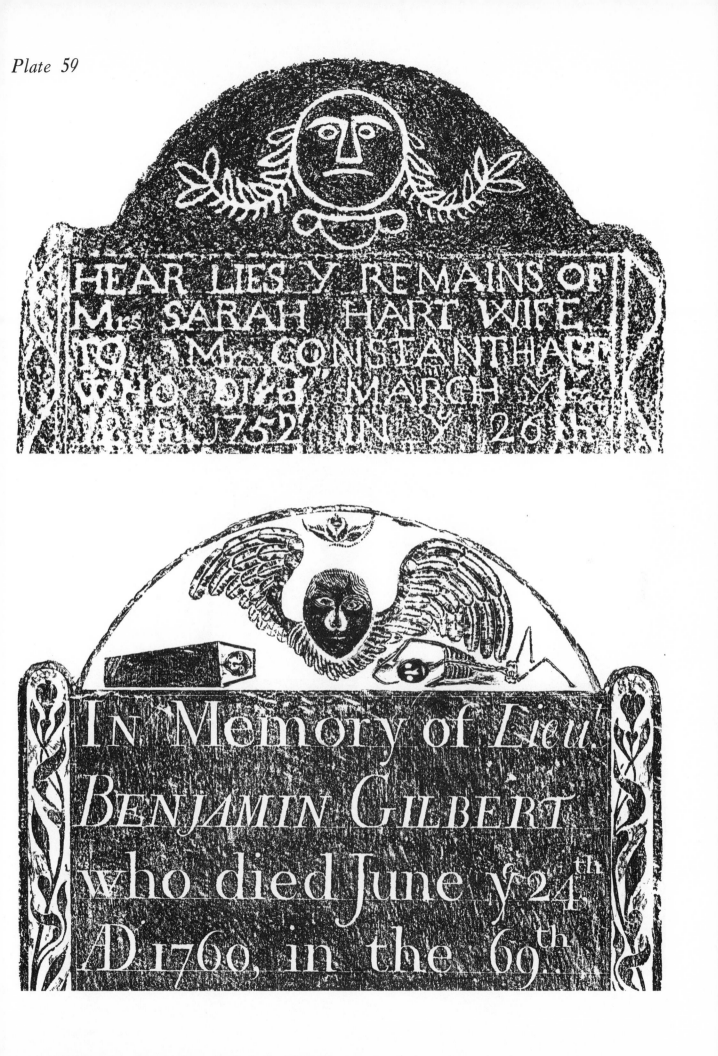

Plate 60

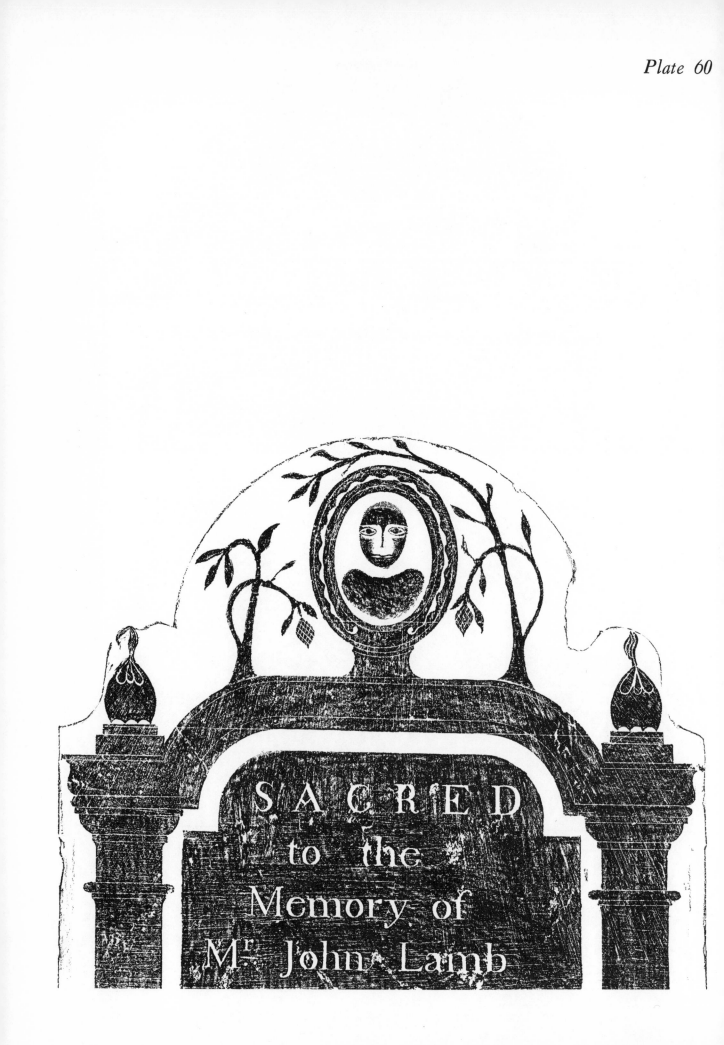

Plate 61

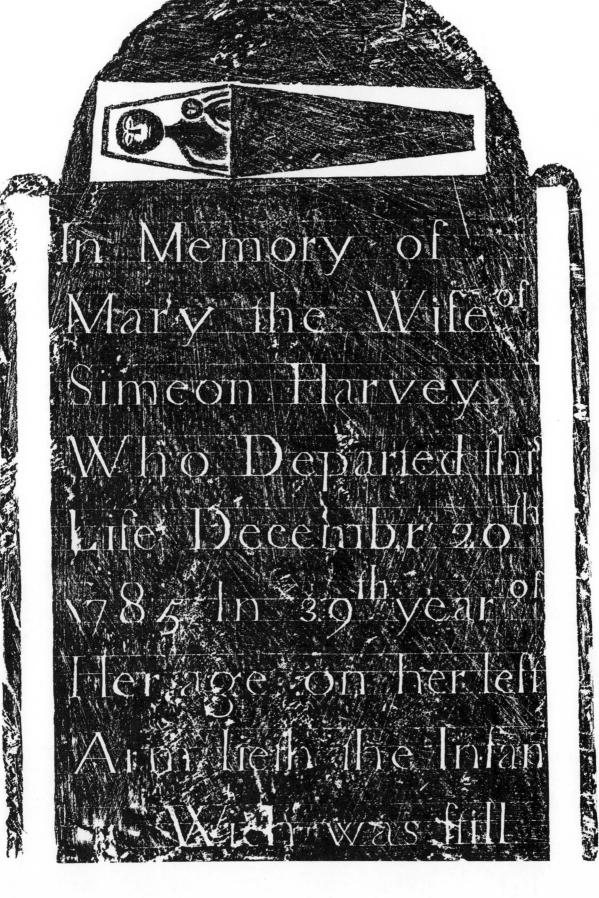

Plate 62

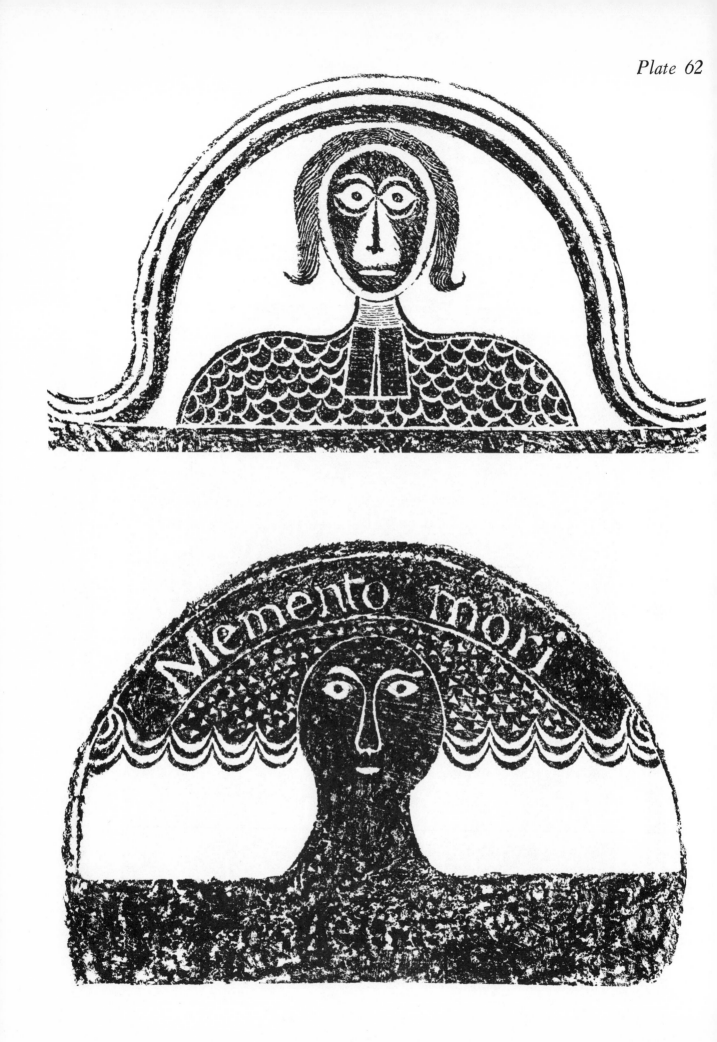

Plate 63

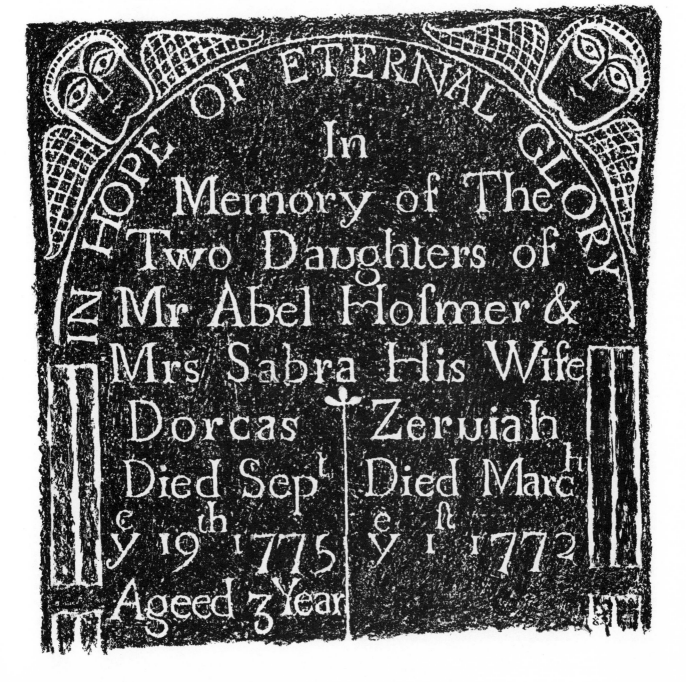

IN HOPE OF ETERNAL GLORY

In
Memory of The
Two Daughters of
Mr Abel Hosmer &
Mrs Sabra His Wife
Dorcas Zeruiah
Died Sep^t Died Marc^h
y^e 19 1775 y^e 1 1772
Ageed 3 Year

Plate 64

In memory of Oliver
Bacon, Son of Lieut Oliver
& Mrs Rebecca Bacon
who was killed by lightning
July 2nd 1801. aged
8 Years, & 7 months

Plate 65

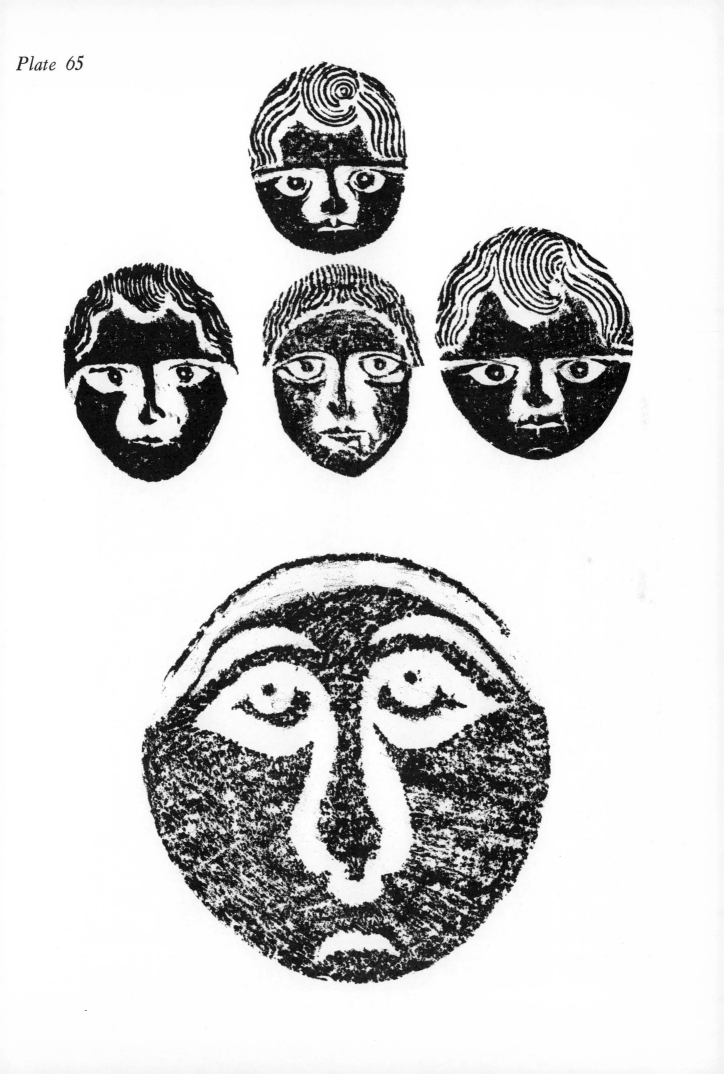

Plate 66

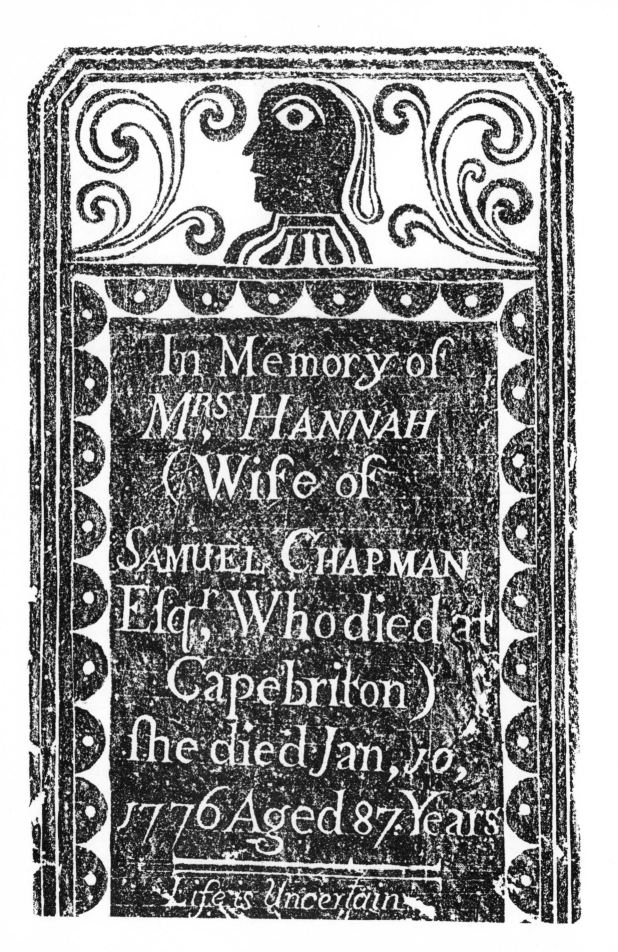

In Memory of
Mrs Hannah
(Wife of

Samuel Chapman
Esqr Who died at
Capebriton)
she died Jan, 10,
1776 Aged 87 Years

Life is Uncertain

Plate 67

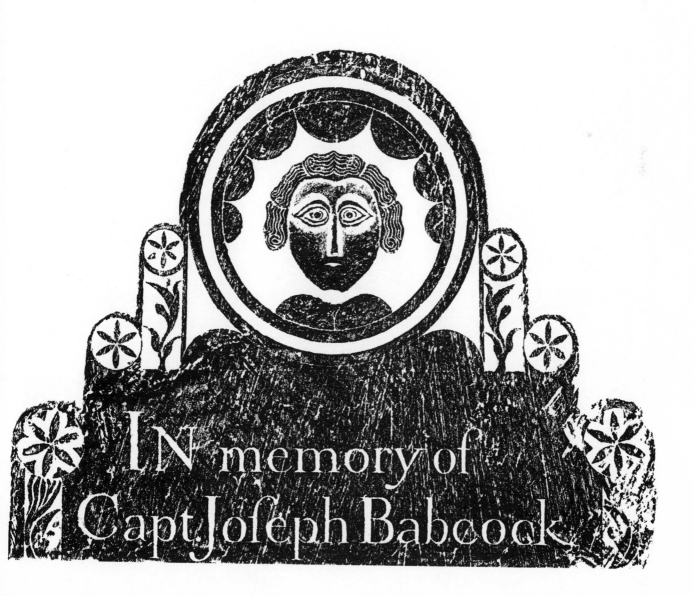

Plate 68

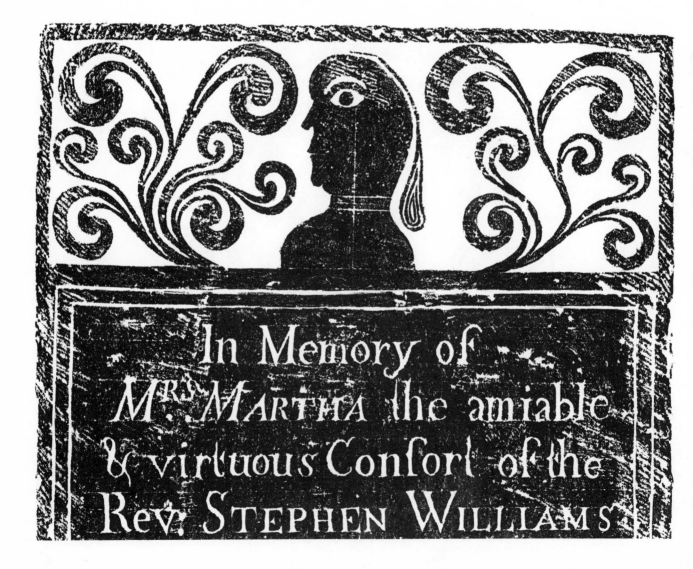

Plate 69

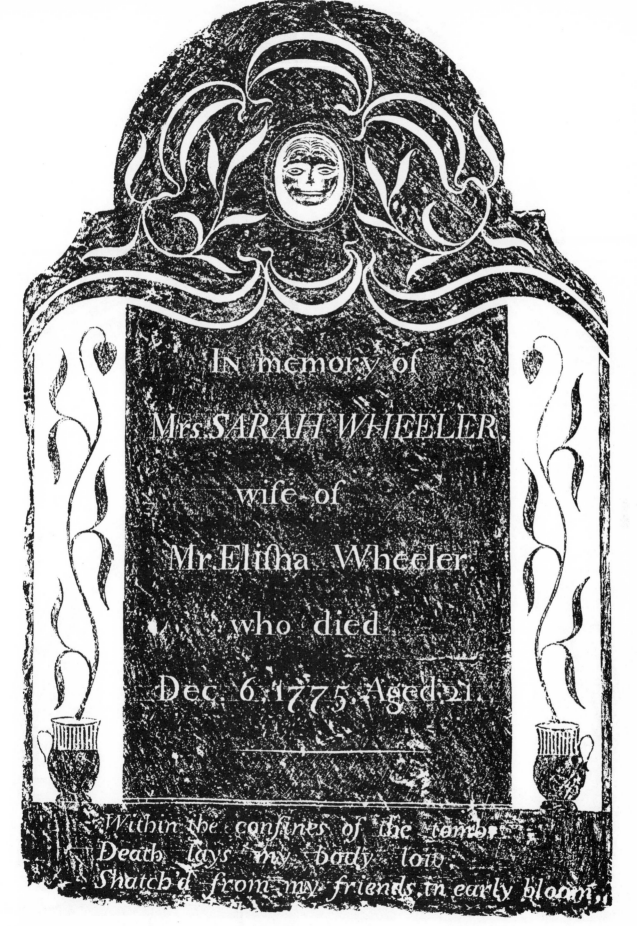

Plate 70

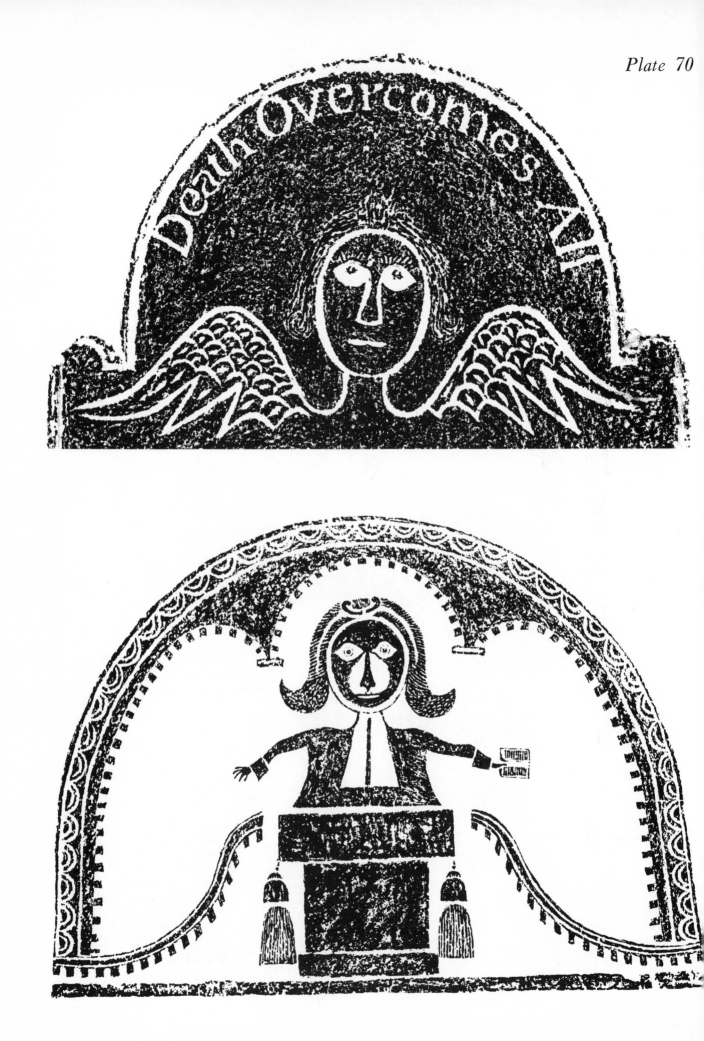

Plate 71

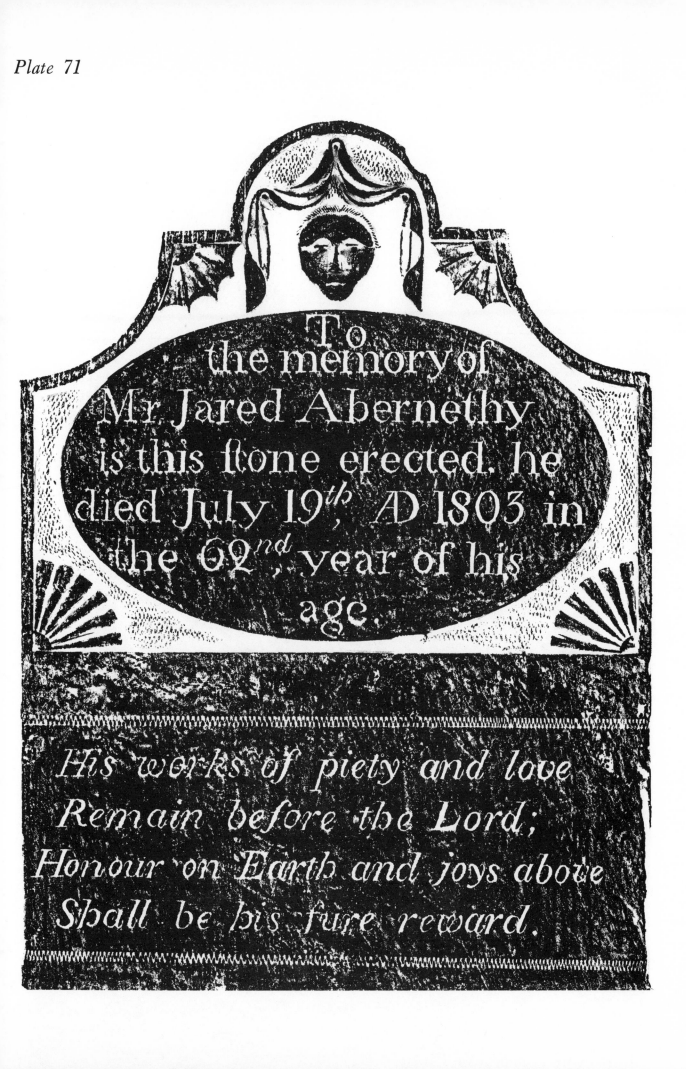

Plate 72

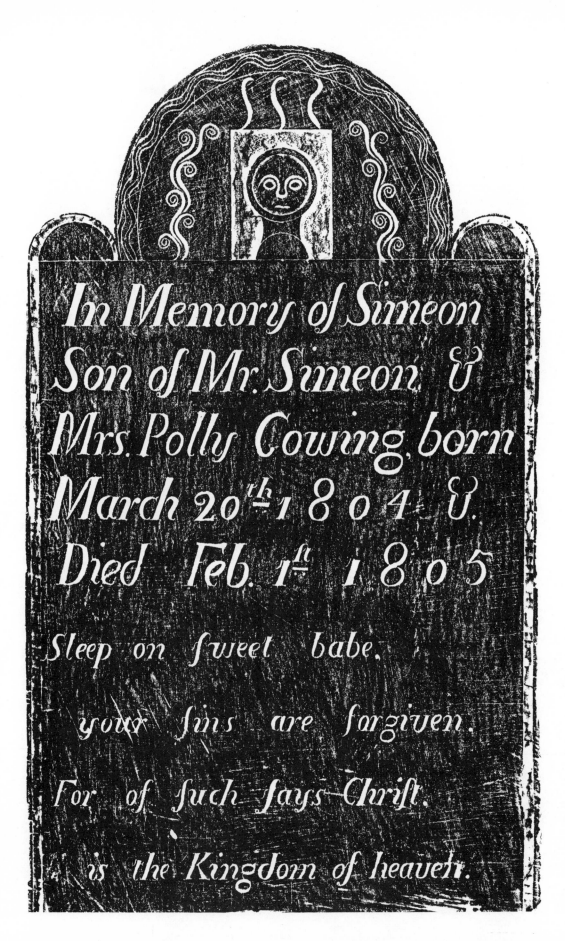

Plate 73

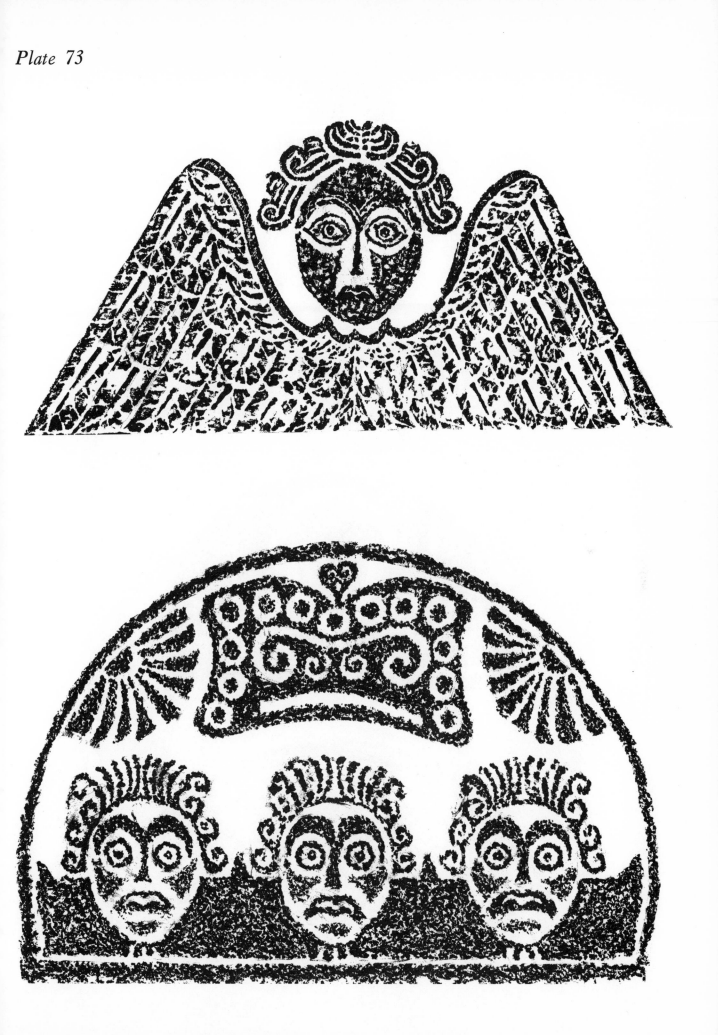

Plate 74

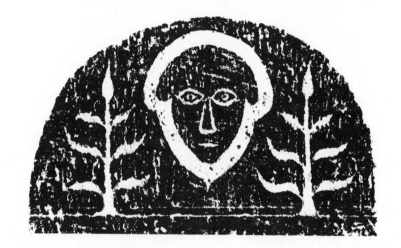

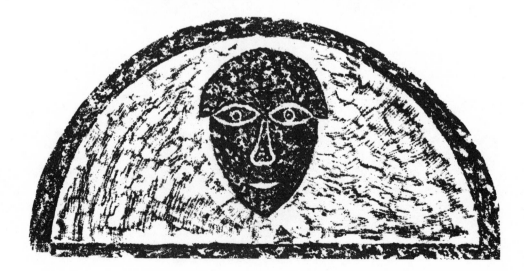

Willows & Urns

Plate 75

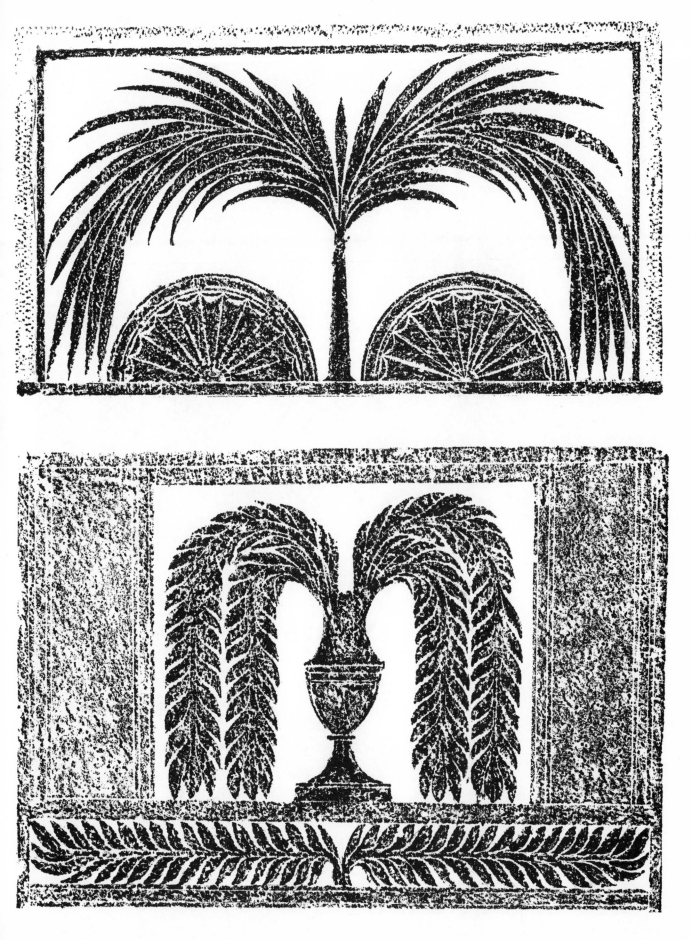

Plate 76

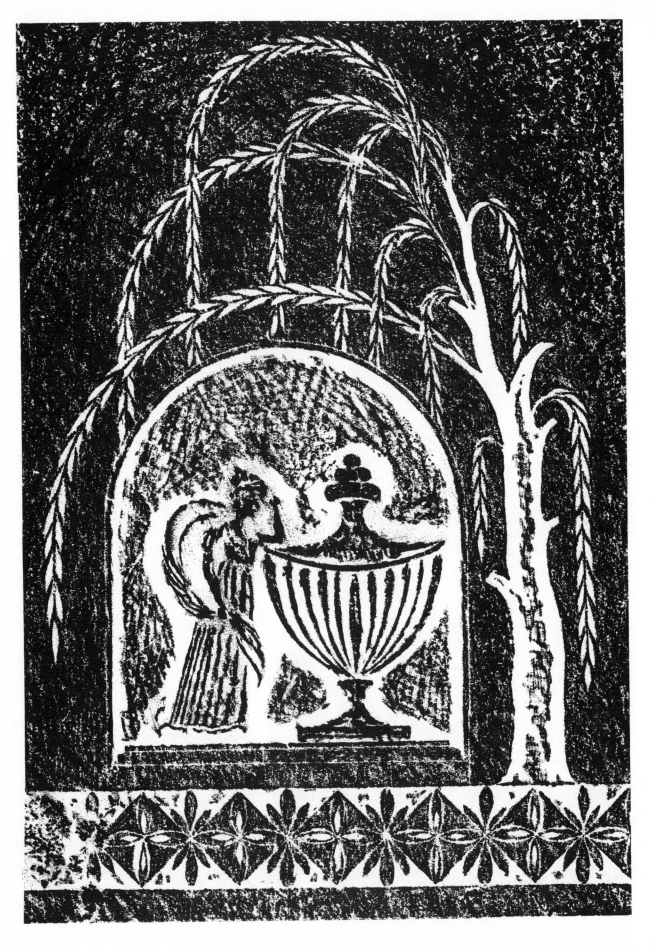

Plate 77

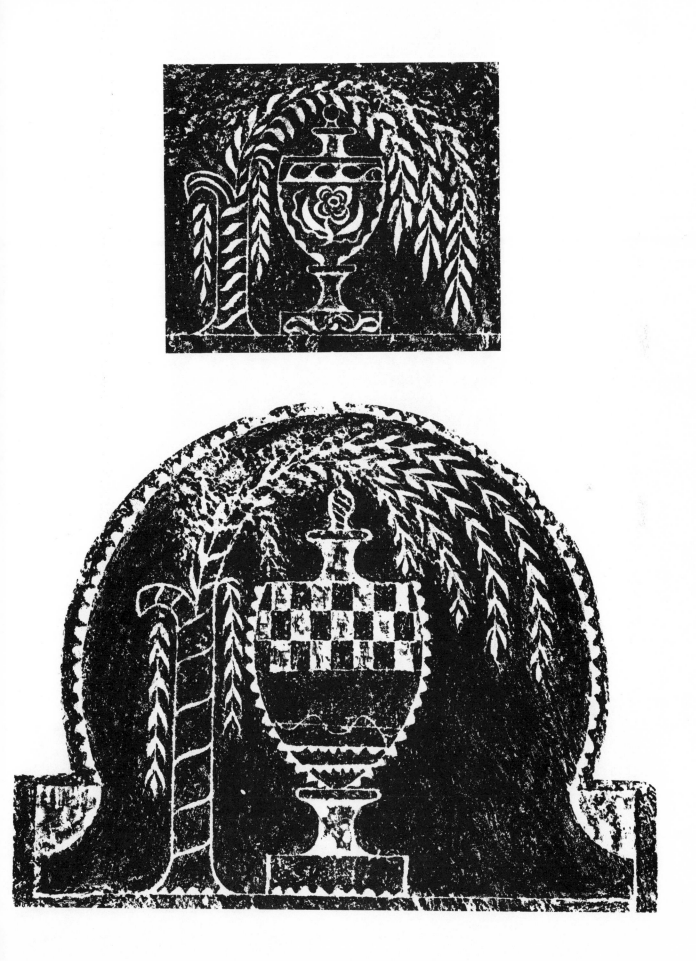

Plate 78

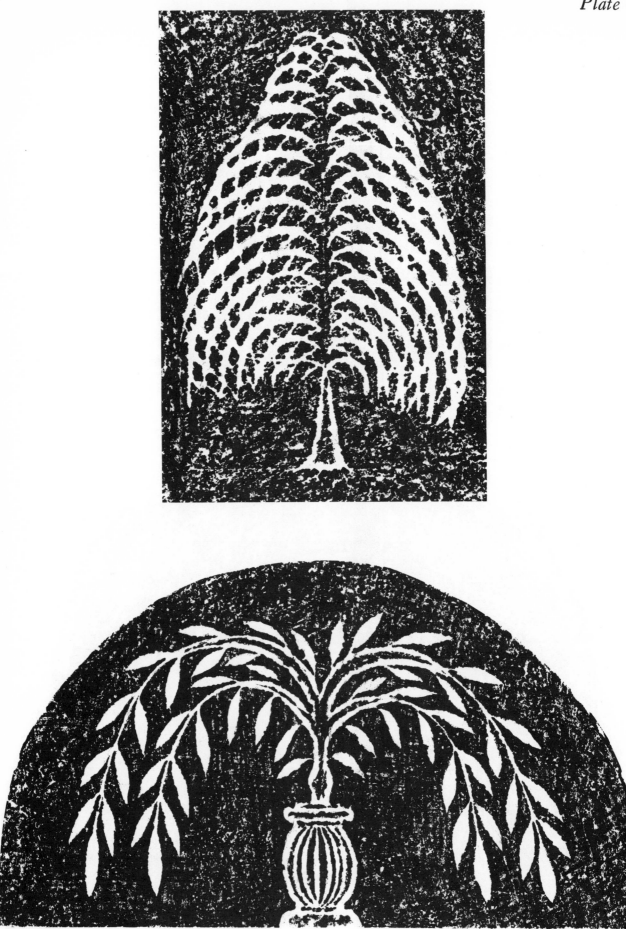

Plate 79

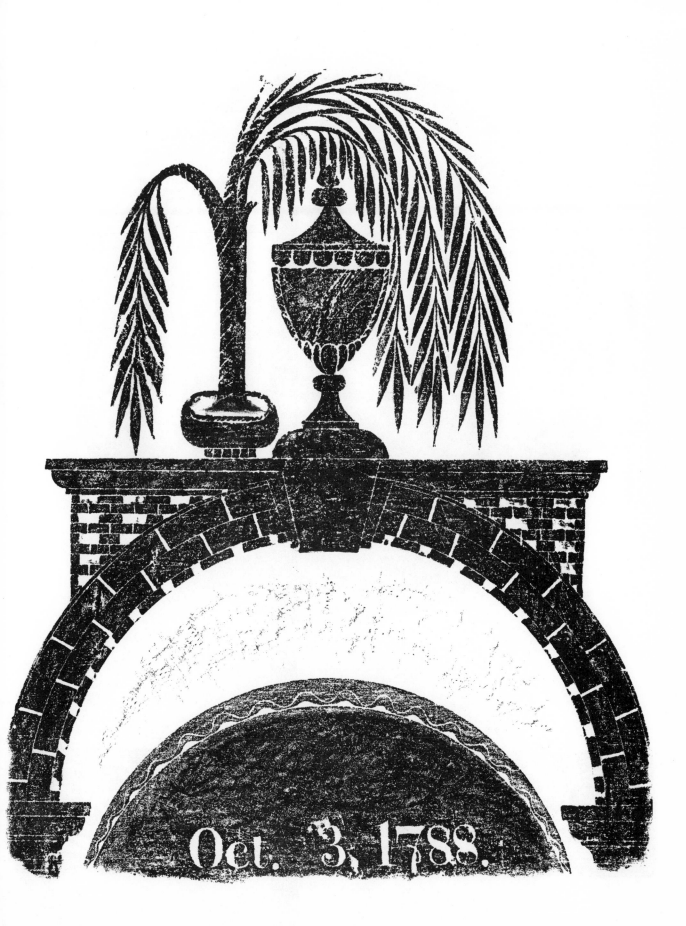

Oct. 3, 1788.

Plate 80

Plate 81

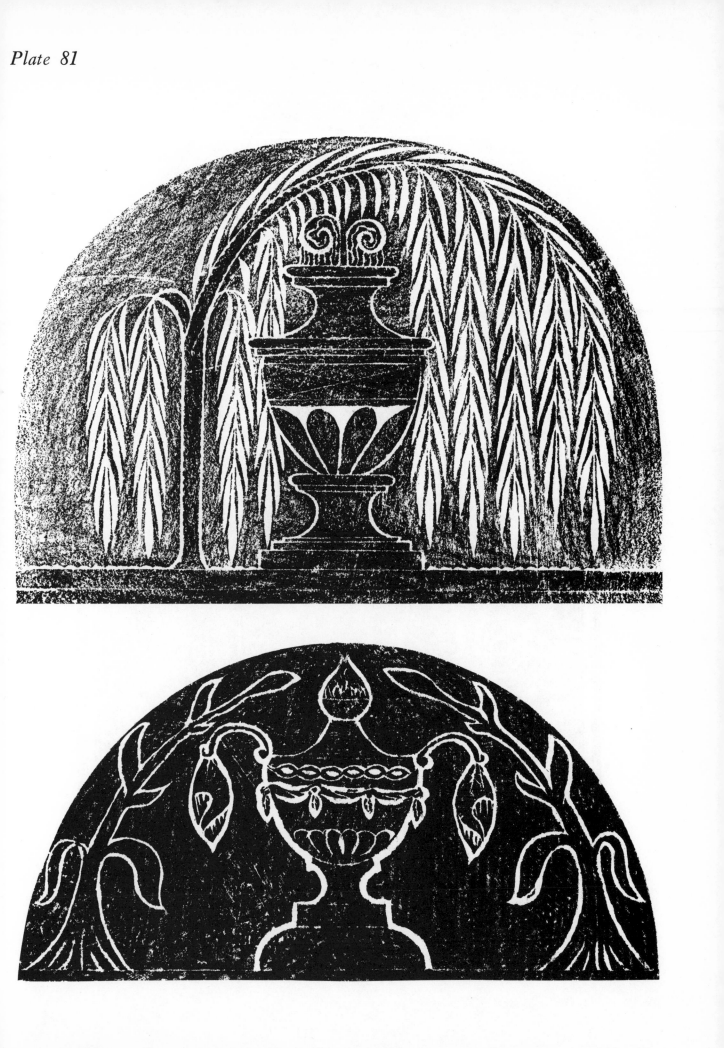

Plate 82

Here in the cold bed of death, free from trouble and pain, sleeps at rest, Eliza Bradford, Daughter of Fordyce & Elizabeth Foster, who died *Oct* 14 1811. Æt. 14 Months

Sleep on sweet child for God our trust
Will raie thee blooming from the dust.

Plate 83

THIS MONUMENT
IS ERECTED TO
THE MEMORY OF
CAPT. WILLIAM
BRACKENRIDGE WHO
DEPARTED THIS
LIFE FEB'Y 16th
AD 1807 IN THE
84th YAR OF
HIS AGE

Shout and proclaim the saviour's love,
Ye saints that tastd his wine,
Join with your kindred saints above,
In loud hosannas join.

Martin Wnods Whatby

Plate 84

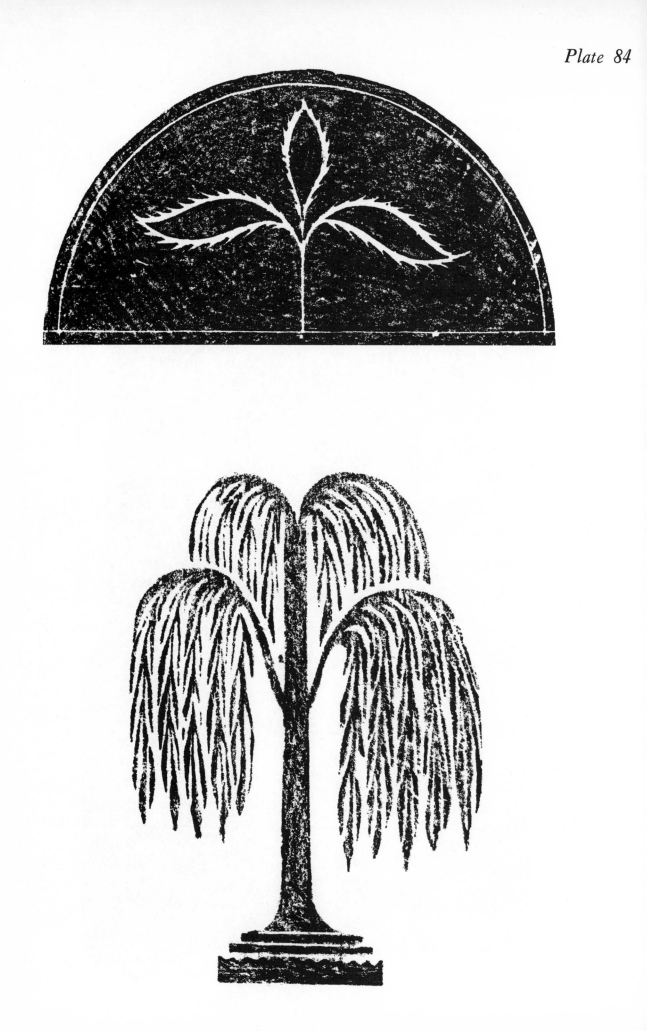

Plate 85

In Memory of
JAMES HULL ALLEN,
Son of Capt Gabriel &
Mrs. Sarah Allen:
He departed this Life the
6ᵗʰ of Auguſt, 1793. Aged
15 Years, 3 Months & 21 Days

Young Friends regard this ſolemn Truth,
Soon you may die like me in youth:
Death is a debt to nature dye,
Which I have paid, and ſo muſt you.

Plate 86

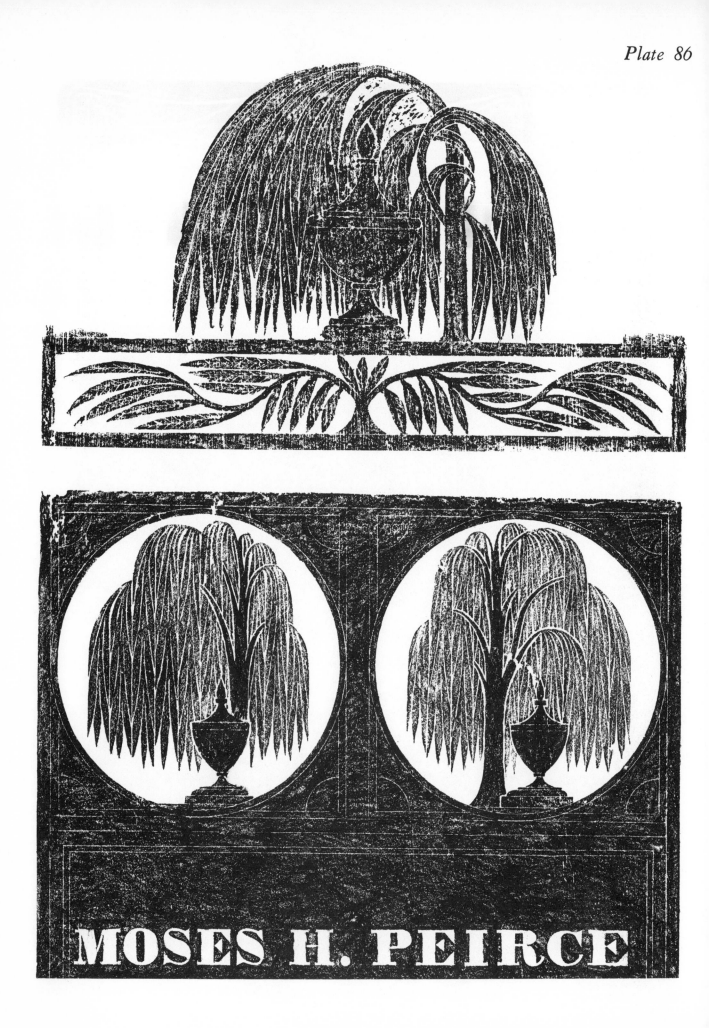

Plate 87

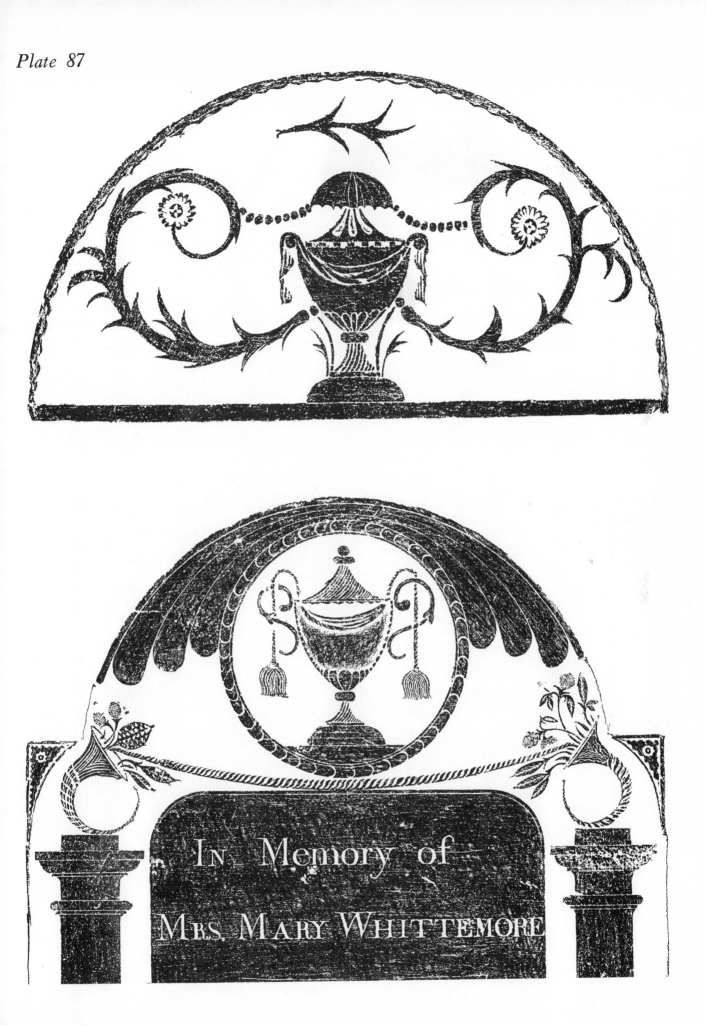

Plate 88

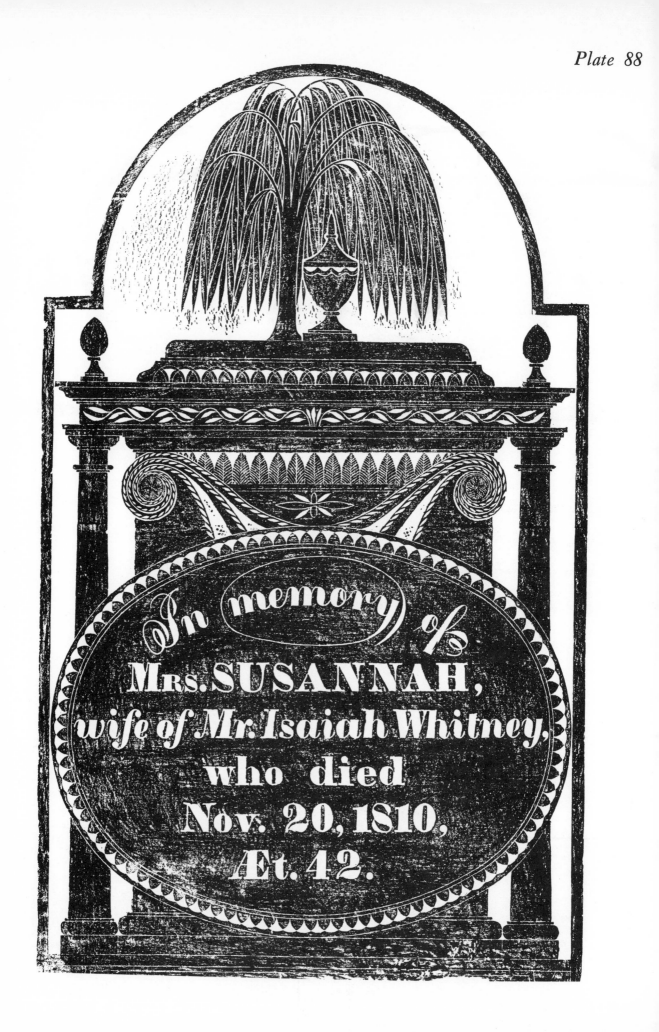

Plate 89

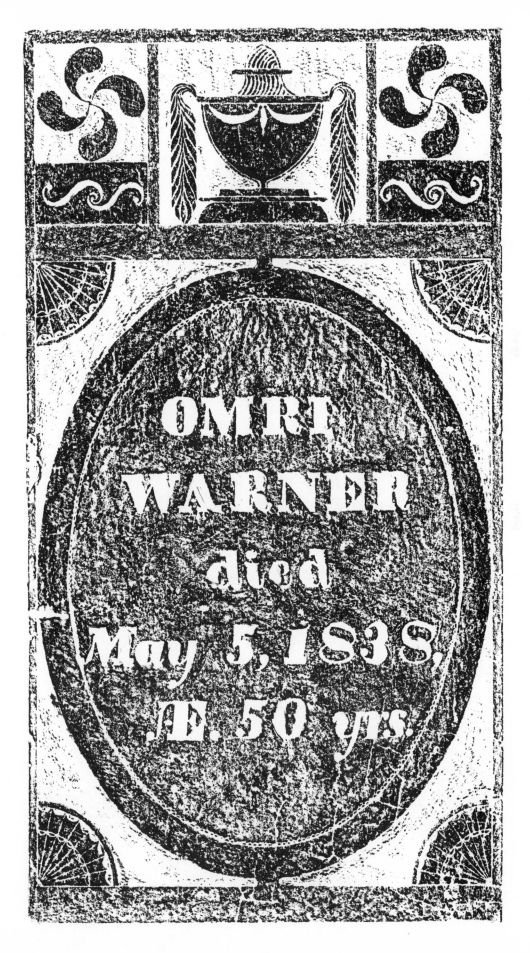

Plate 90

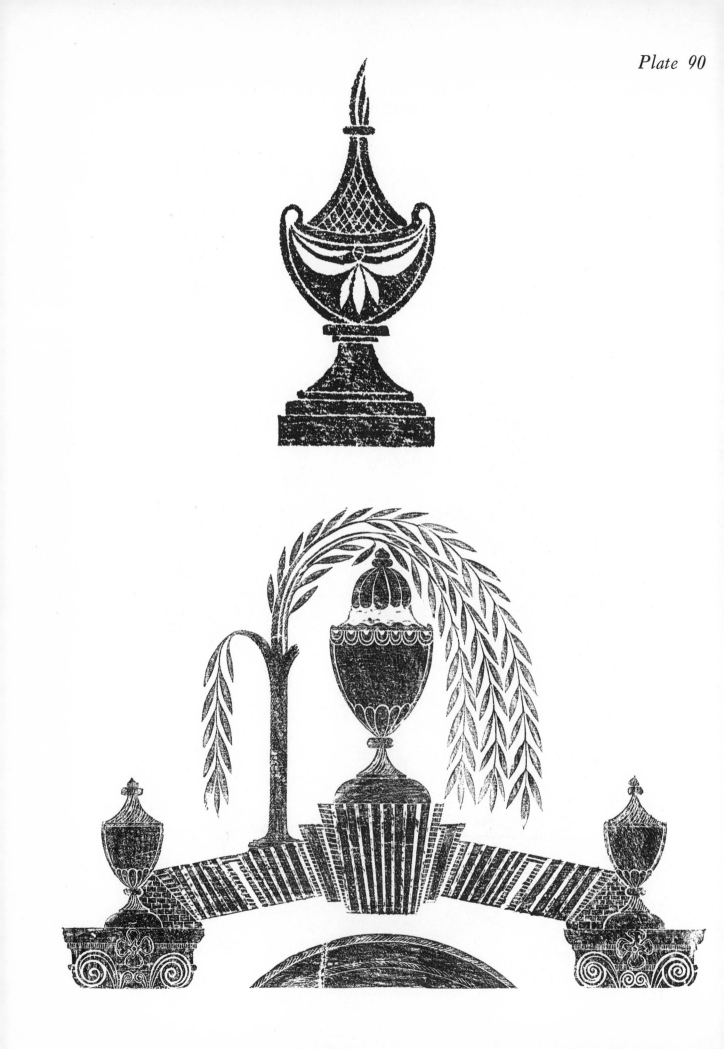

Plate 91

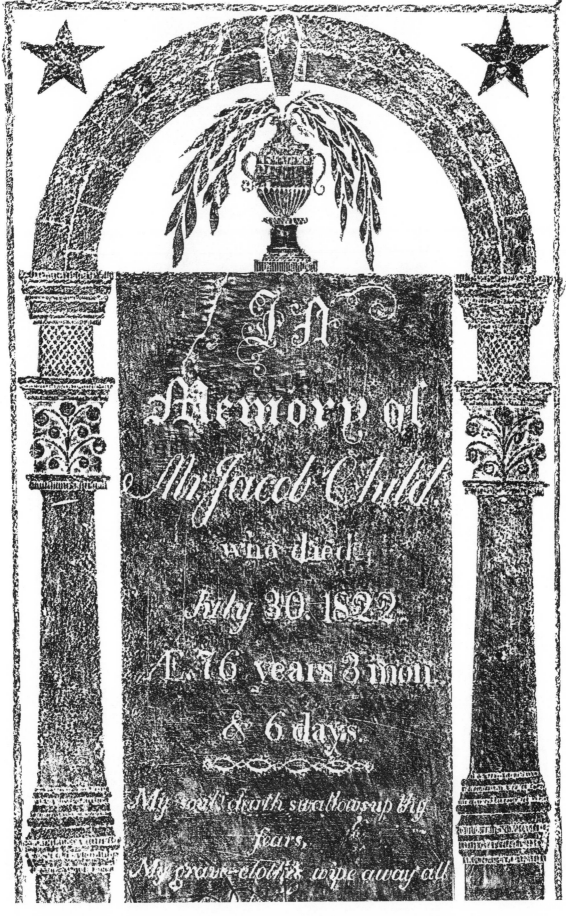

Plate 92

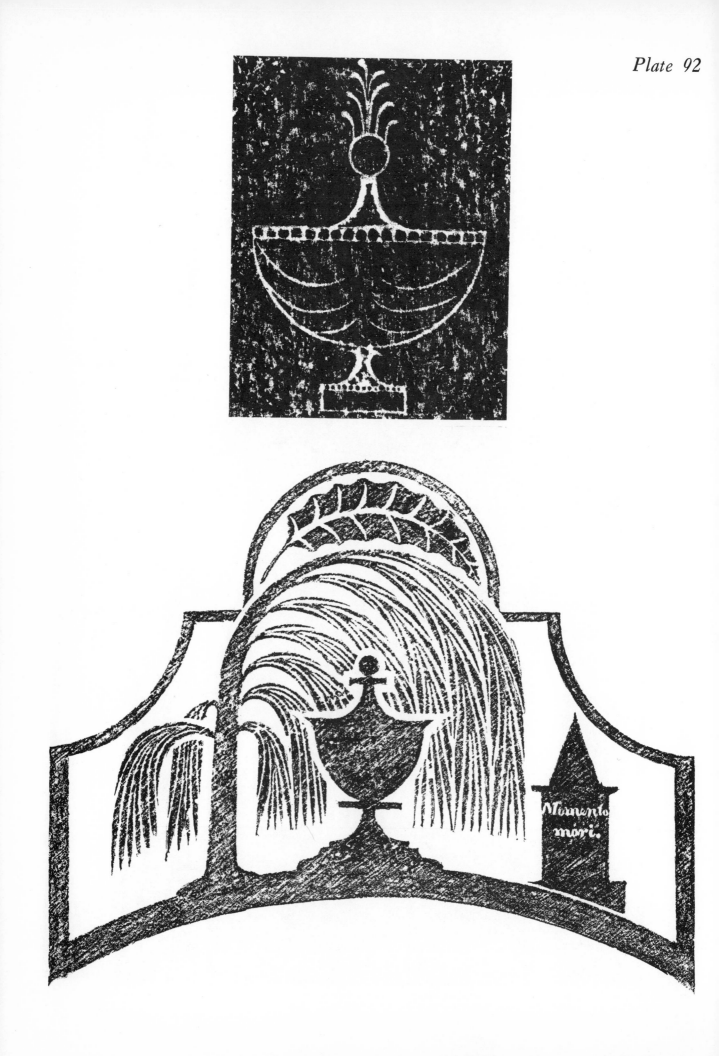

Plate 93

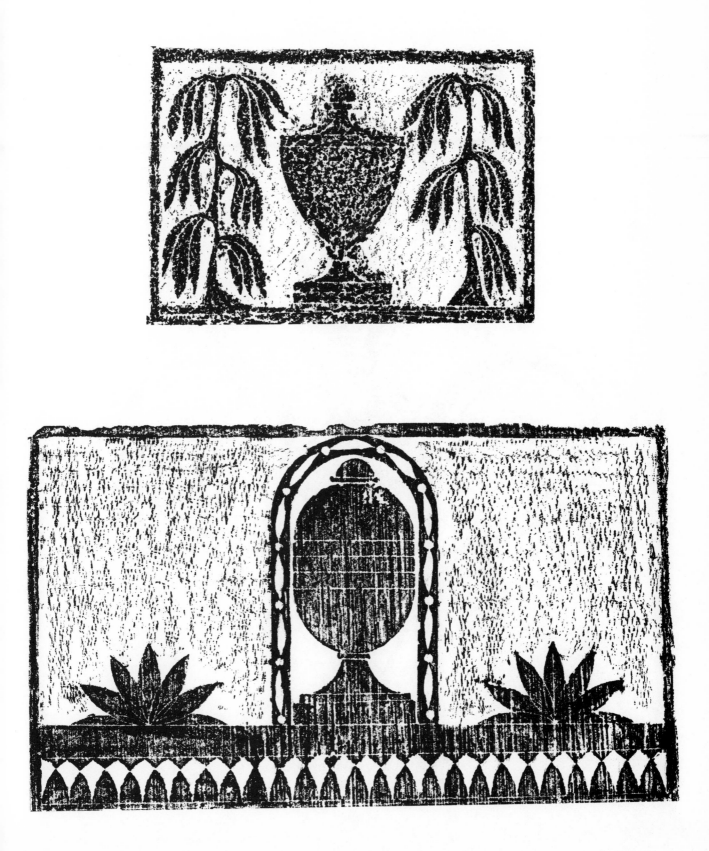

Plate 94

Plate 95

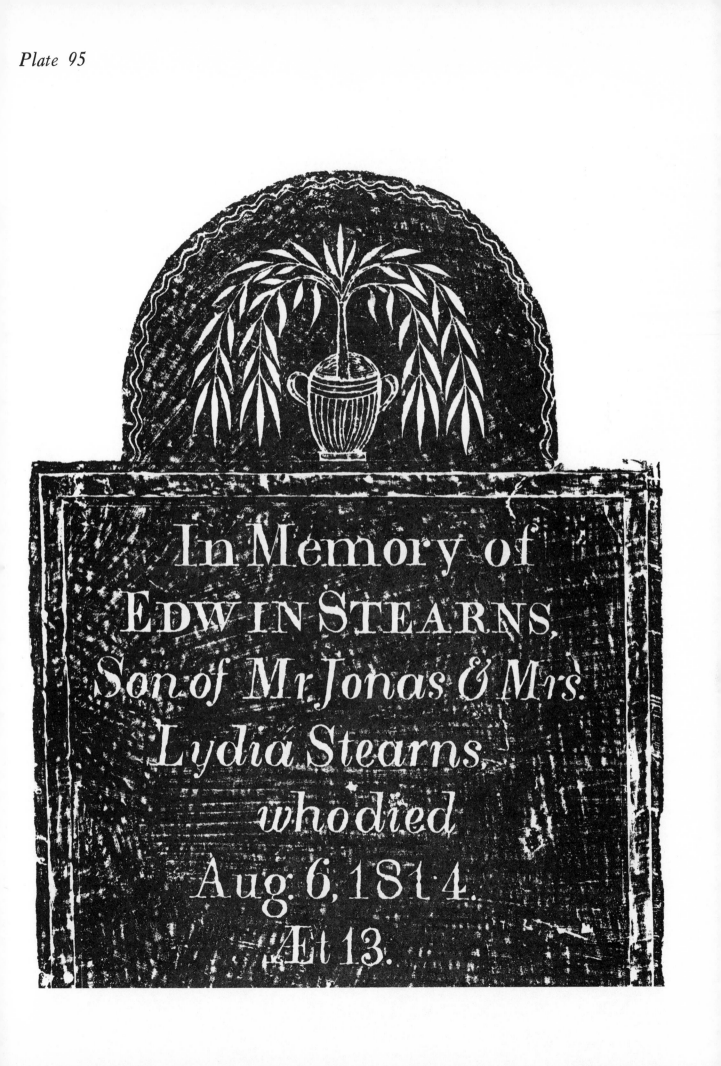

Plate 96

Plate 97

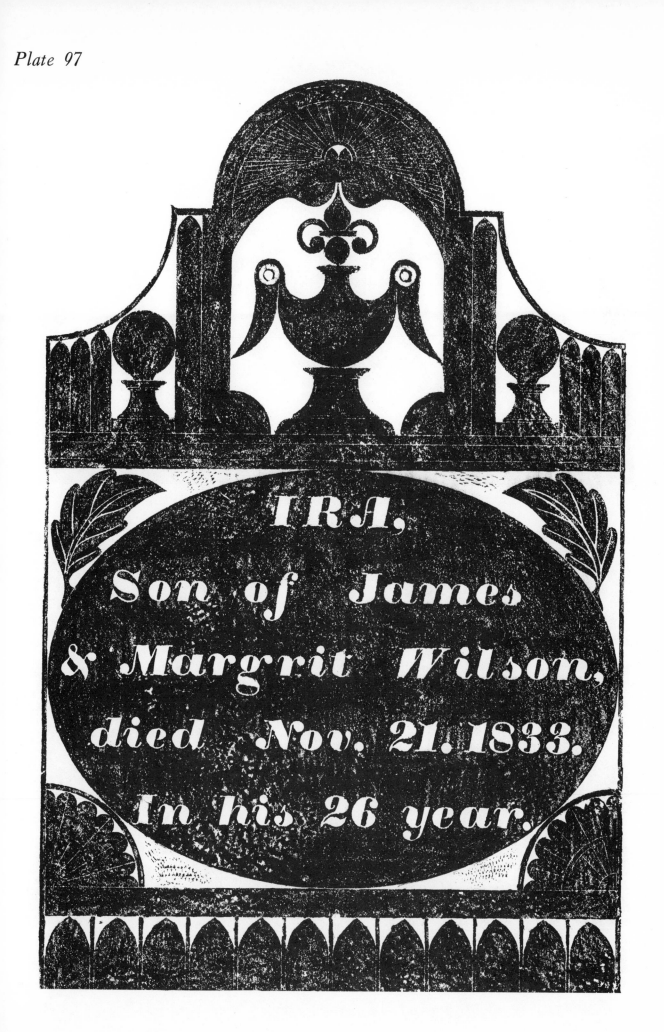

Plate 98

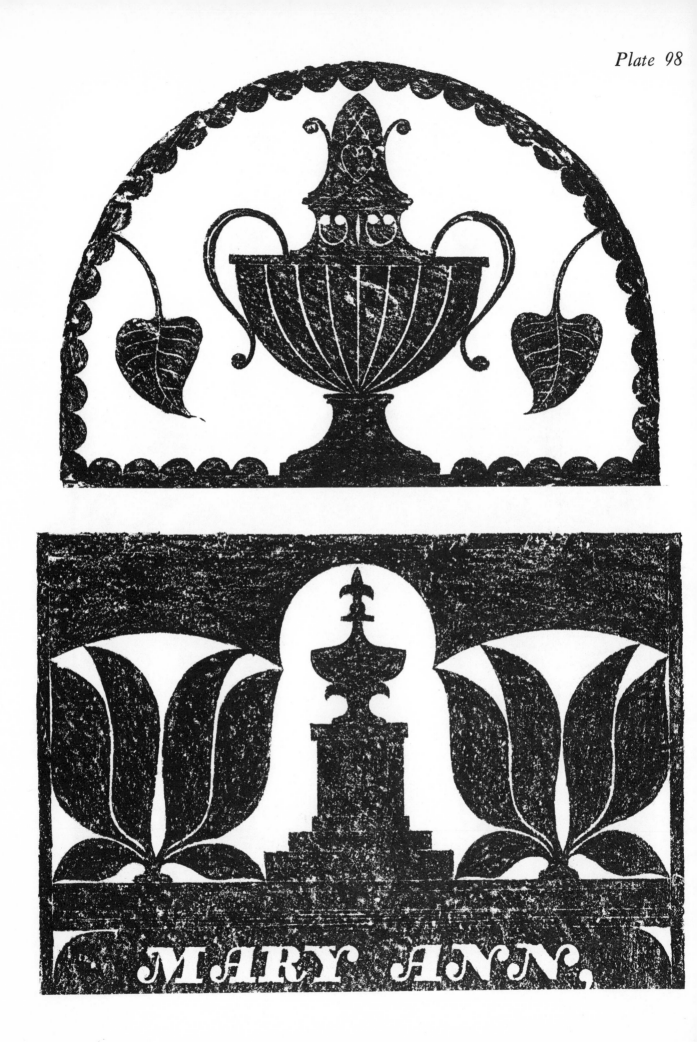

Plate 99

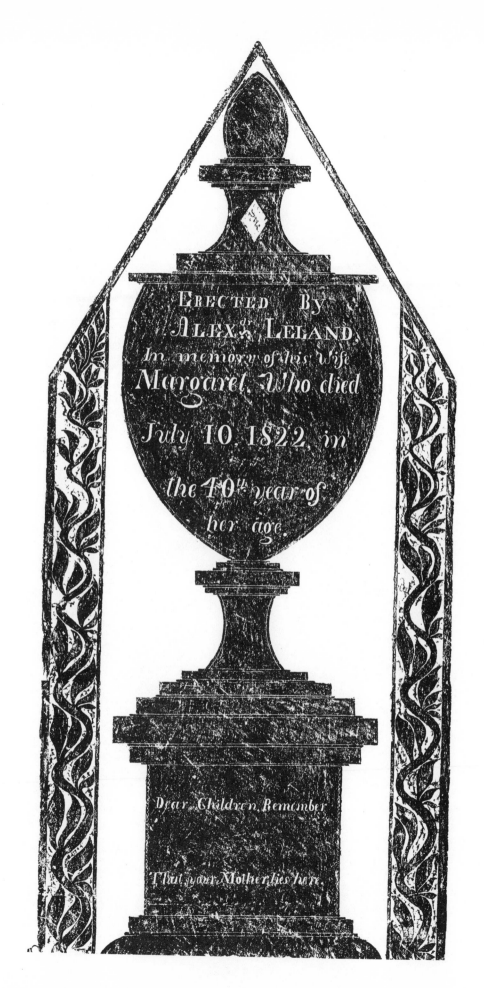

Plate 100

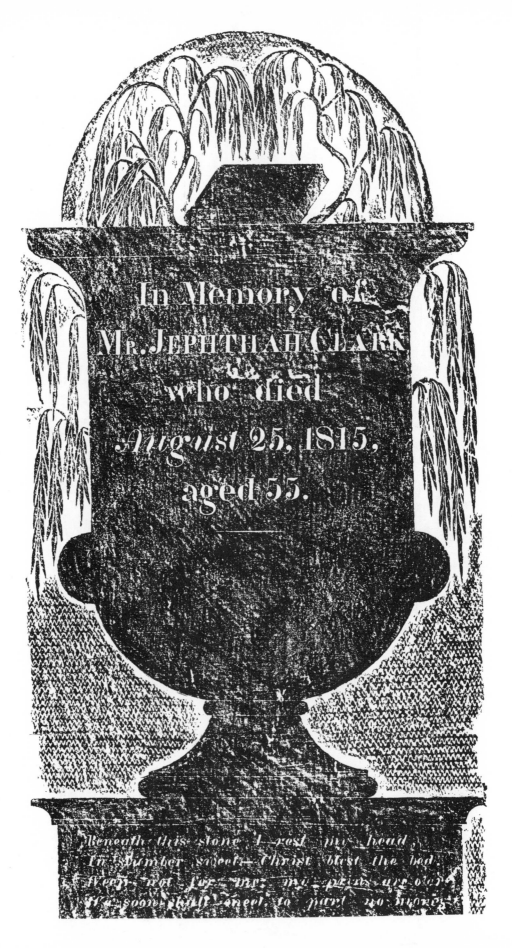

Plate 101

In Memory of
MRS. LYDIA,
widow of the late
Enoch Kingsbury

Plate 102

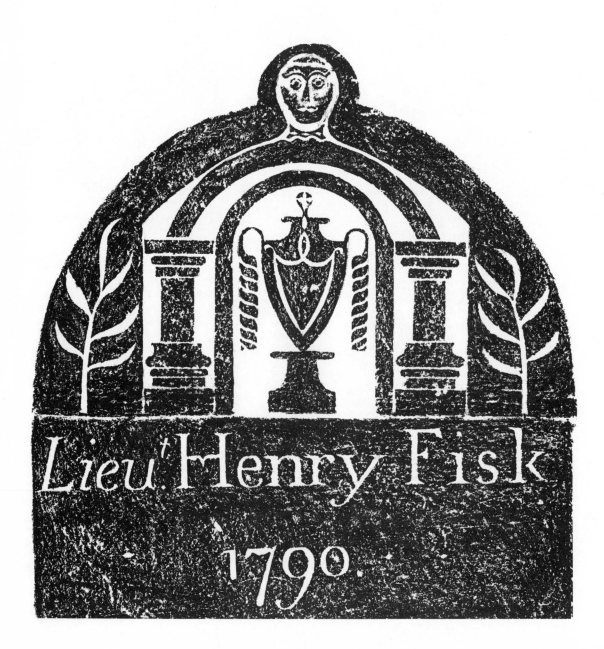

Plate 103

Here Lies the Boddy of
Mrs Mary Wilder wife of John
Wilder she wos born the 6
of June 1781 and died Oct' 20
1809 in the 29 year of her age

How lov'd how valued once avails thee not
To whom related or by whom begat
A heap of dust alone remains of thee
Tis all thou art and what we all must be

Plate 104

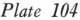

Plate 105

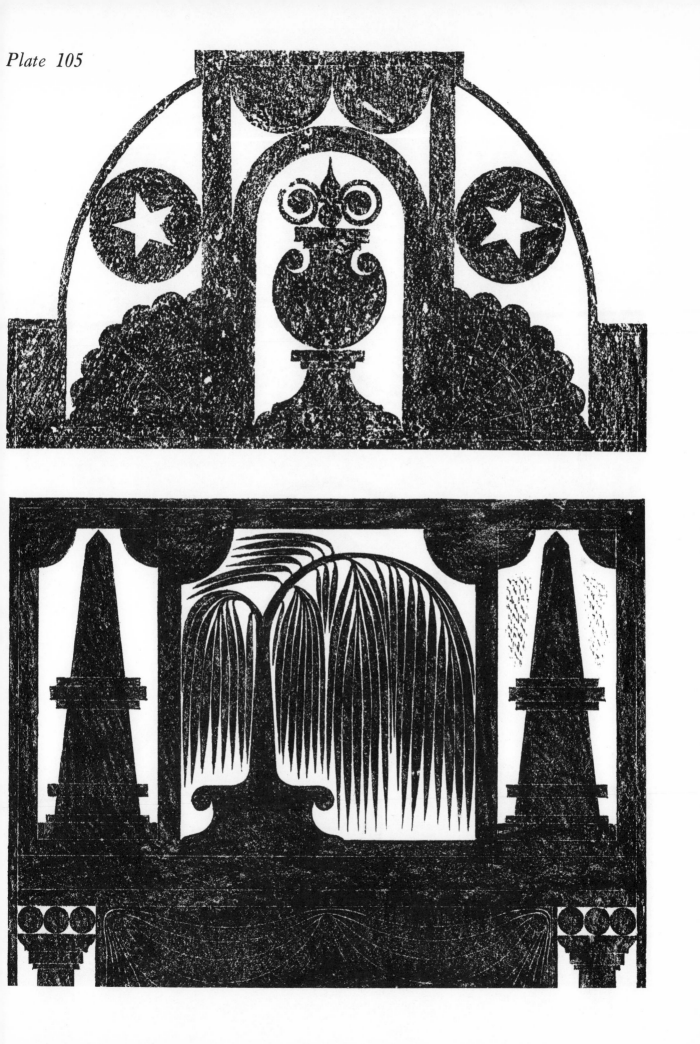

Plate 106

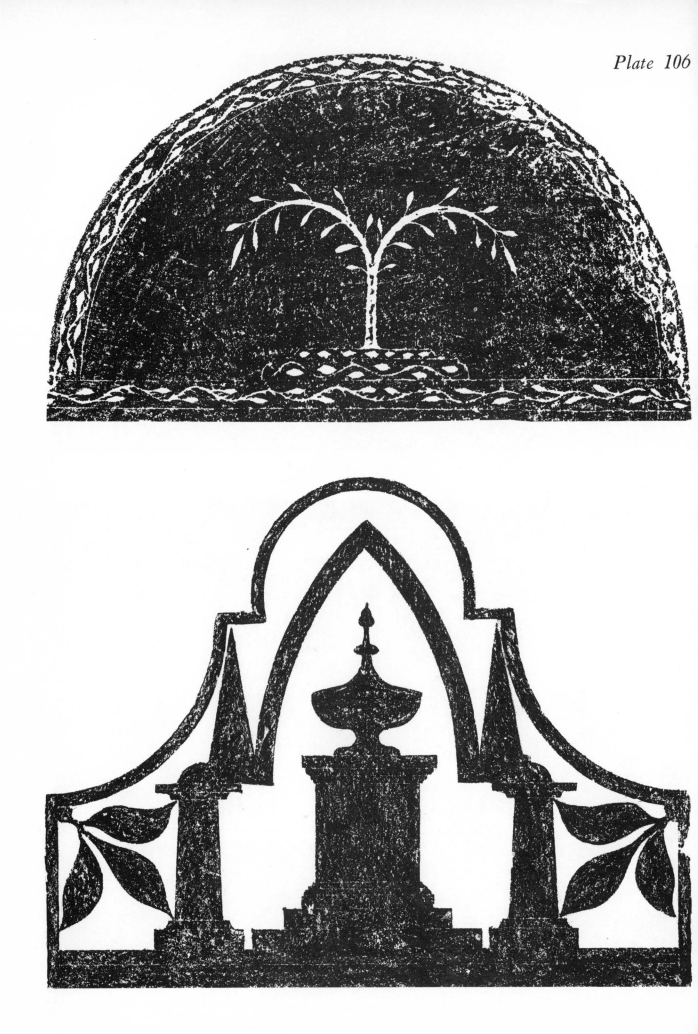

Plate 107

Plate 108

Plate 109

Plate 110

ALMIRA GRAVES,

Plate 111

IN MEMORY OF

Plate 112

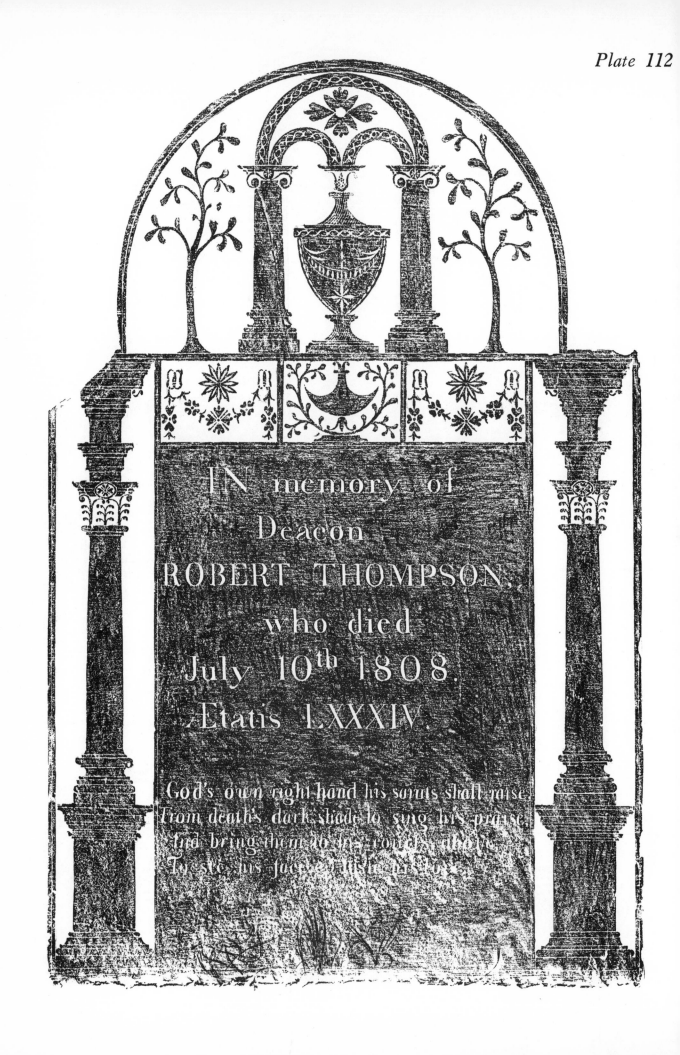

Plate 113

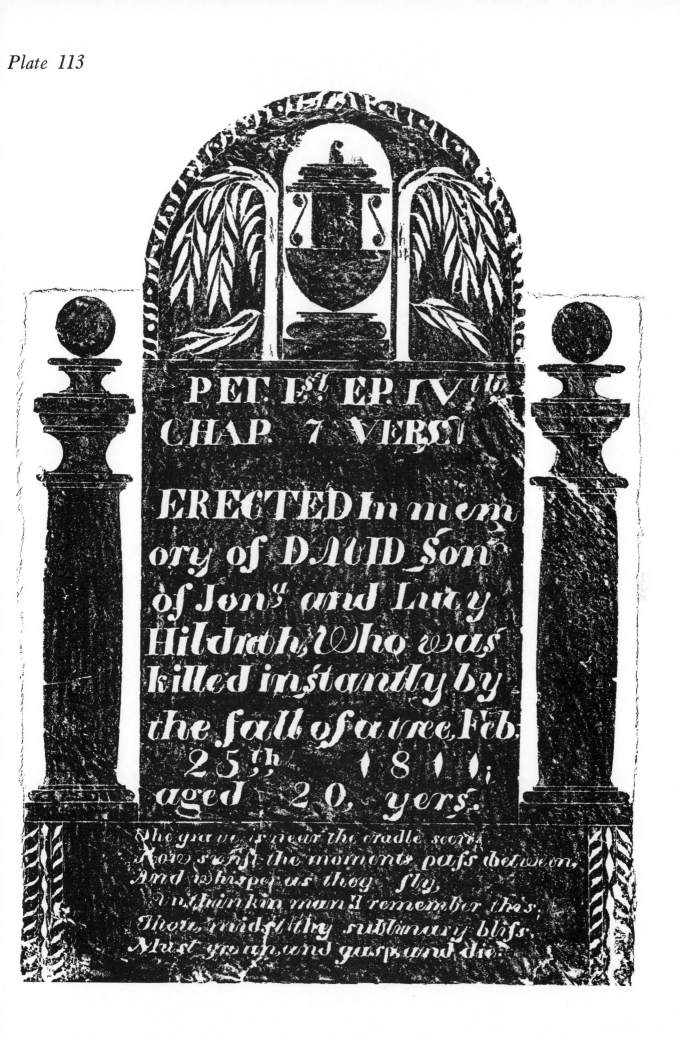

Plate 114

Plate 115

This stone is erected to the
Blessed memory of
Mr. NATHAN CHADWICK,
who died Nov.r 17th 1801.
In his 68th Year.

A Husband kind and good a parent dear,
To all obliging and to all sincere;
True to his God the orphans friend and guide,
He liv'd beloved and lamented di'd.

Engrav'd by Beza Soule of Brookfield N.P.

Plate 116

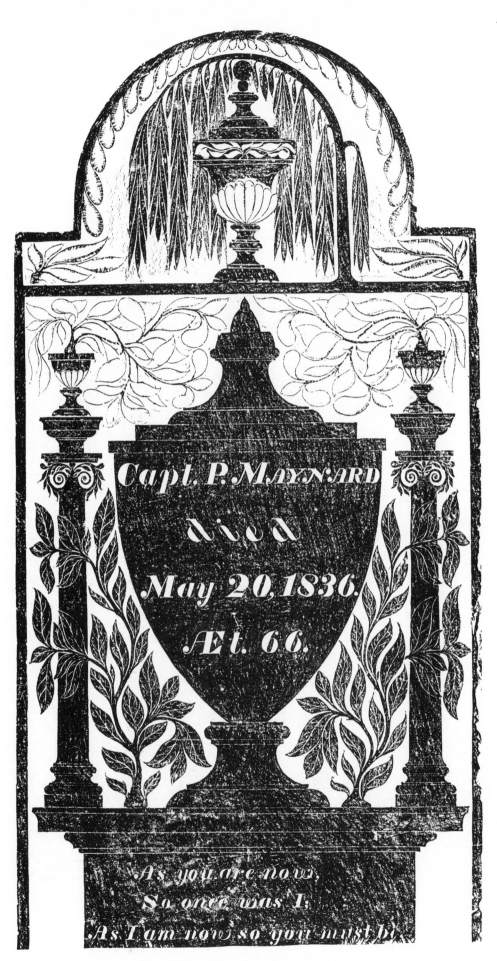

Plate 117

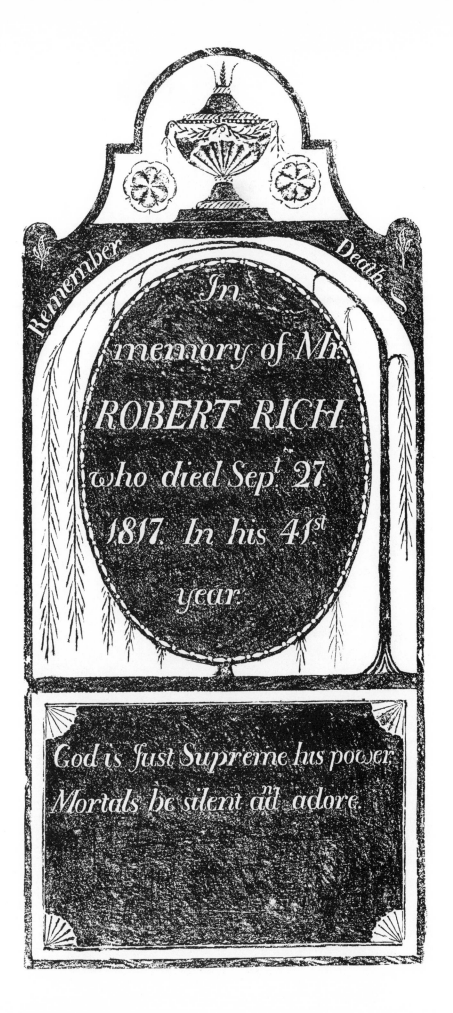

Plate 118

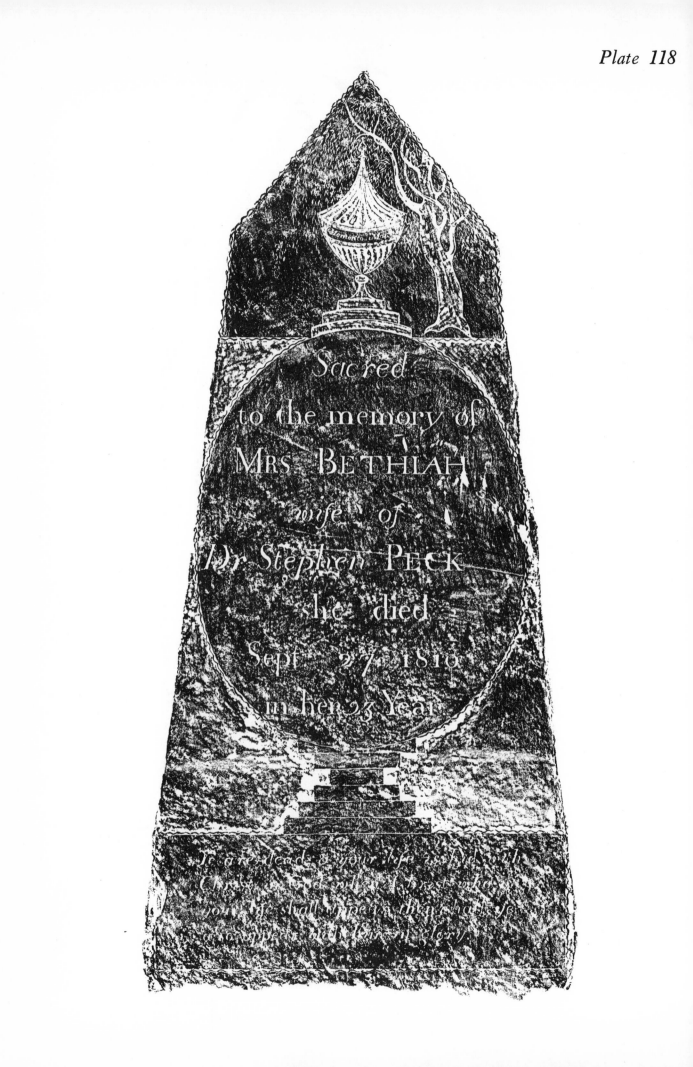

Plate 119

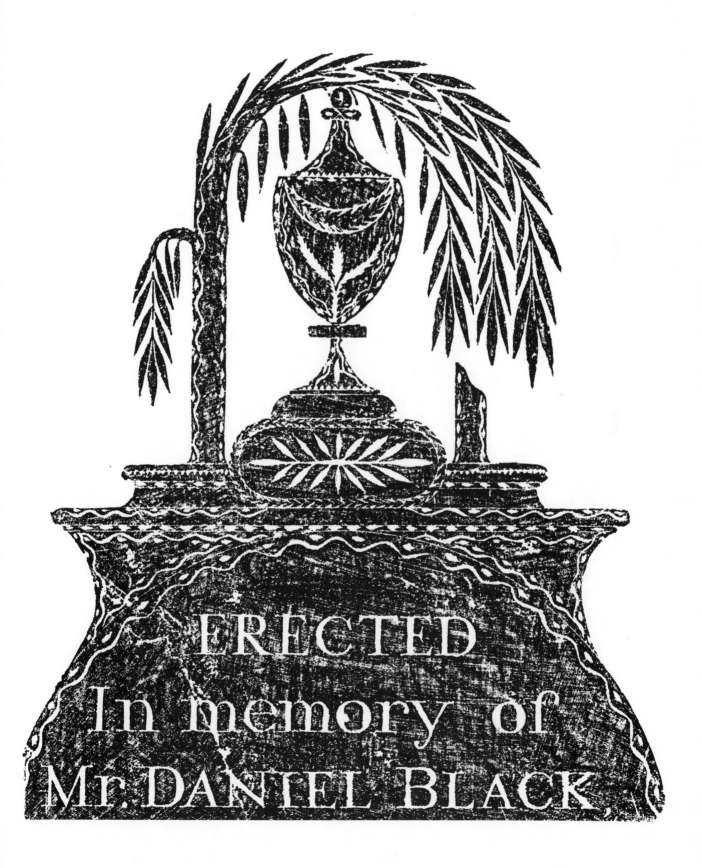

Plate 120

Plate 121

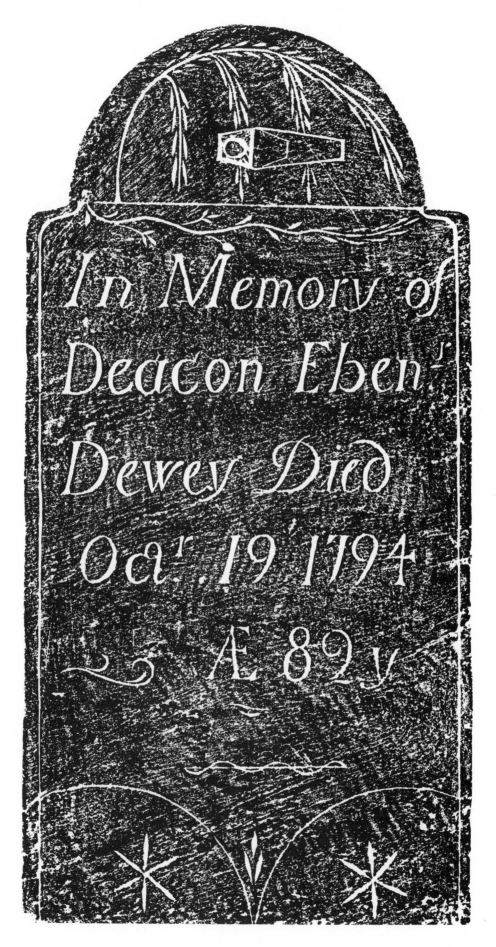

Plate 122

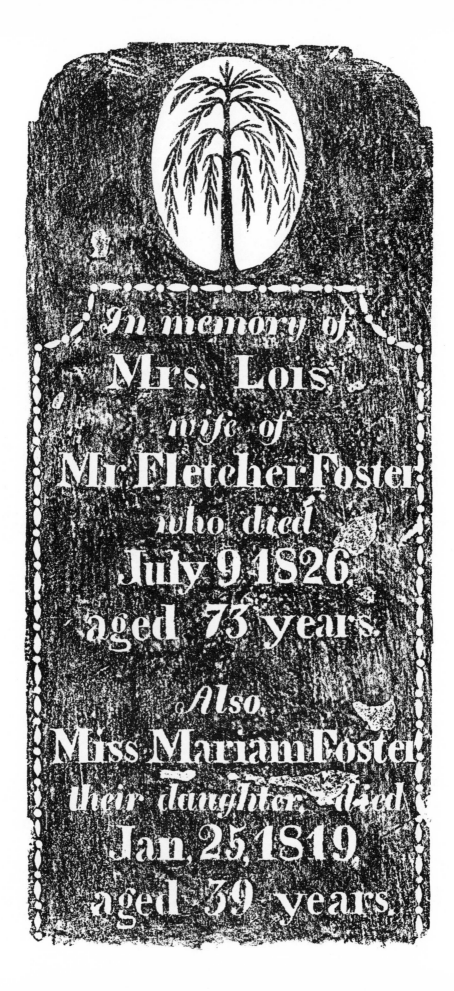

In memory of,
Mrs. Lois
wife of
Mr Fletcher Foster
who died
July 9 1826,
aged 73 years.

Also,
Miss Mariam Foster
their daughter, died
Jan, 25, 1819,
aged 39 years.

Plate 123

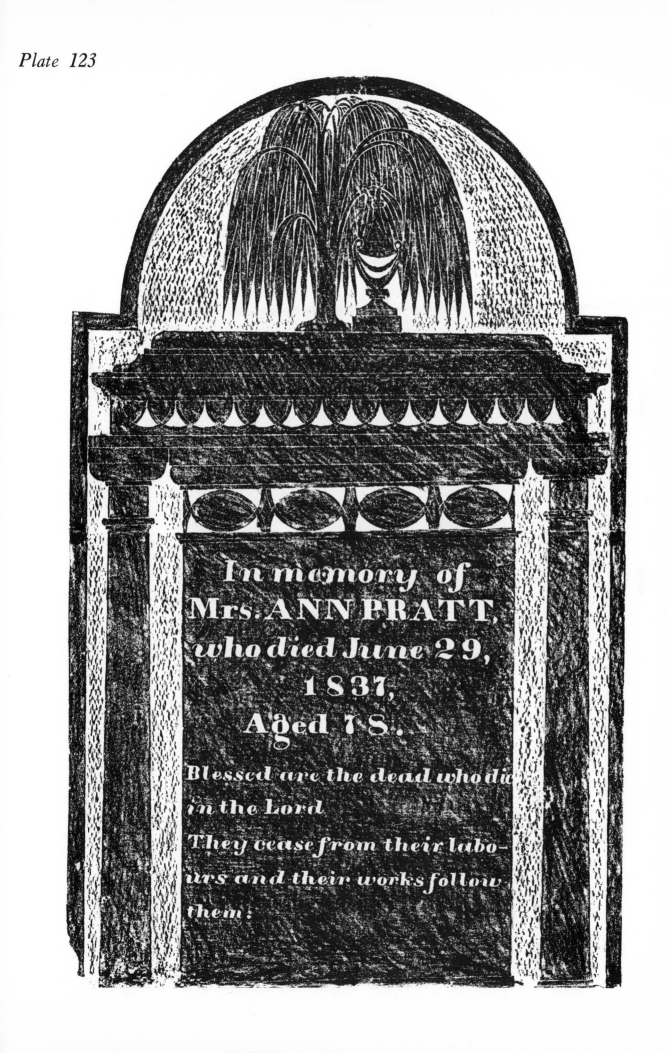

Plate 124

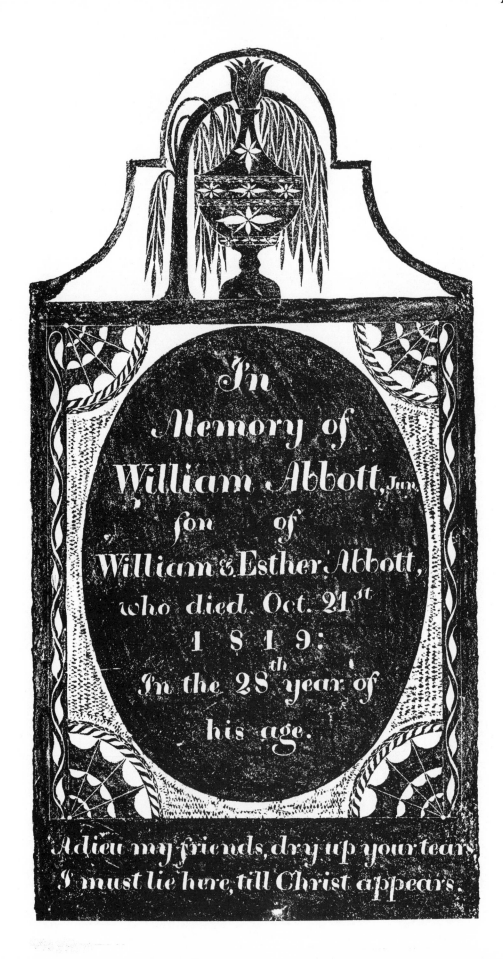

Decorative
Motifs,
Symbols
& Oddities

Plate 125

Plate 126

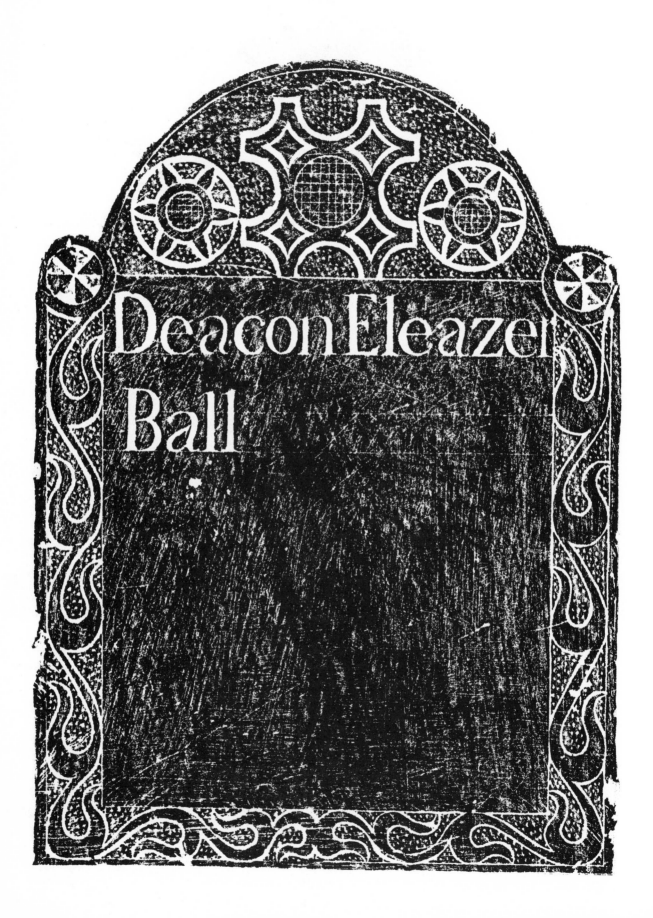

Plate 127

Plate 128

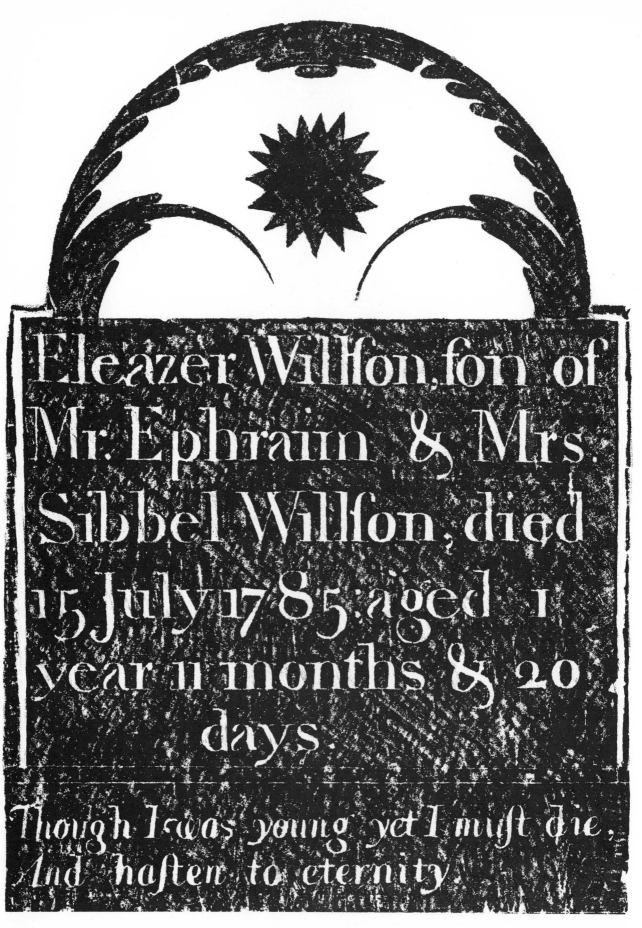

Plate 129

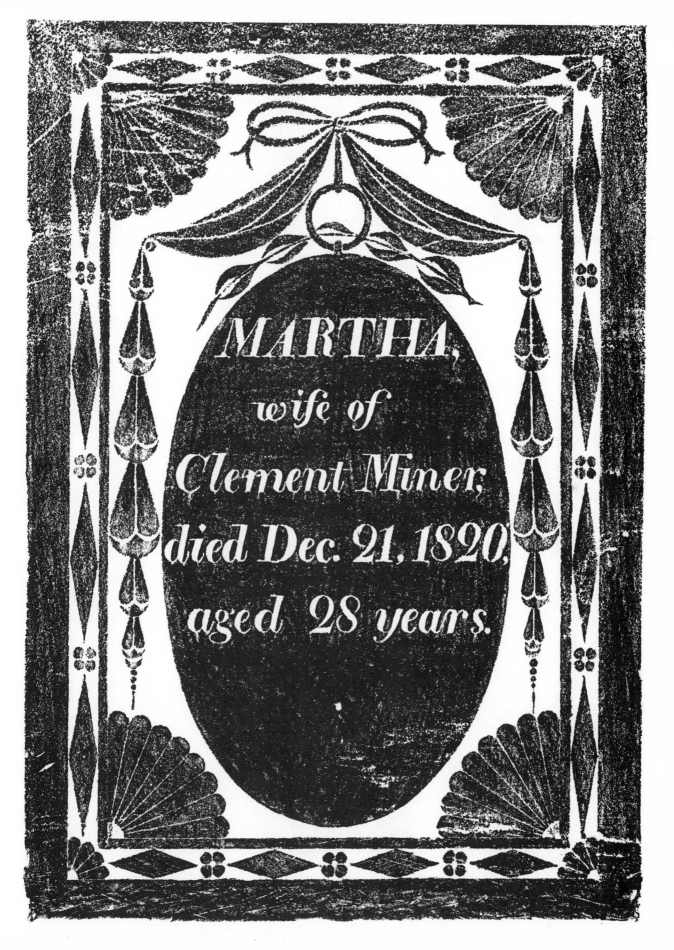

Plate 130

Plate 131

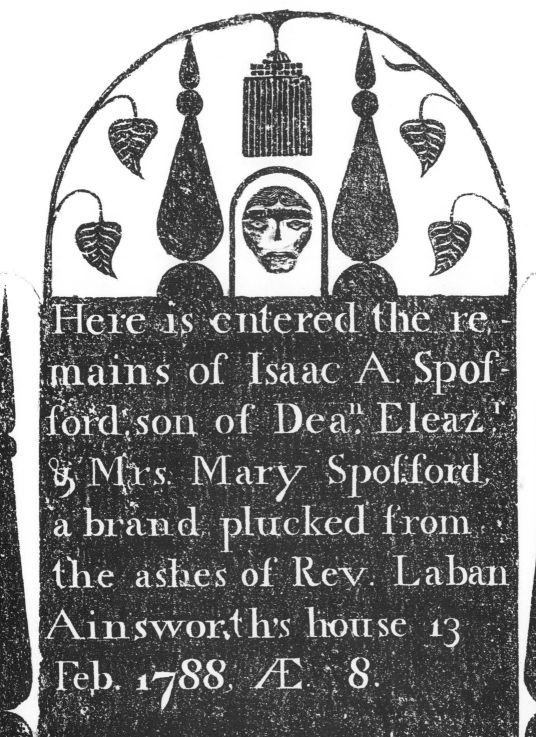

Here is entered the re-
mains of Isaac A. Spof-
ford, son of Dea" Eleaz"
& Mrs. Mary Spofford,
a brand plucked from
the ashes of Rev. Laban
Ainsworth's house 13
Feb. 1788, Æ. 8.

Oh say grim Death, why thus destroy,
The parents hope, their fondest joy,
Presume not to ask the hidden cause,
God's will is done revere his laws

Plate 132

Plate 133

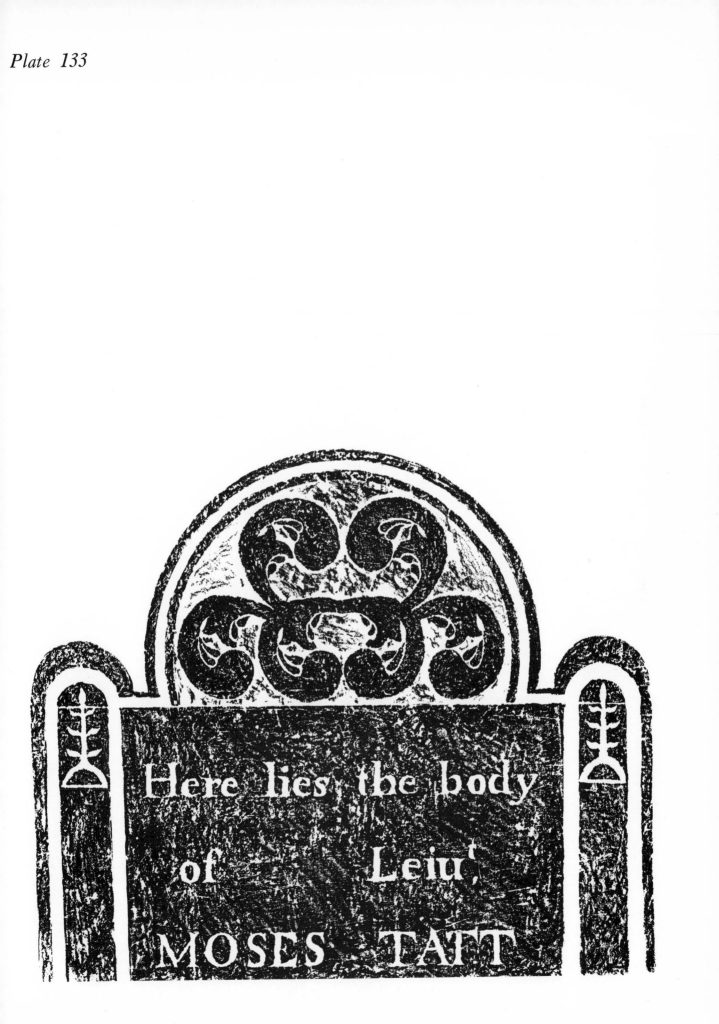

Plate 134

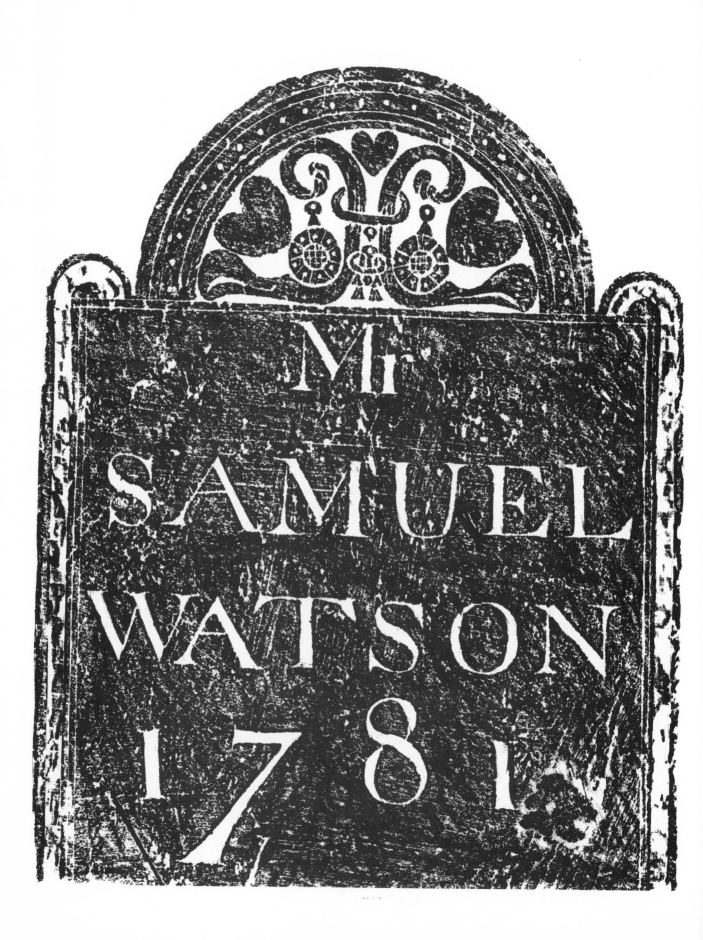

Plate 135

Plate 136

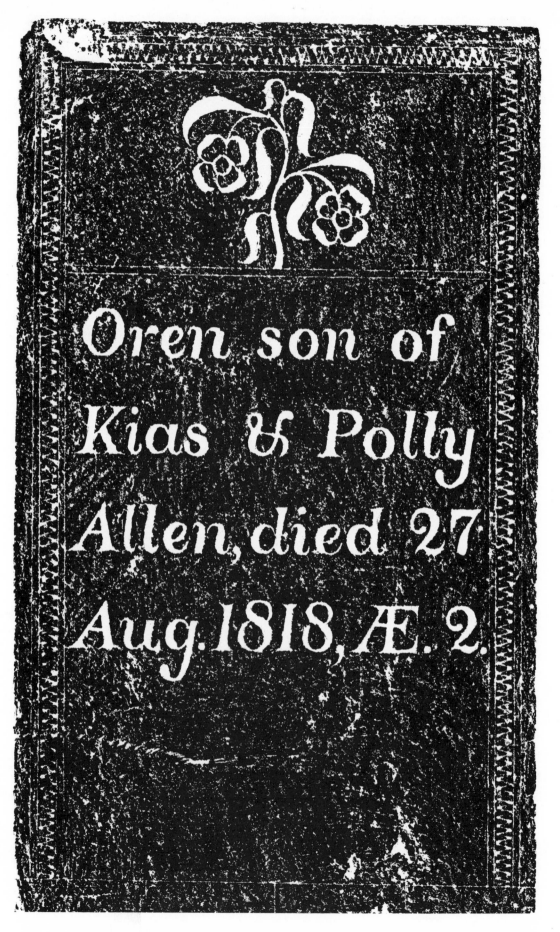

Plate 137

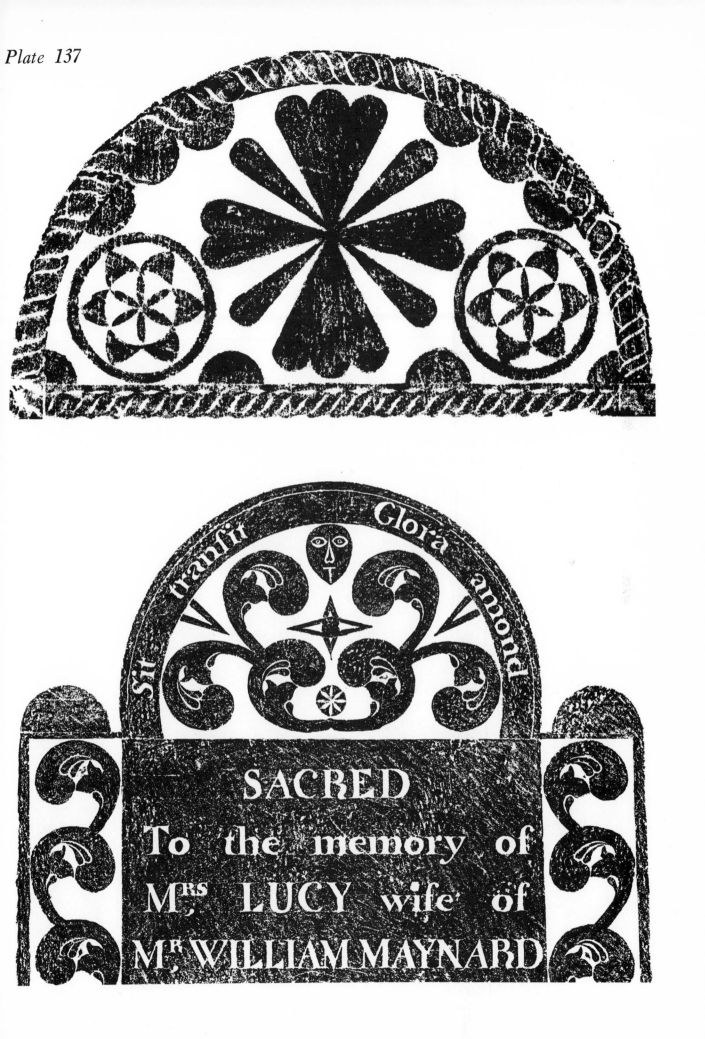

Plate 138

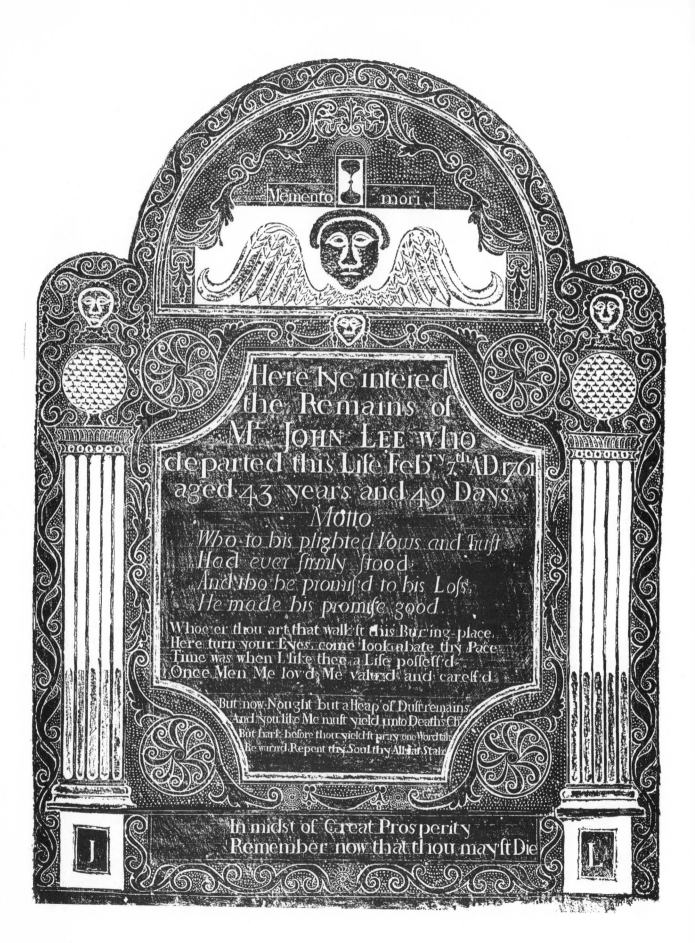

Plate 139

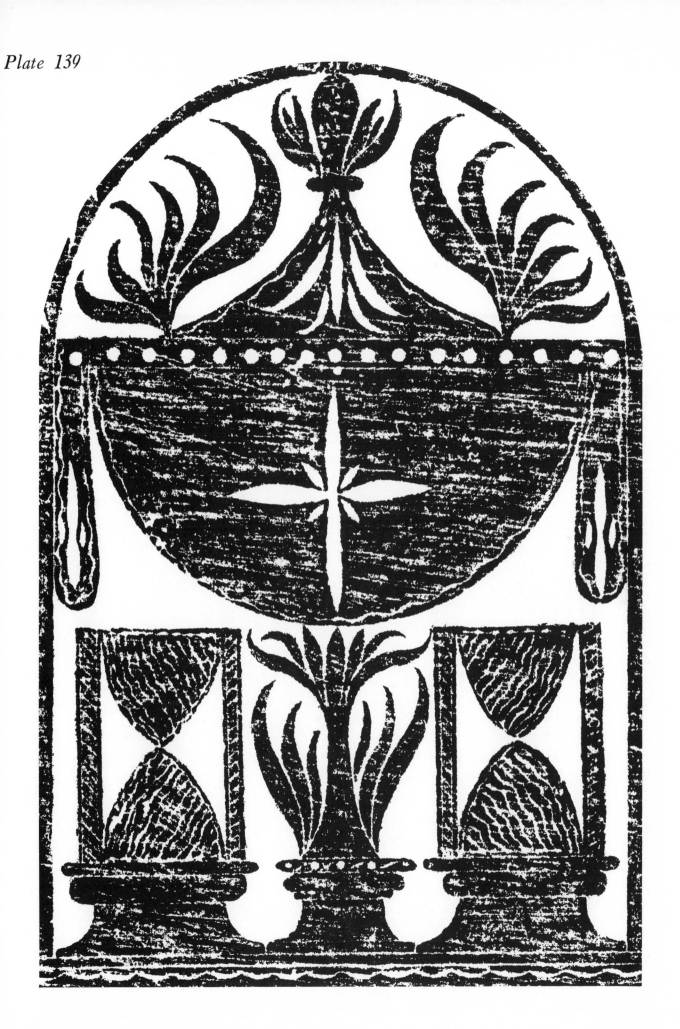

Plate 140

Huldah B. Hunt died 26
Nov. 1815, Æ 2.
Lyman Hunt died 11 Apr.
1816, ag. 3 mon.
Children of John & Huldah
Hunt.

Plate 141

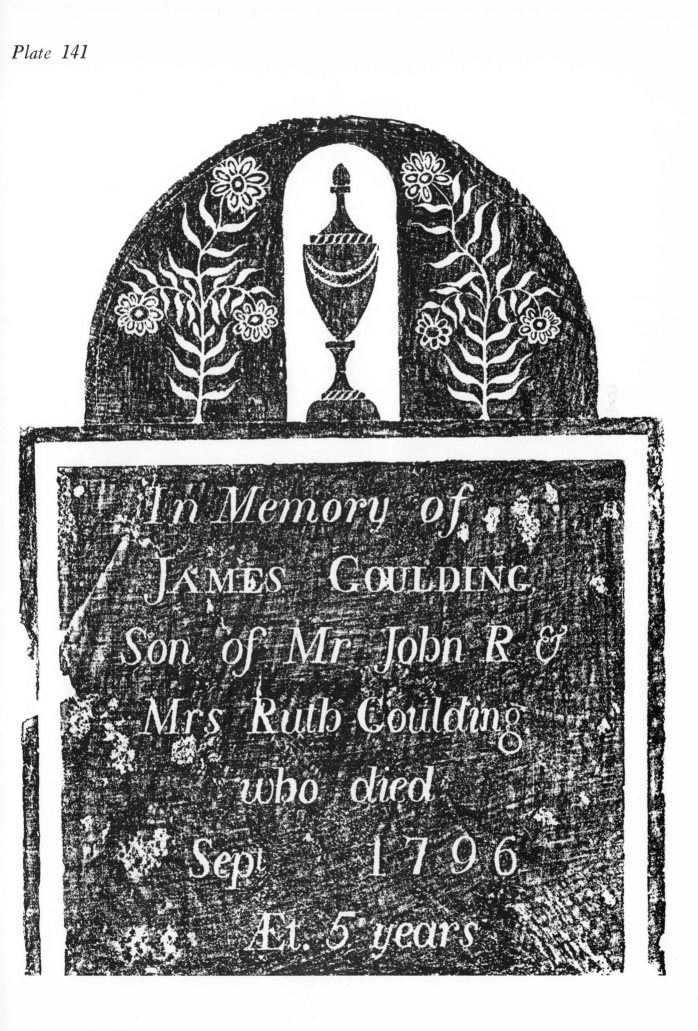

Plate 142

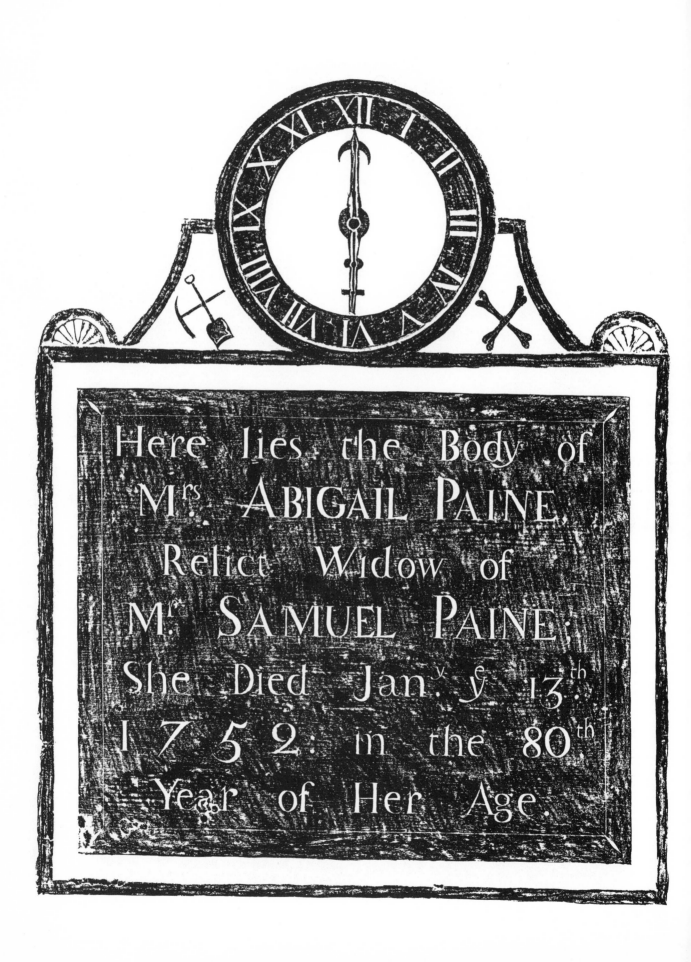

Plate 143

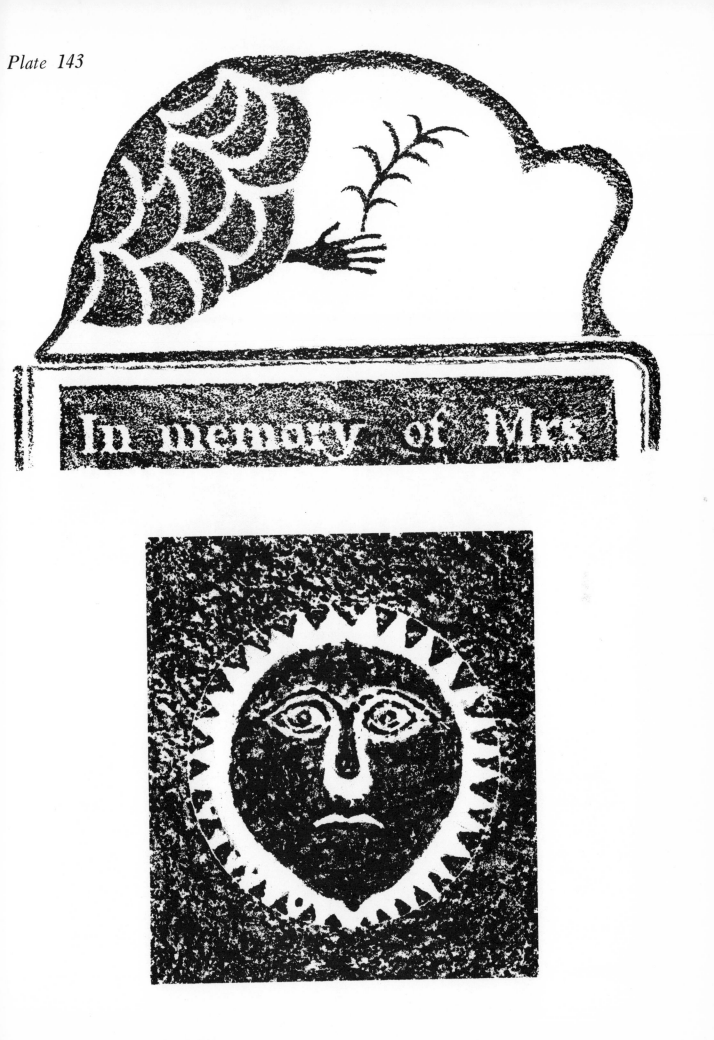

Plate 144

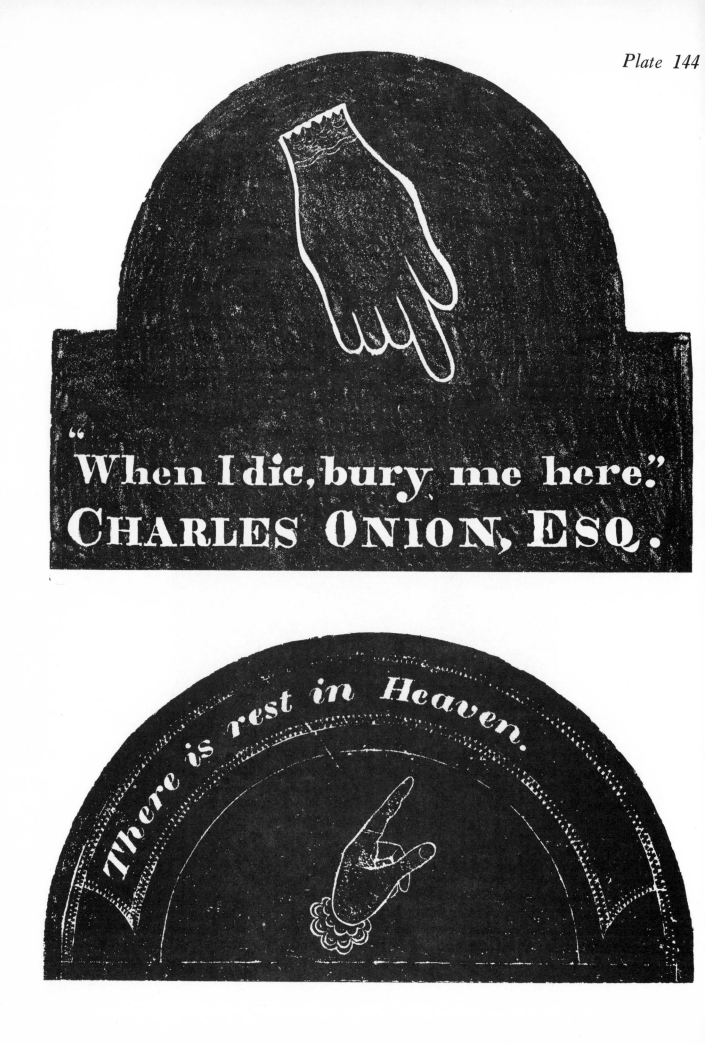

Plate 145

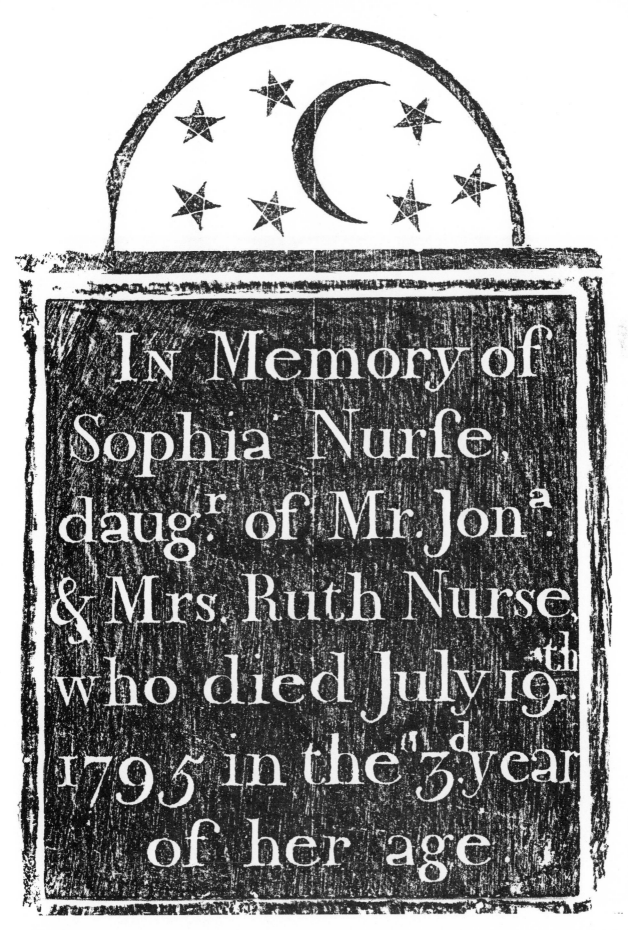

Plate 146

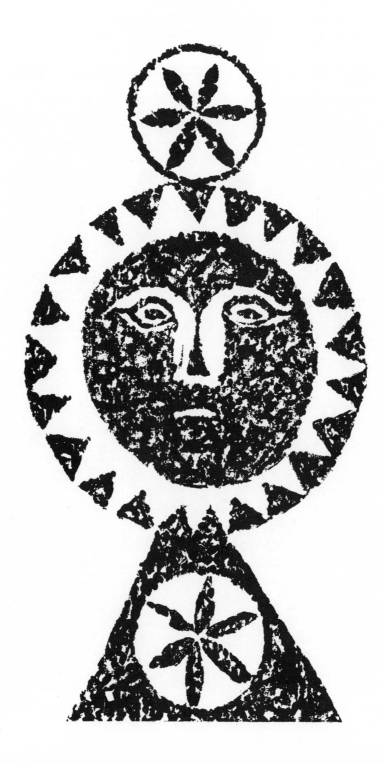

Plate 147

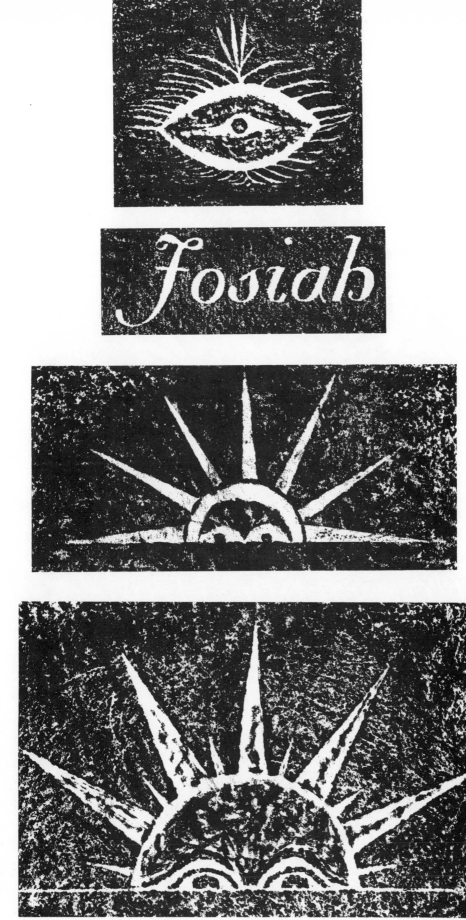

Plate 148

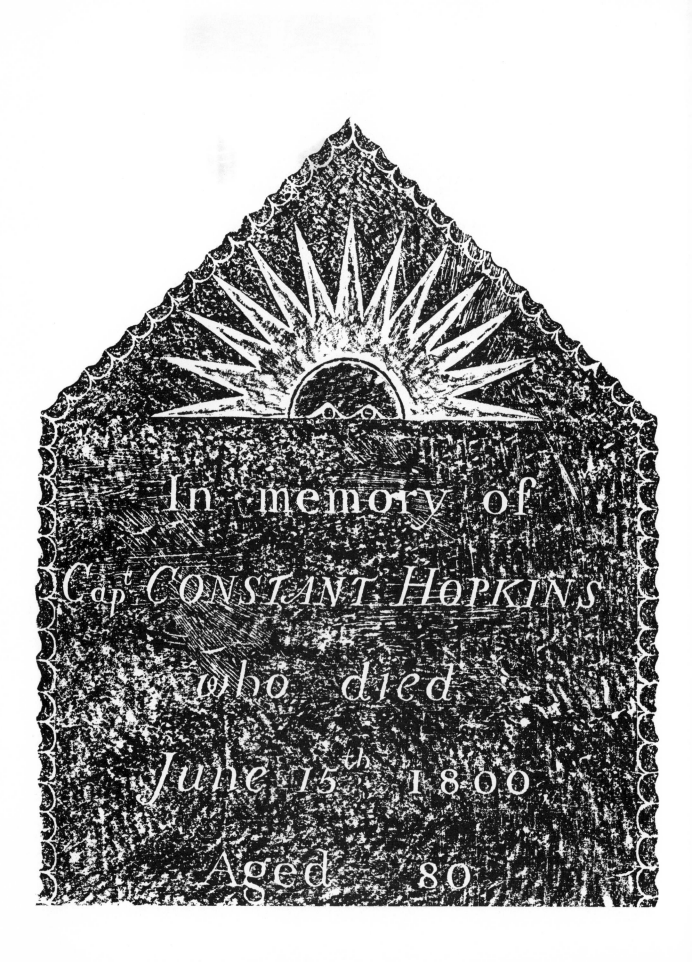

Plate 149

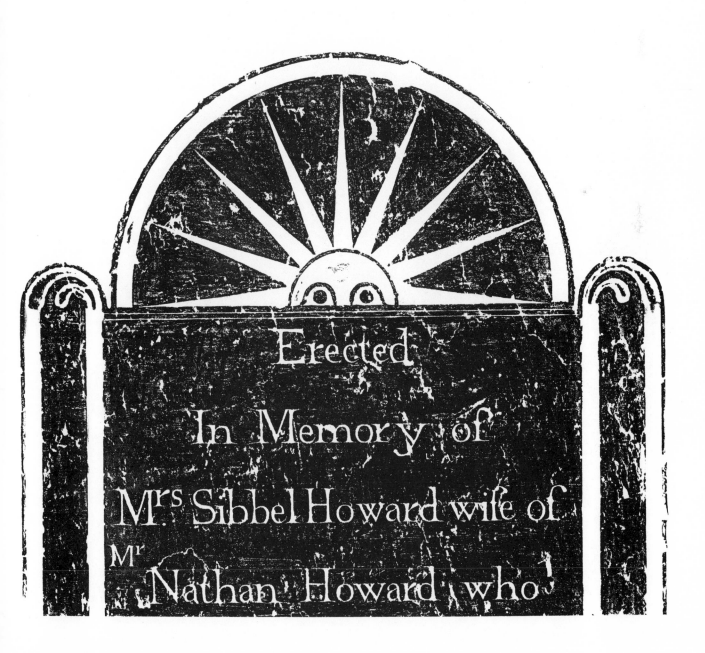

Plate 150

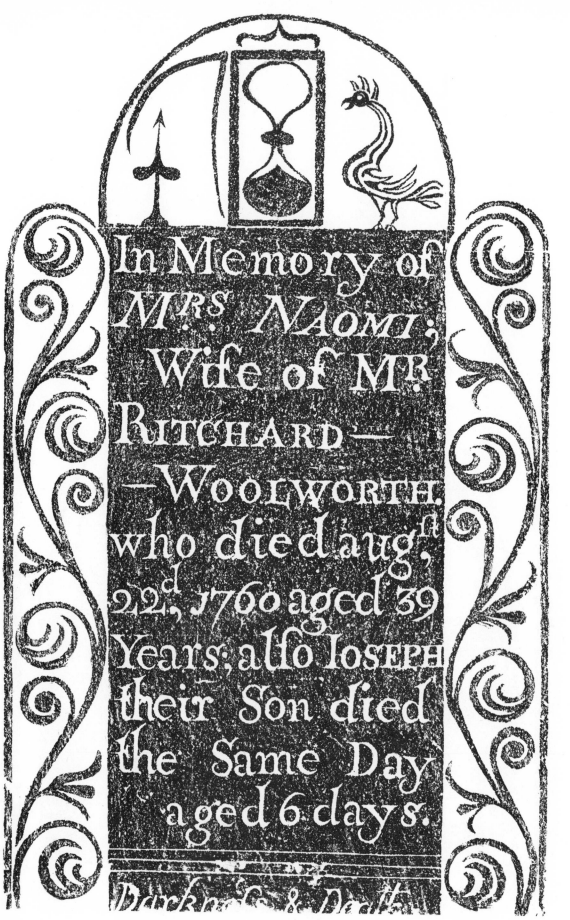

Plate 151

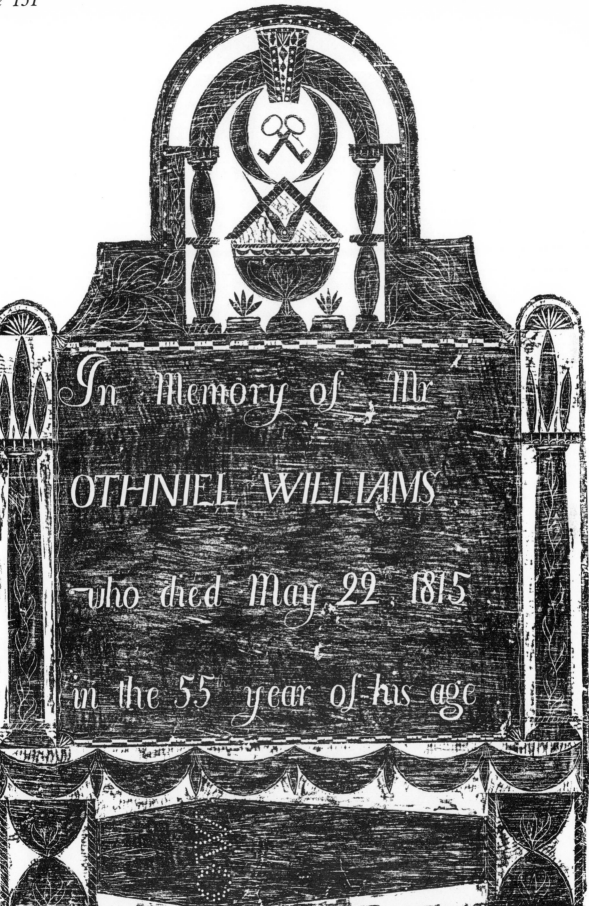

Plate 152

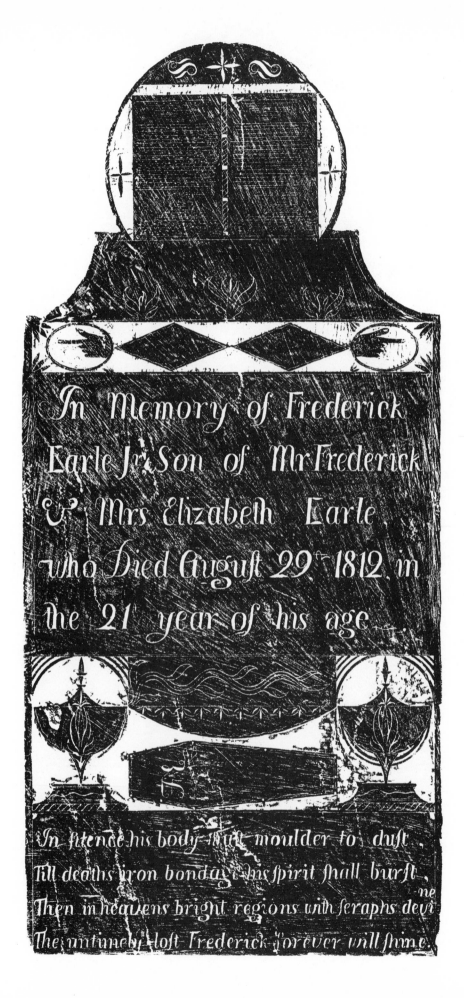

Plate 153

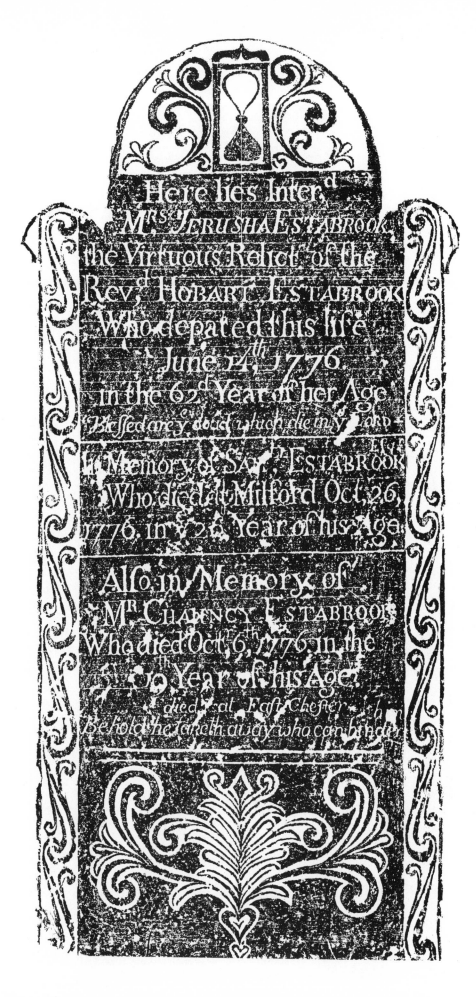

Plate 154

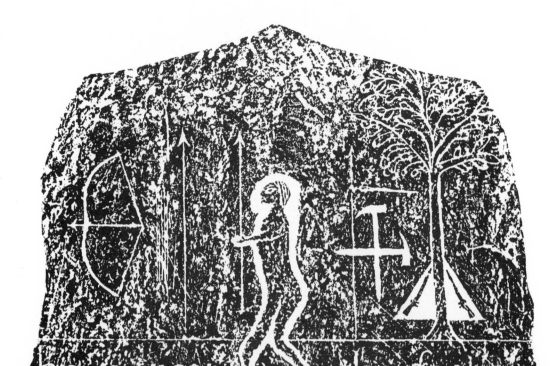

his is near the spot
that the Indians Encamp'd the
Night after they took Mr Johnson &
Family Mr Laberee & Farnsworth,
August 30th 1754 And Mrs
Johnson was Deliver'd of her Child
Half a mile up this Brook

When troubles near the Lord is kind
He hears the Captives crys,
He can subdue the savage mind,
And Learn it sympathy.

Plate 155

On the 31st of
August 1754
Capt James
Johnson had
a Daughter born
on this spot of
Ground being
Captivated with
his whole Family
by the Indians

Plate 156

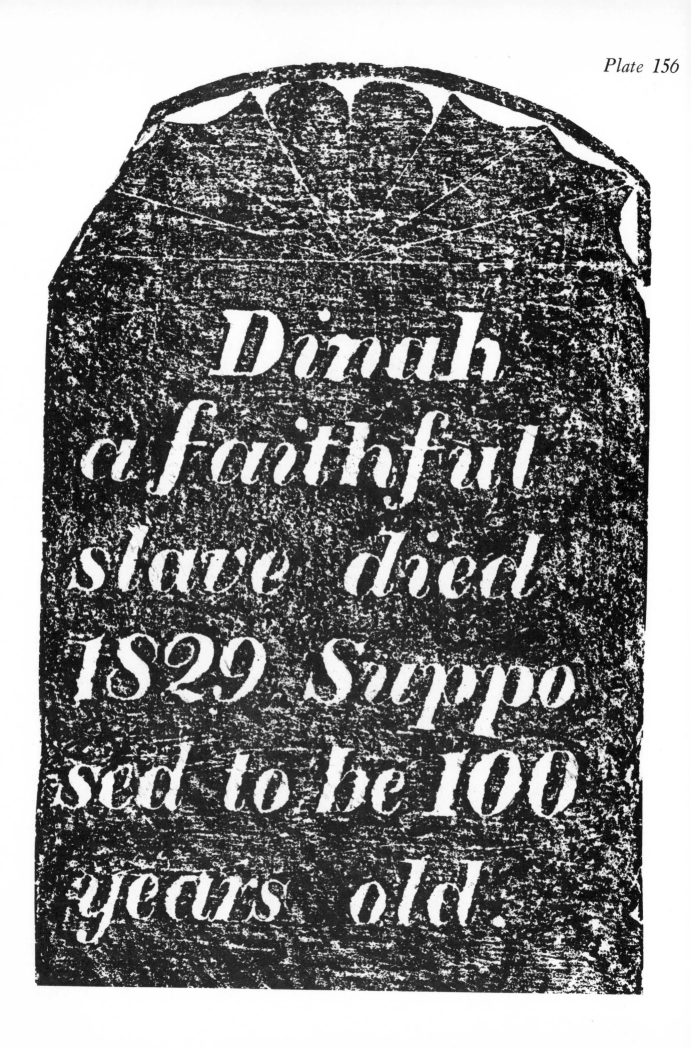

Plate 157

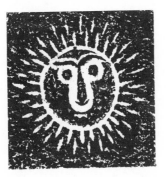

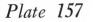

Plate 158

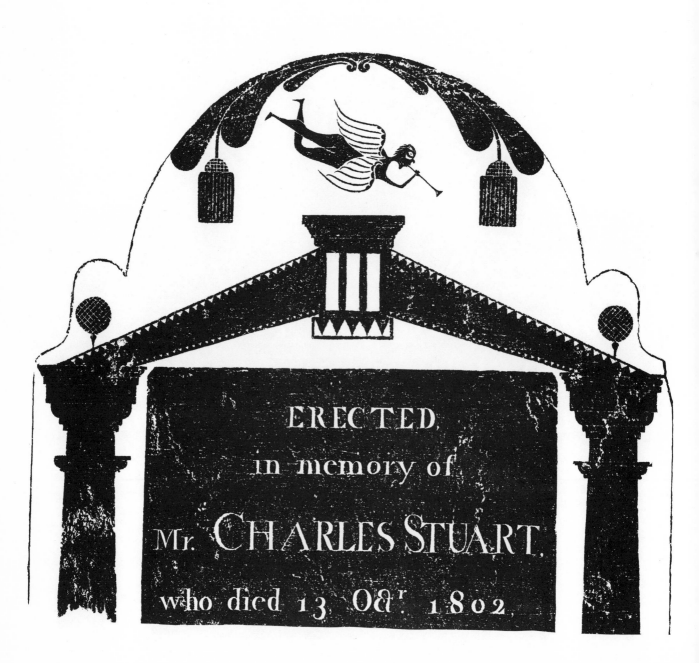

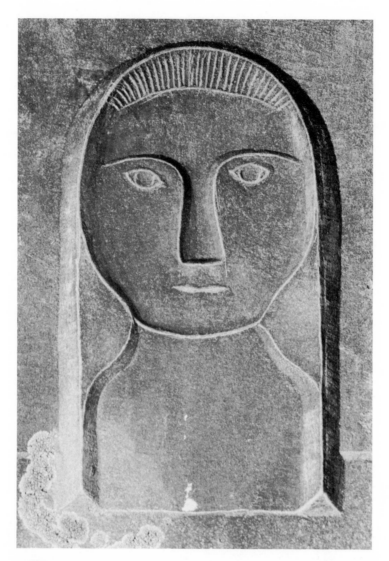

Photographs

Plate 159

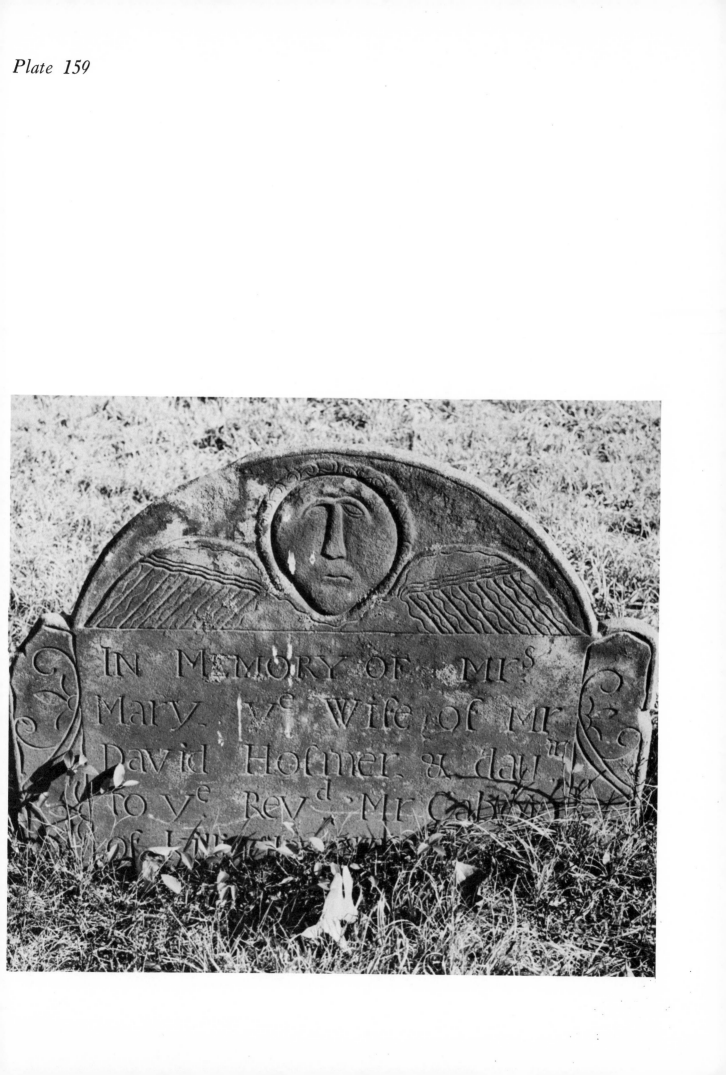

Plate 160

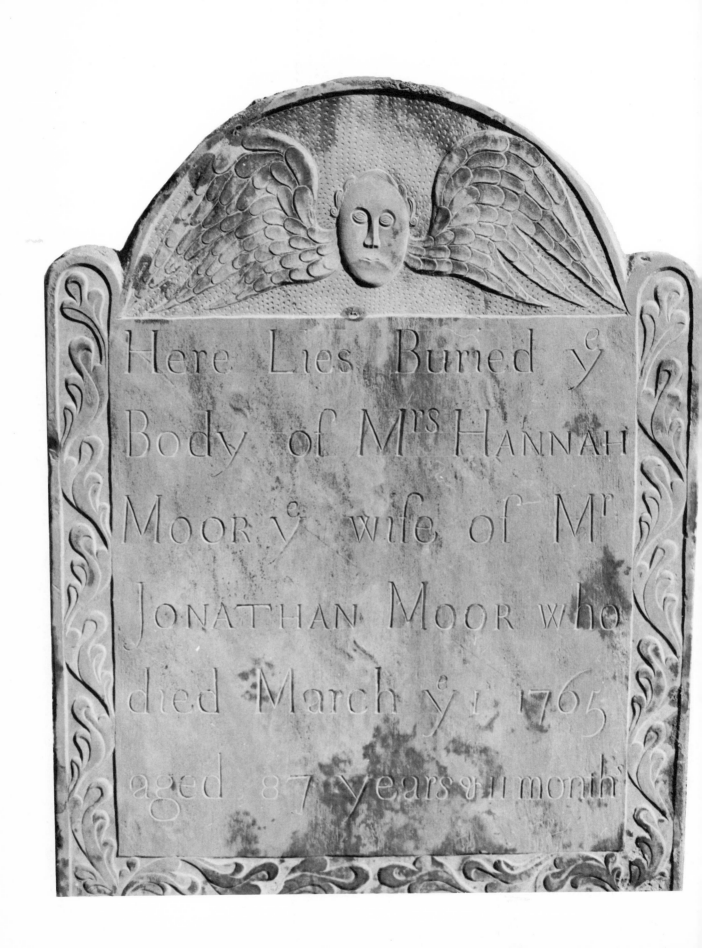

Plate 161

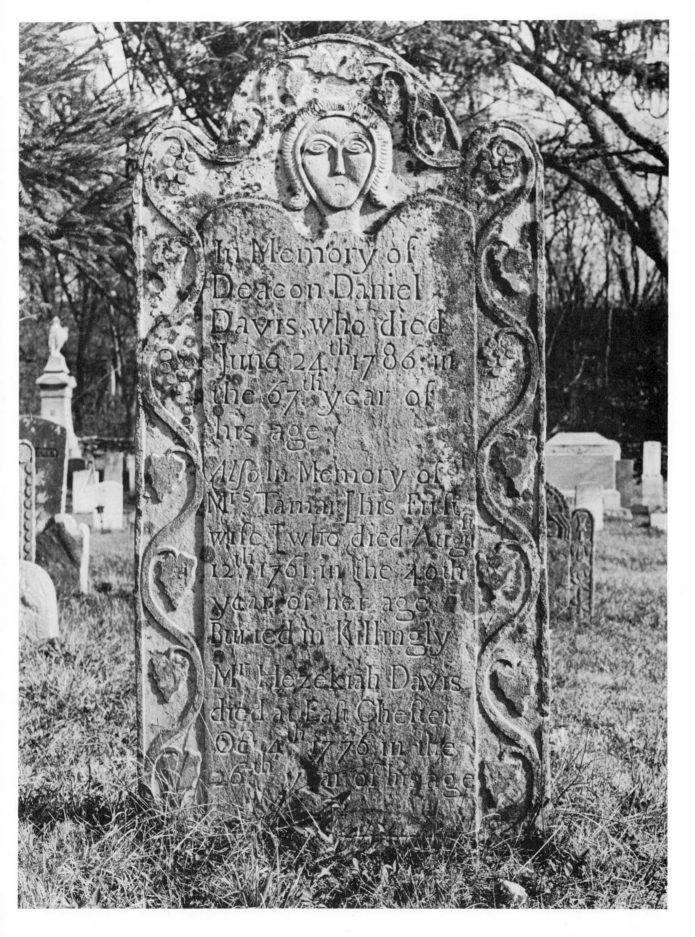

Plate 162

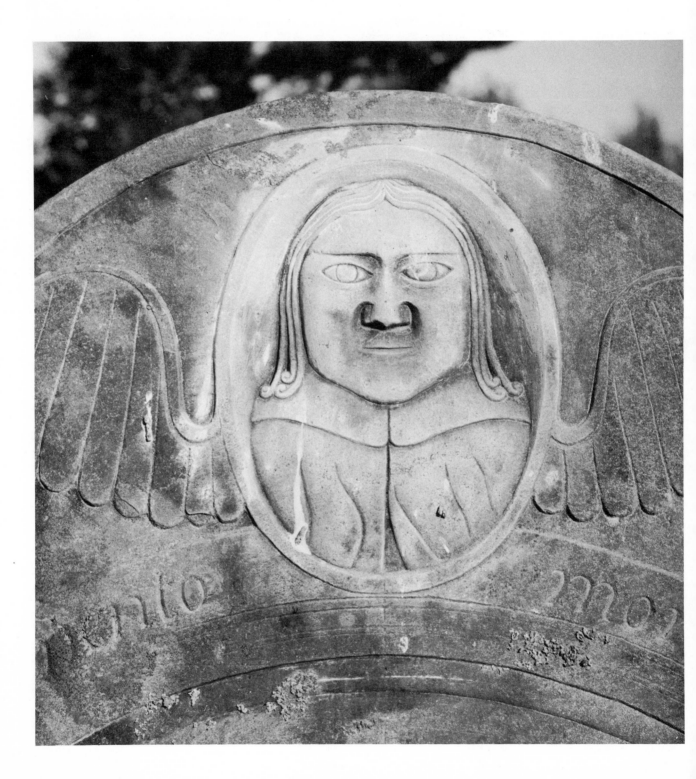

Plate 163

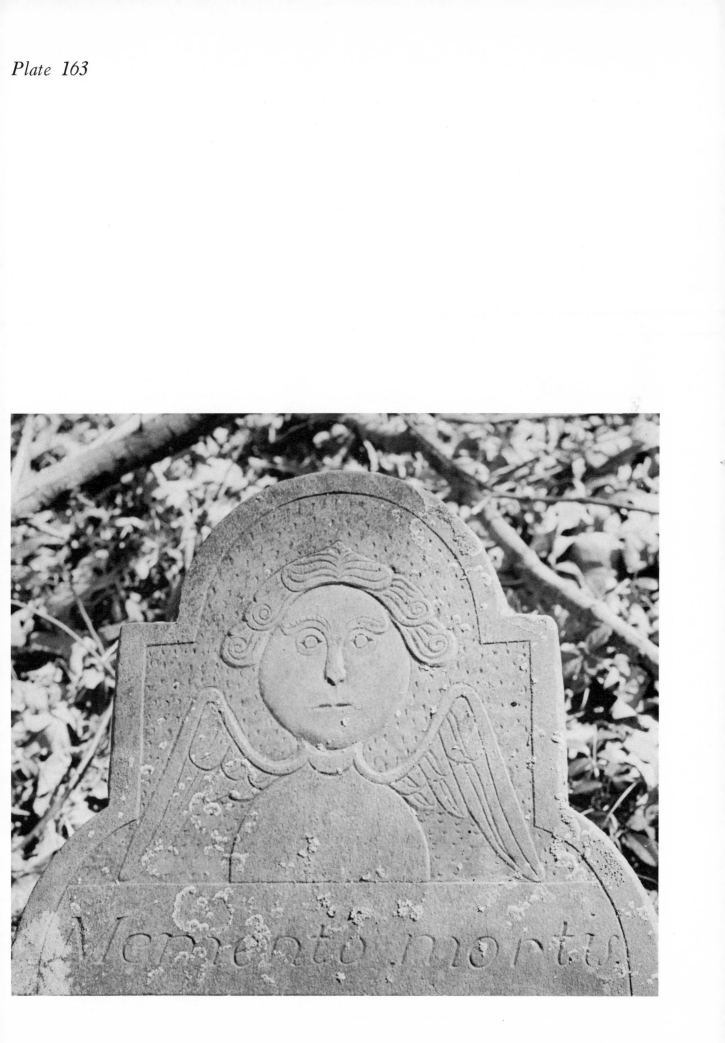

Plate 164

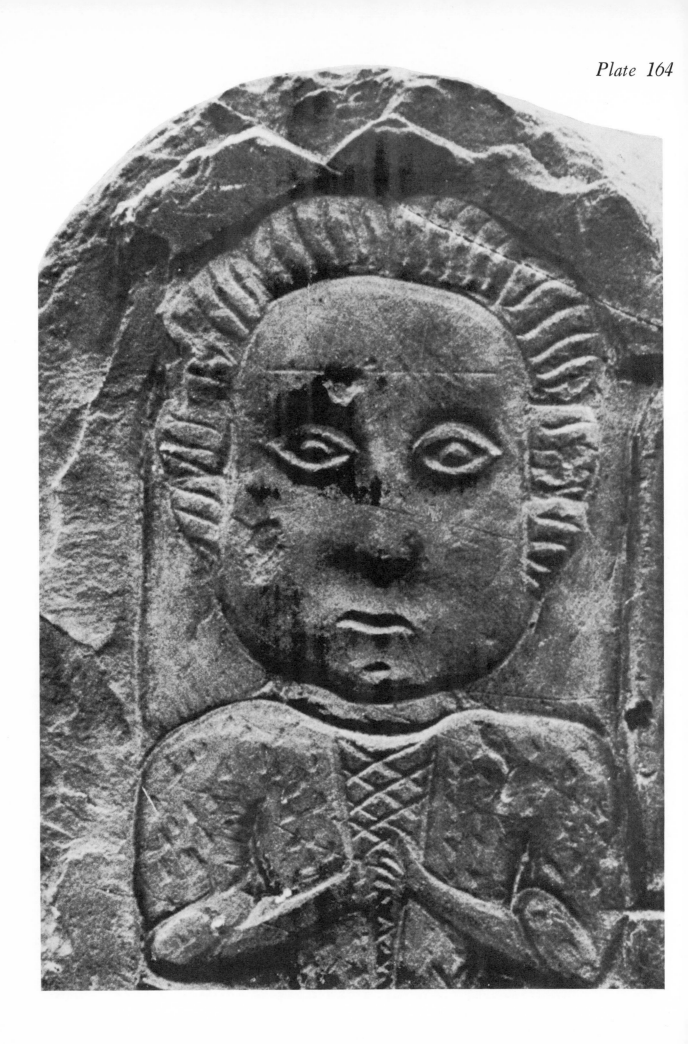

Plate 165

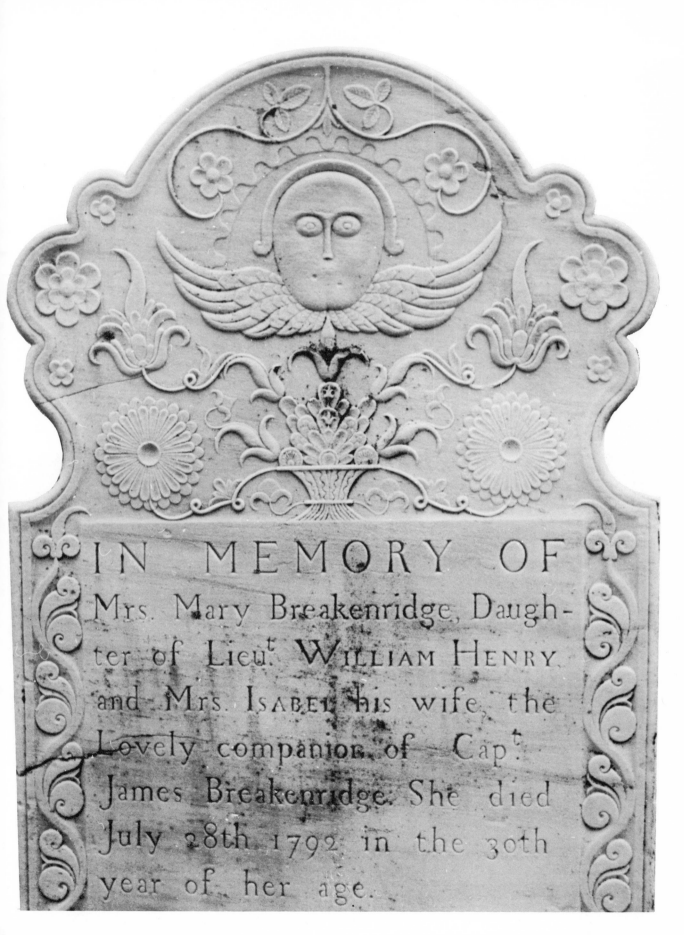

Plate 166

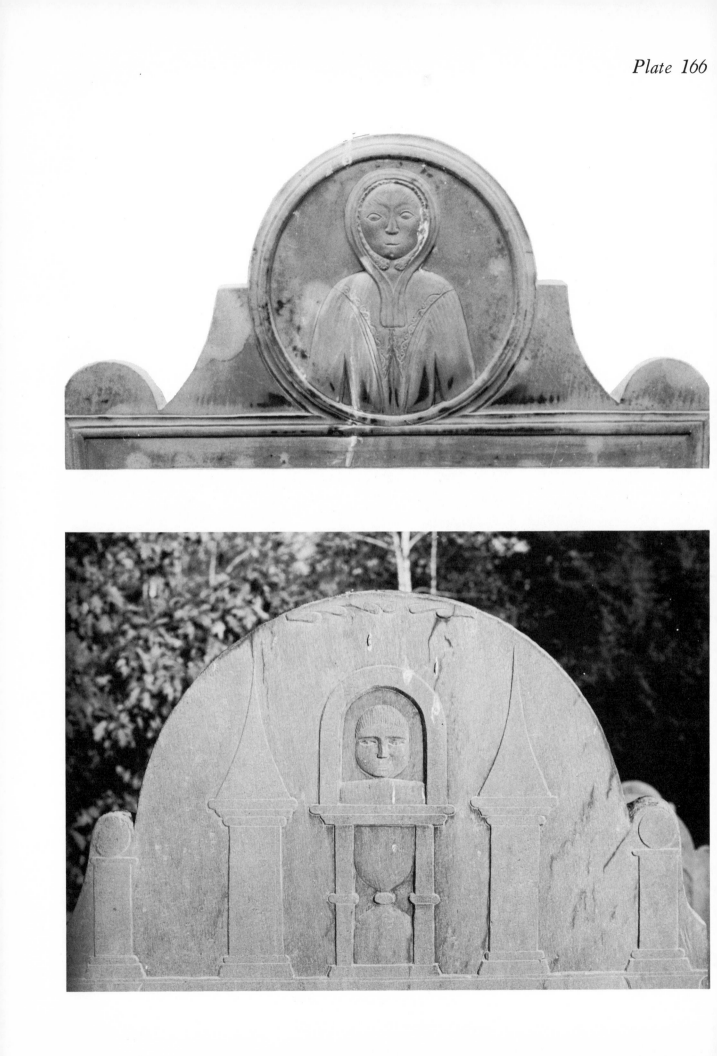

Plate 167

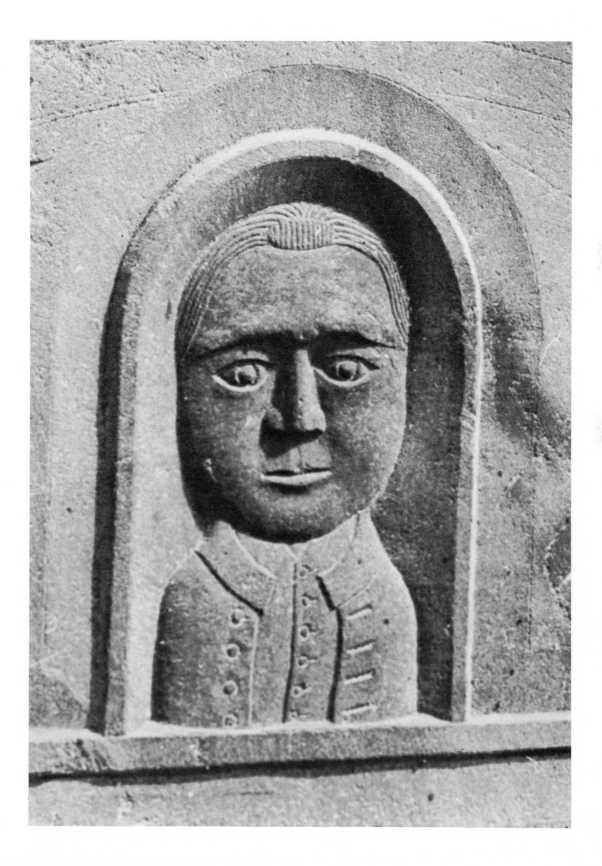

Plate 168

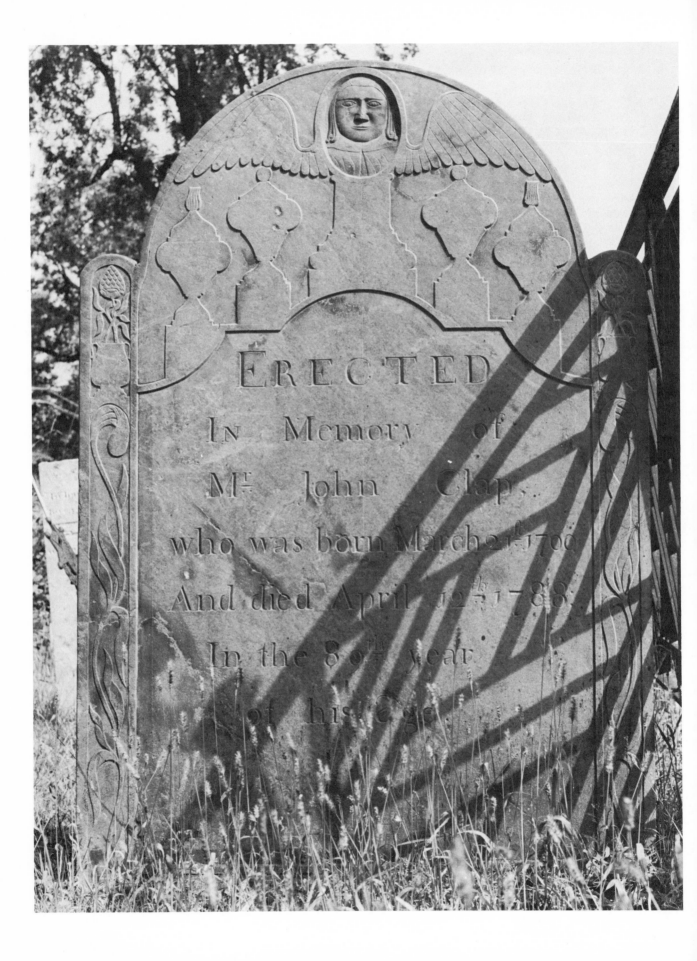

Plate 169

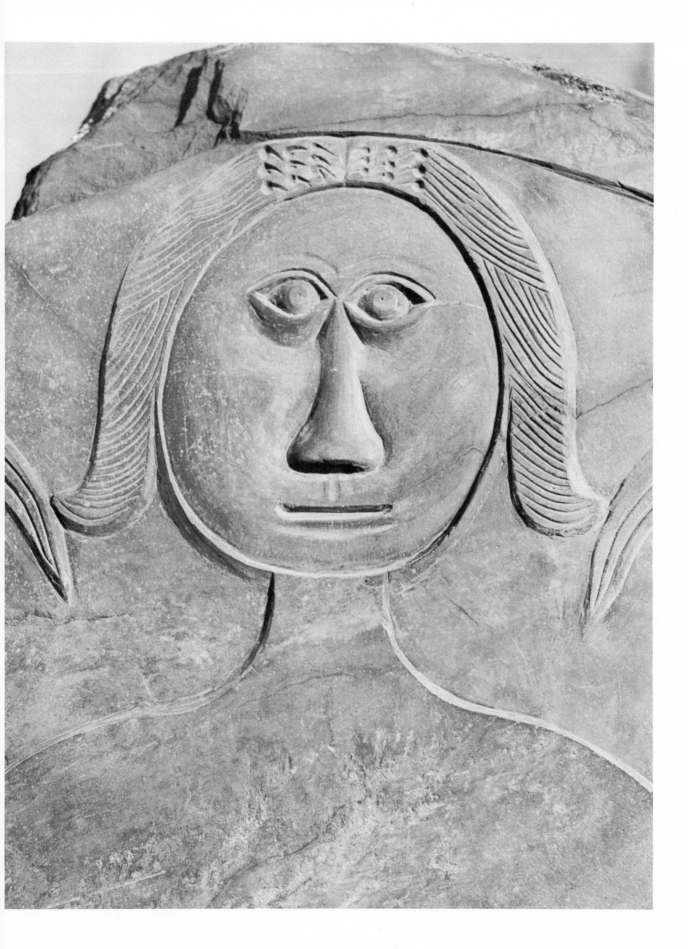

Plate 170

Plate 171

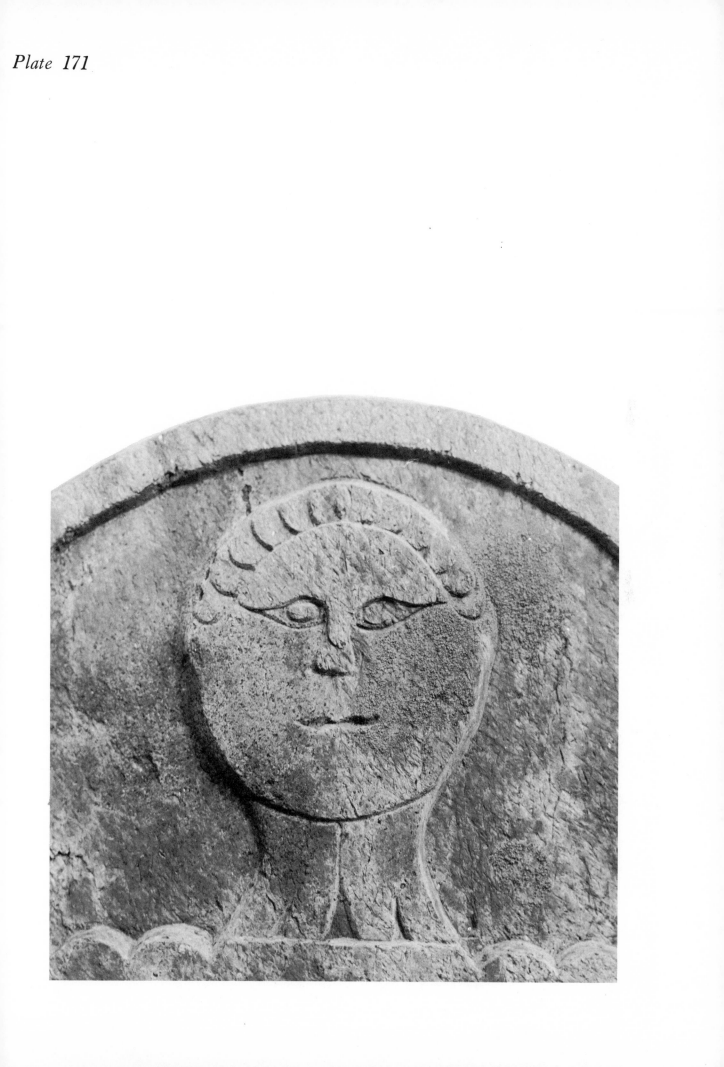

Plate 172

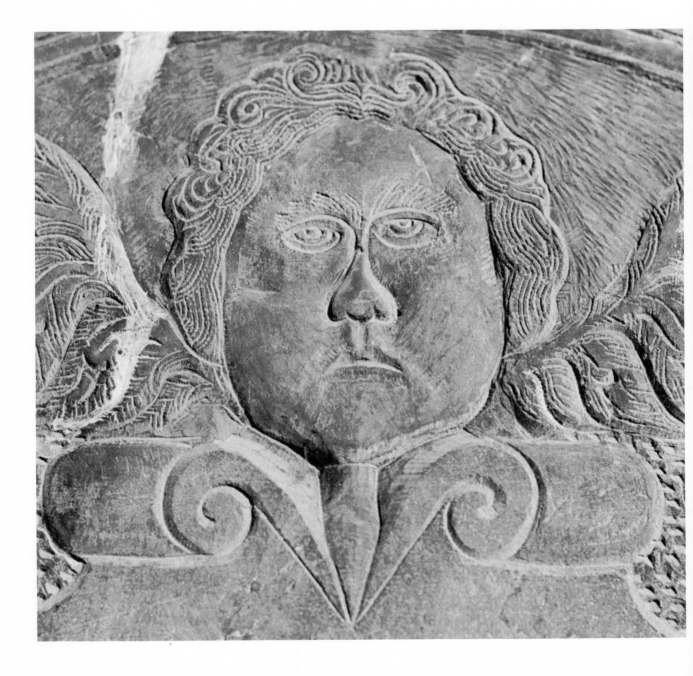

Plate 173

MEMENTO MORI
Here lies the remaines of th Reve Mr
EBENEZER WAYMAN the first pastor of the
Church of Christ in Union who departed
This Life JANUARY the 29 — A: 1743.6
Ætat Su 78

Lo here the Sacred dust of WYMAN lies
Who fell to Death A Glorious Sacrifice
Humility and Meeknes wer his Robes
His Patience Seemed to equal Iobs
His Masters Servis was his chief delight
In which he Strenght he was to day & night
At length God calls & Wyman come away
His Sovl consents and springs to eternal day

Plate 174

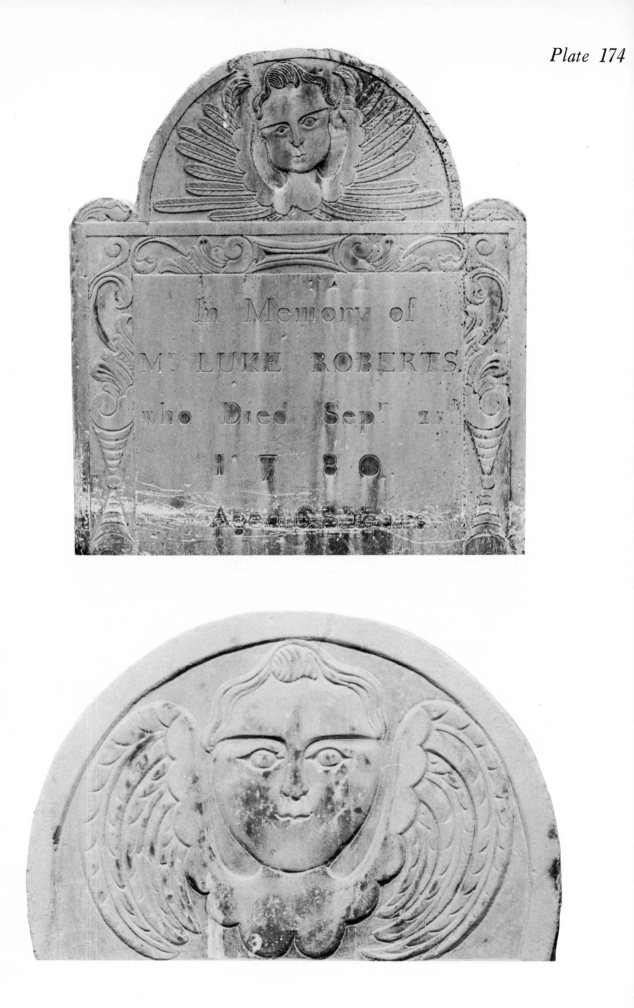

Plate 175

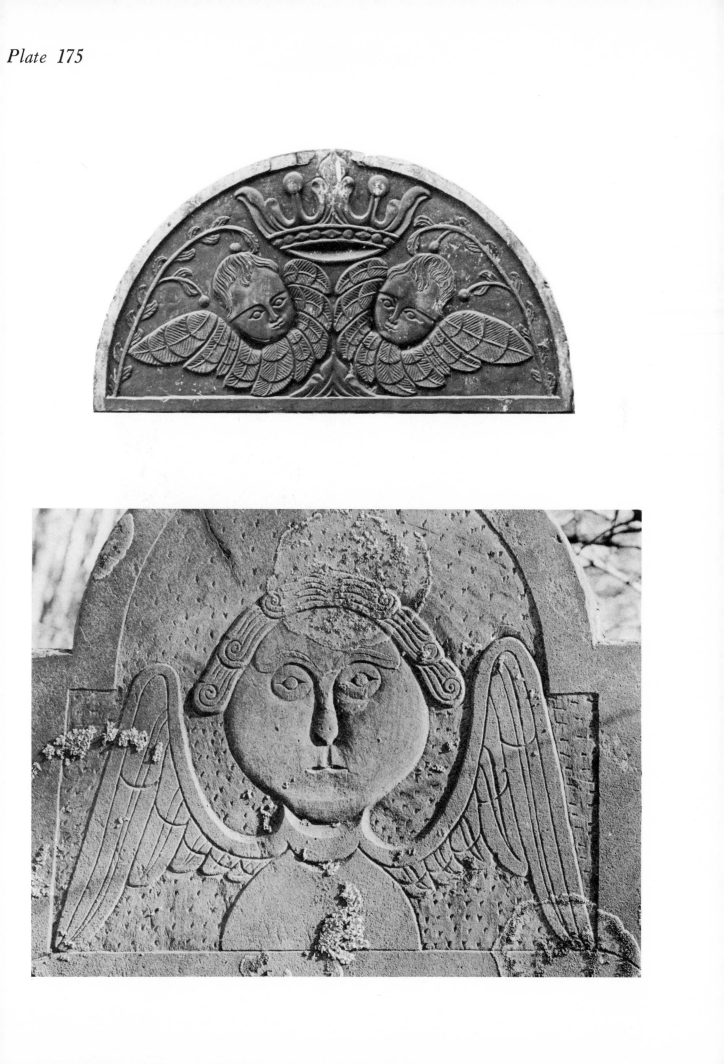

Plate 176

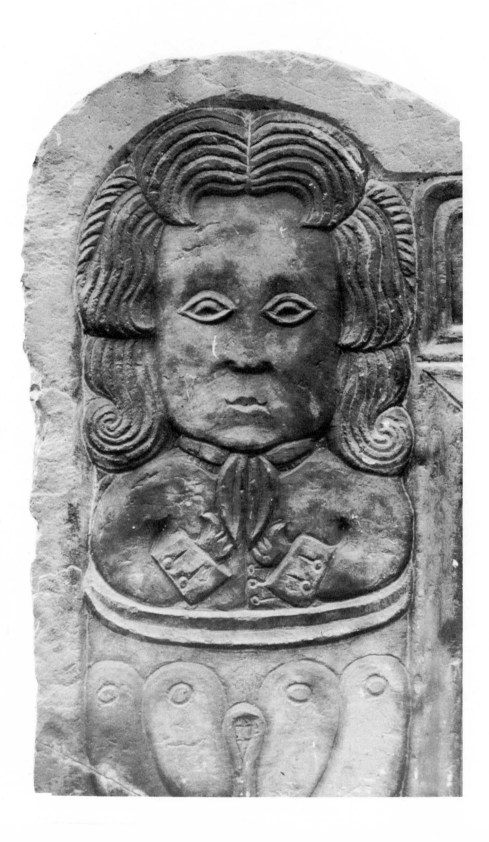

Plate 177

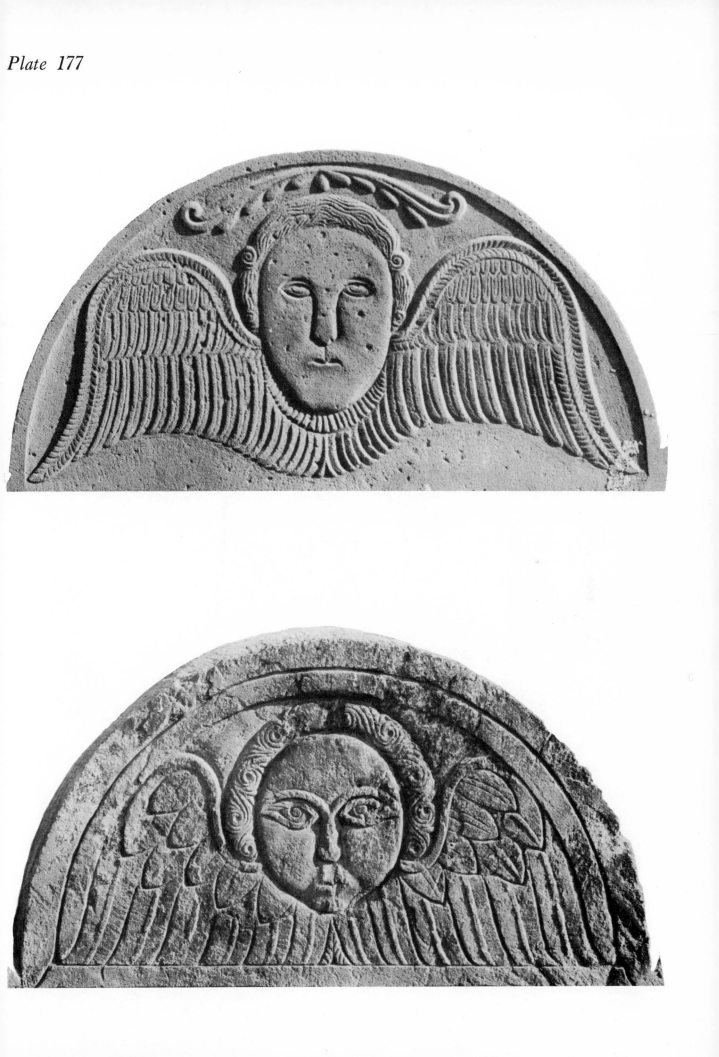

Plate 178

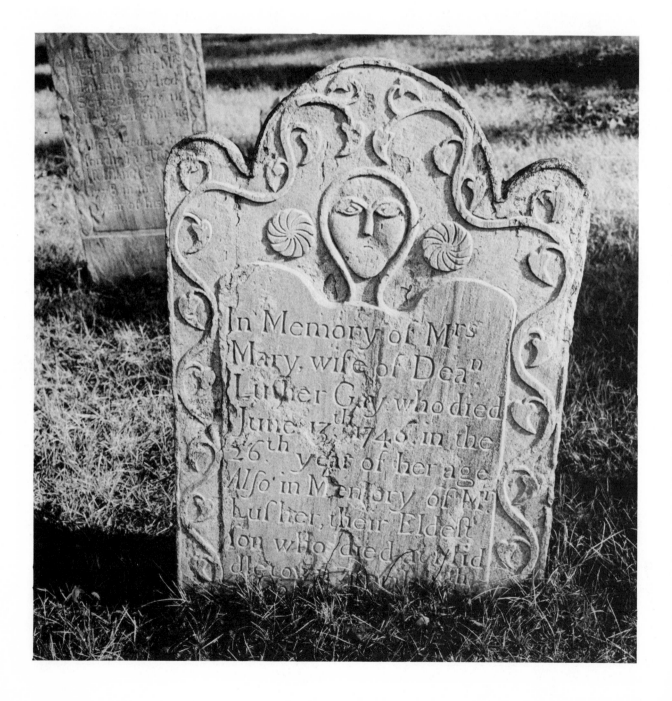

Plate 179

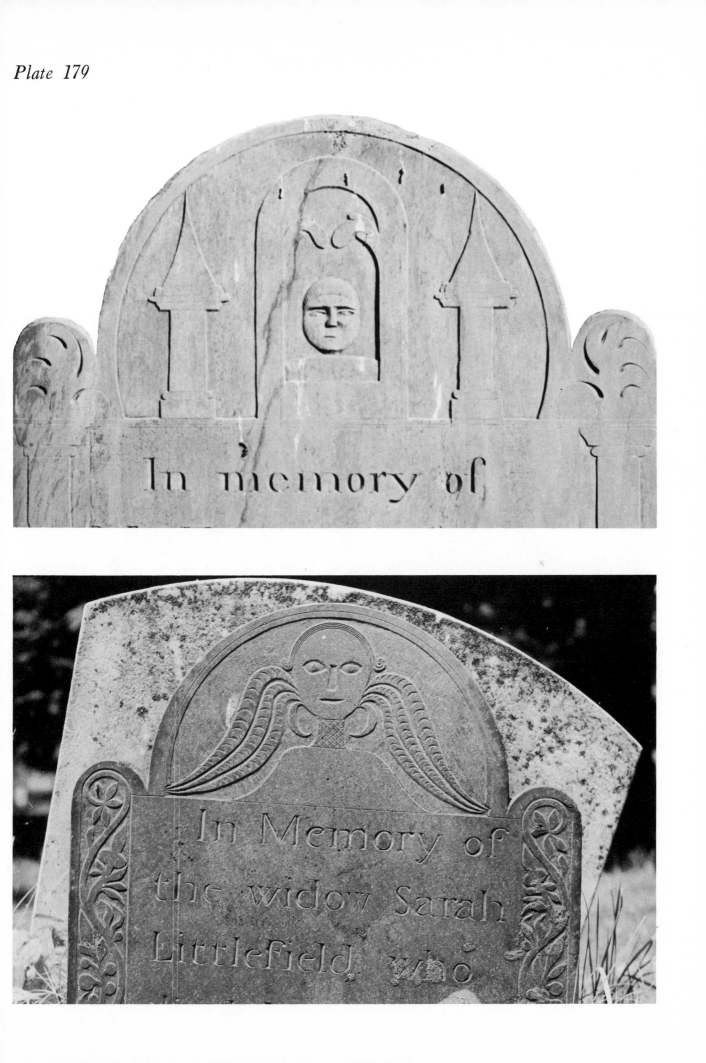

Plate 180

Here lies Buried the Body
of M.ʳ NATHANIEL BAND
who departed this Life
August the 11.ᵗʰ
1773 in the 74.ᵗʰ
Year of his Age.

Plate 181

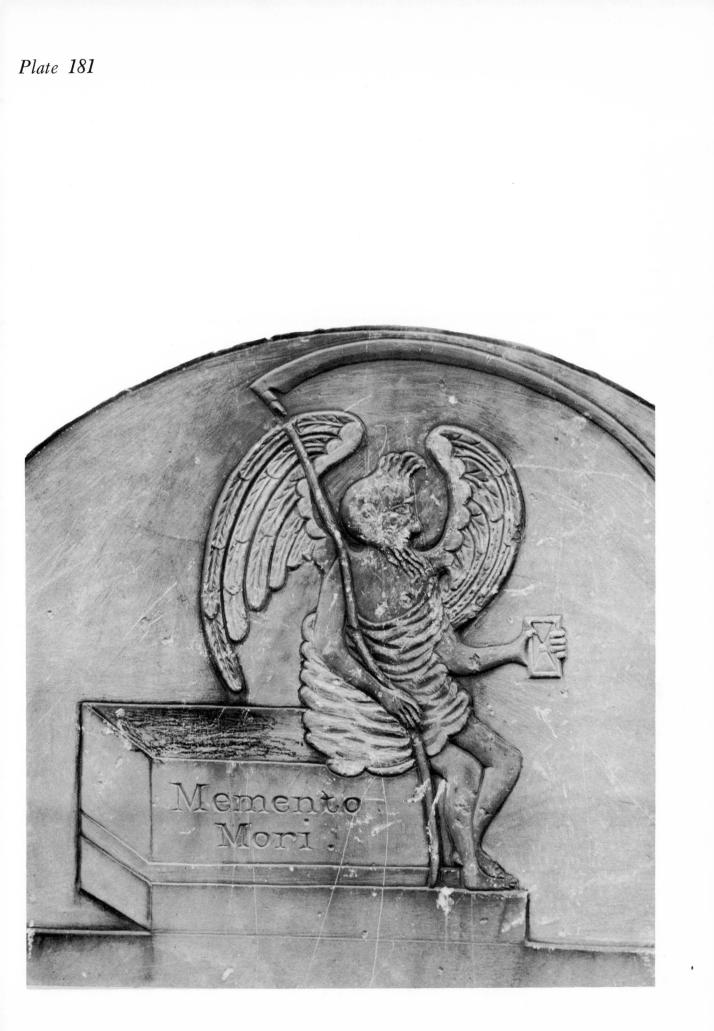

Plate 182

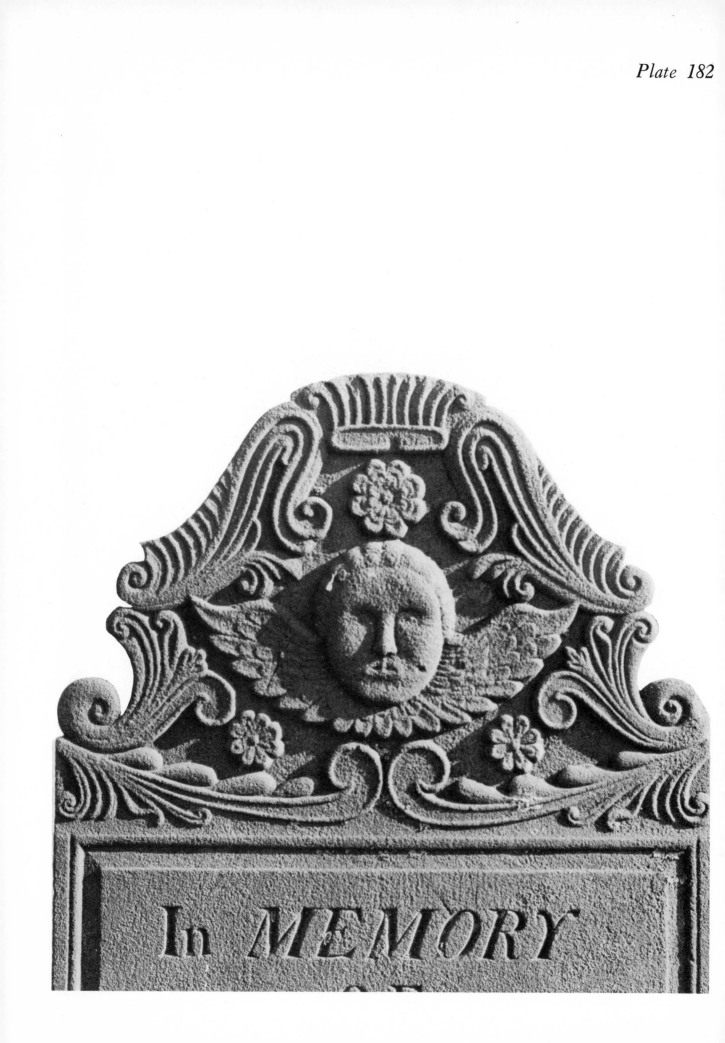

Plate 183

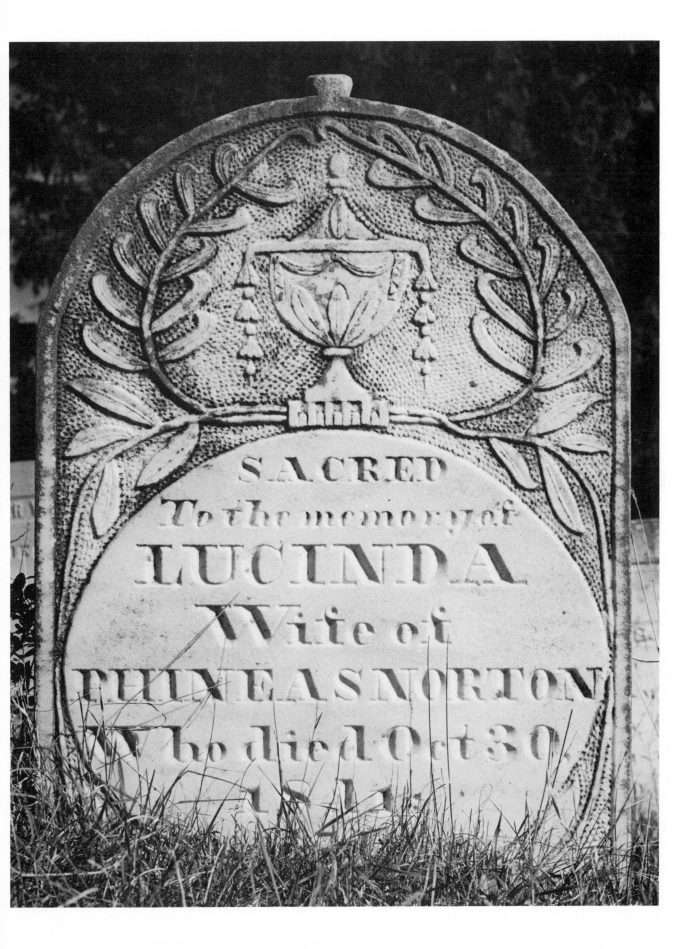

Plate 184

Sacred
To
Mr. FREDERICK GILBERT,
who died
Octr. 2d 1802,
Ætat. 36

Plate 185

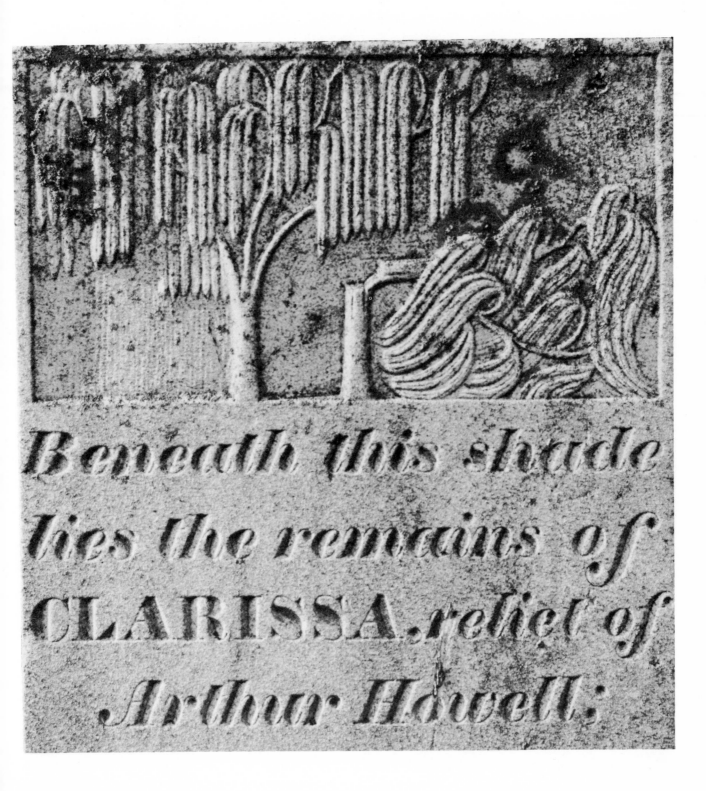

Plate 186

"An honeſt man's the nobleſt work of God."

CAPTAIN EPHRAIM CARTER
died May 19. 1798 age 55.
He was a comfort & ſtaff to aged
Parents, a guide to Children,
a faithful & affectionate Conſort,
a Patron & Lover of Free Maſonry,
& a conſtant Benefactor to the Poor.
Animated with public Spirit,
he promoted the good of ſociety,
and in his numerous private and
public employments, acted with
ſtrict integrity.
He was a ſincere Chriſtian & his

Plate 187

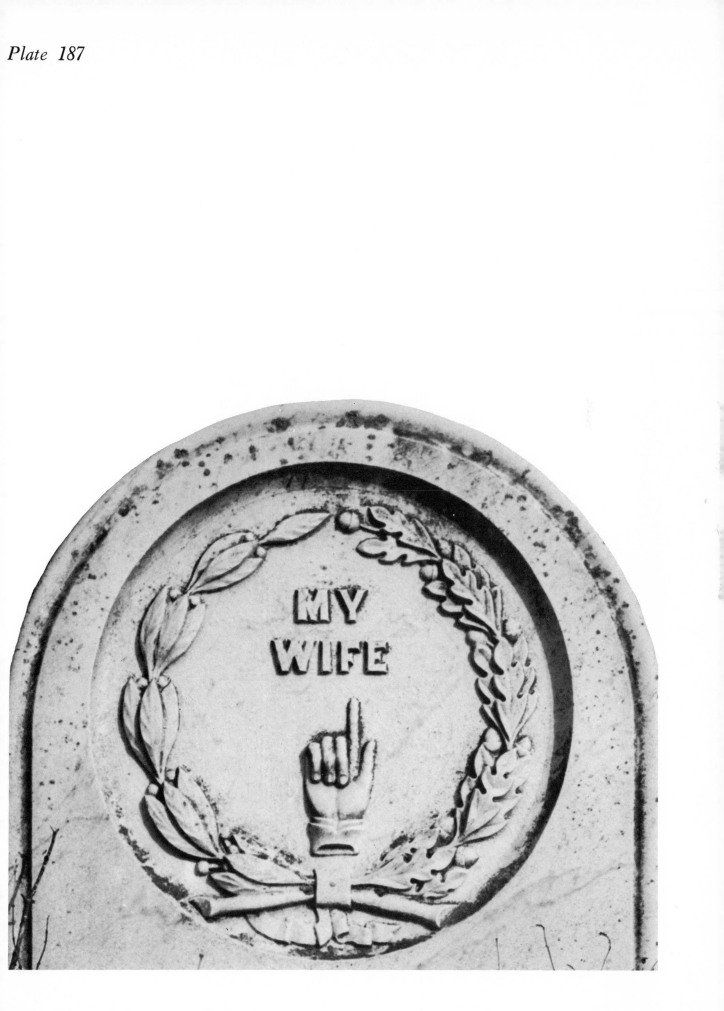

Plate 188

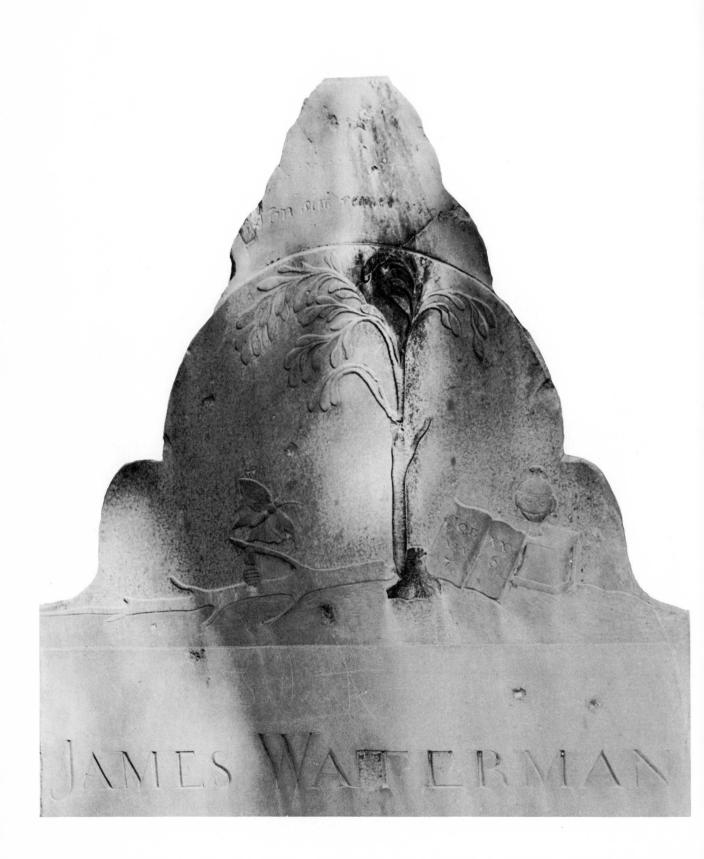

Plate 189

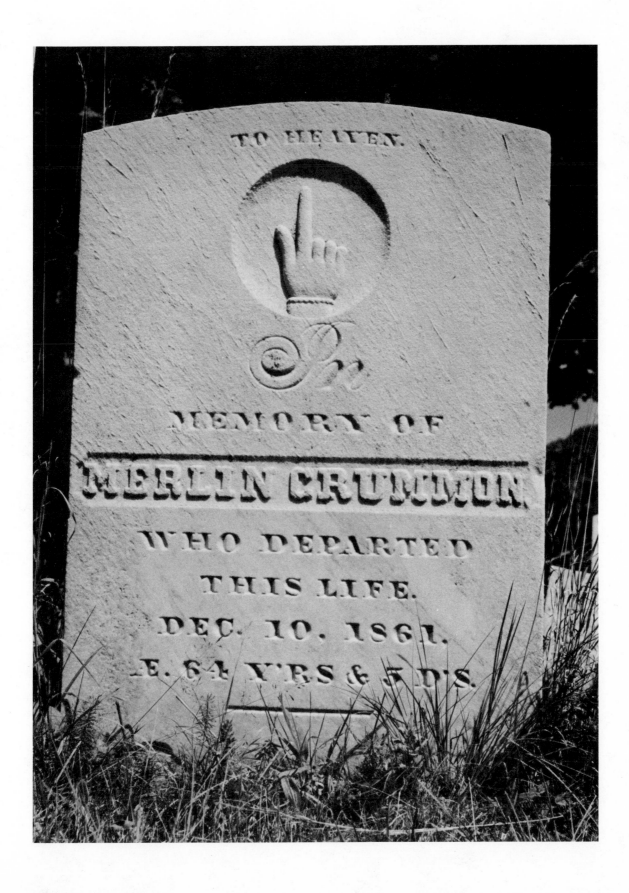

Plate 190

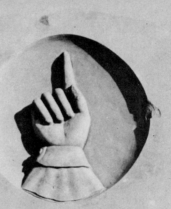

HARRIET.
wife of
JOSEPH PICKMAN,
Died Aug. 22,1861.

Plate 191

IN MEMORY OF
Mrs. HARRIET DAVIS,
WIFE OF
SIMON DAVIS Esq.
AND DAUGHTER OF
Mr. AMOS KETCHUM
OF THE CITY OF
NEW YORK.
WHO DIED AUGUST 16, A.D. 1828
IN THE 28, YEAR
OF HER AGE.

Plate 192

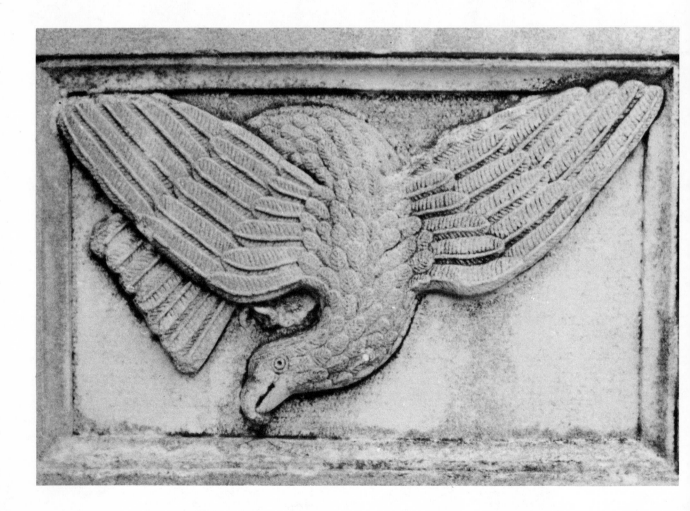

Plate 193

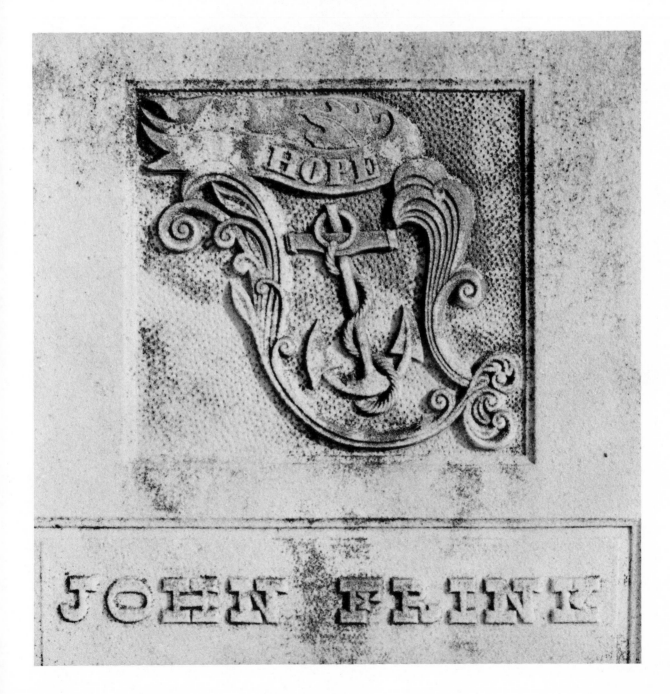

Plate 194

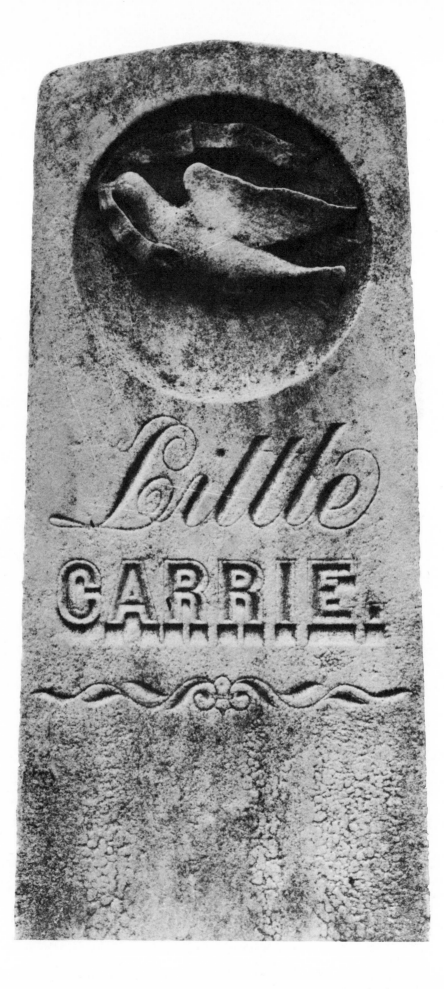

Plate 195

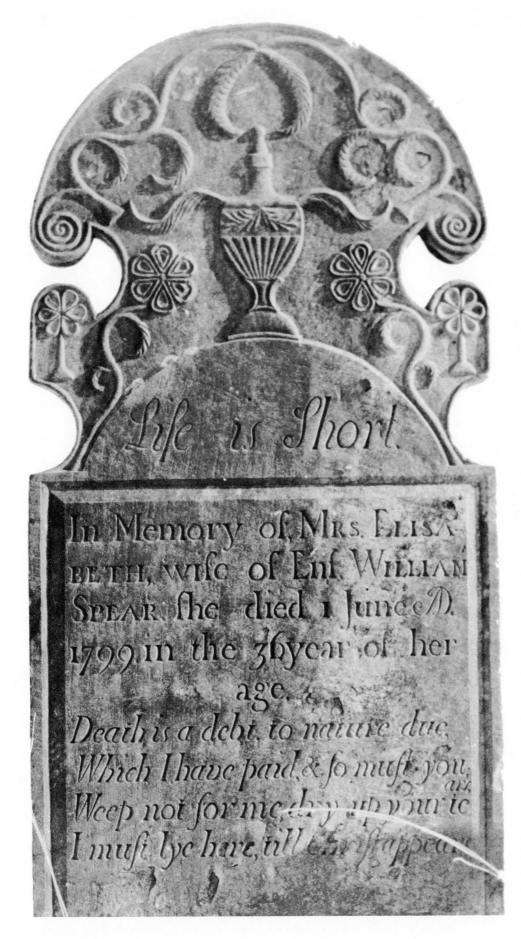

TABLE
OF WIDTHS OF RUBBINGS

Virtually all the rubbings had to be reduced in order to fit into the format of this book. The following table gives the width in inches of the stones at their widest point.

PLATE 1. 25¼.

PLATE 2. 23½.

PLATE 3. top, 10¾; center, 12; bottom, 13¼.

PLATE 4. 18⅝.

PLATE 5. top, 20⅝; bottom, 18½.

PLATE 6. 15⅛.

PLATE 7. 17⅝.

PLATE 8. top, 13; center, 11¾; bottom, 17.

PLATE 9. top, 14¼; bottom, 18.

PLATE 10. top, 22½; bottom, 30⅛.

PLATE 11. 22⅞.

PLATE 12. top, 31; bottom, 23¼.

PLATE 13. 20¼.

PLATE 14. 35½.

PLATE 15. top, 19⅛; bottom, 16⅝.

PLATE 16. top, 19¼; bottom, 20¼.

PLATE 17. top, 18⅛; bottom, 14½.

PLATE 18. top, 17⅞; bottom, 20⅝.

PLATE 19. 25¼.

PLATE 20. top, 23⅝; bottom, 19⅞.

PLATE 21. 19⅝.

PLATE 22. 23¾.

PLATE 23. top, 17½; bottom, 23½.

PLATE 24. 22⅞.

PLATE 25. top, 26½; bottom, 19¾.

PLATE 26. 15.

PLATE 27. top, 18⅝; bottom, 20⅝.

PLATE 28. top, 19¼; bottom, 10¼.

PLATE 29. 17.

PLATE 30. 19.

PLATE 31. 14½.

PLATE 32. top, 14½; bottom, 16¼.

PLATE 33. 21⅛.

PLATE 34. 21⅛.

PLATE 35. top, 21; bottom, 16⅝.

PLATE 36. 19¾.

PLATE 37. 20¼.

PLATE 38. 20⅝.

PLATE 39. top, 22⅞; bottom, 18⅛.

PLATE 40. top, 14⅛; bottom, 15⅝.

PLATE 41. 21.

PLATE 42. 16⅝.

PLATE 43. 22⅜.

PLATE 44. 19½.

PLATE 45. 24.

PLATE 46. top, 30; bottom, 28¼.

PLATE 47. top, 30⅜; bottom, 22¼.

PLATE 48. top, 23¼; bottom, 30⅞.

PLATE 49. 36.

PLATE 50. top, 34⅜; bottom, 24¾.

PLATE 51. 20.

PLATE 52. 26⅞.

PLATE 53. 18¼.

PLATE 54. top, 3½, bottom, 17⅞.

PLATE 55. 34⅜.

PLATE 56. 17.

PLATE 57. top, 17⅞; bottom, 26¾.

PLATE 58. top, 23; bottom, 27½.

PLATE 59. top, 27½; bottom, 28½.

PLATE 60. 27.

PLATE 61. 19¼.

PLATE 62. top, 20⅜; bottom, 14.

PLATE 63. 28¼.

PLATE 64. 20.

PLATE 65. top, 2⅞; center left, 2⅞; center middle, 2⅞; center right, 3¼; bottom, 6⅞.

PLATE 66. 20⅜.

PLATE 67. 22¼.

PLATE 68. 24¼.

PLATE 69. 23½.

PLATE 70. top, 17¾; bottom, 21½.

PLATE 71. 21¾.

PLATE 72. 15.

PLATE 73. top, 16⅛; bottom, 16⅞.

PLATE 74. top, 2⅞; second, 8⅜; third, 7; bottom, 9¼.

PLATE 75. top, 21¾; bottom, 20½.

PLATE 76. 11⅞.

PLATE 77. top, 7¾; bottom, 14⅞.

PLATE 78. top, 6½; bottom, 12¾.

PLATE 79. 19.

PLATE 80. top, 12; bottom, 14¼.

PLATE 81. top. 15⅛; bottom, 15.

PLATE 82. 11¼.

PLATE 83. 26¾.

PLATE 84. top, 9½; bottom, 6⅝.

PLATE 85. 14¾.

PLATE 86. top, 22¼; bottom, 28.

PLATE 87. top, 24⅜; bottom, 29.

PLATE 88. 26¾.

PLATE 89. 17.

PLATE 90. top, 2⅞; bottom, 29¾.

PLATE 91. 28.

PLATE 92. top, 5⅛; bottom, 26.

PLATE 93. top, 9½; bottom, 16.

PLATE 94. 5¾.

PLATE 95. 16¼.

PLATE 96. 17¼.

PLATE 97. 22⅝.

PLATE 98. top, 20⅜; bottom, 20⅞.

PLATE 99. 22¾.

PLATE 100. 23⅜.

PLATE 101. 19.

PLATE 102. 15¼.

PLATE 103. 29⅞.

PLATE 104. 22¾.

PLATE 105. top, 23⅛; bottom, 23⅞.

PLATE 106. top, 15½; bottom, 23.

PLATE 107. top, 5⅛; bottom, 6⅝.

PLATE 108. top, 23¾; bottom, 21½.

PLATE 109. 21⅞.

PLATE 110. 21¾.

PLATE 111. top, 19¾; bottom, 22½.

PLATE 112. 30.

PLATE 113. 20¾.

PLATE 114. top, 3¼; bottom, 6⅞.

PLATE 115. 23.

PLATE 116. 27½.

PLATE 117. 31.

PLATE 118. 22.

PLATE 119. 17⅞.

PLATE 120. 21⅛.

PLATE 121. 14¼.

PLATE 122. 16.

PLATE 123. 23¾.

PLATE 124. 17⅞.

PLATE 125. top, 11⅞; center, 15½; bottom, 14⅞.

PLATE 126. 14⅛.

PLATE 127. 3⅛.

PLATE 128. 15¼.

PLATE 129. 22¾.

PLATE 130. left, 18½; center, 17⅞; right, 20⅞.

PLATE 131. 21¼.

PLATE 132. 3½.

NOTES ON THE PLATES

PLATE 1 Bolton, Mass. Typical geometric style of stone carving done by the Worcester family of Harvard, Mass. (see also plate 3 and 132). Simple scrollwork adorns the sides of the stone.

PLATE 2 Marblehead, Mass. This stone was designed by Henry Christian Geyer (d. *c.* 1793), a Boston stonecutter. The hourglass flanked by bones warns that time passes rapidly, an idea which is reinforced by the depiction of the scythe, the sun (note its anthropomorphic face) and the moon. The skeleton, with its laurel-wreathed head is a grim reminder of the victory of death, while the bats symbolize the evil of the world. These somber motifs are offset by the rope-like snake swallowing its tail, an expression of eternity, and the winged cherubs, whose innocence evokes the spirituality of life in the world to come. Acanthus leaves ornament the stone.

PLATE 3 Death's-heads, emblems of man's mortality, two of which are depicted with wings, probably symbolic of the flight of the soul. The head in the center design, with its simple geometric motifs, is unmistakably the work of a member of the Worcester family of Harvard, Mass. (see also plates 1 and 132).

PLATE 4 Less somber death's-head with wings and ornamental border work.

PLATE 5 Death's-heads with wings. The style of carving displayed on the stone at the top bears a great resemblance to the description of the work of a member of the Lamson family of Charlestown, Mass., possibly to Joseph Lamson (1658-1722), given by Harriette M. Forbes in her book, *Gravestones of Early New England* (Boston, 1927), pp. 41-2. This stone gives evidence of what was supposed to be Joseph Lamson's "characteristic death symbol"—the head has a broad top to it, while the eyebrows have curves ending in little hooks (see also plates 7, 10, top, and 12, top, for similarly carved heads).

PLATE 6 Hollow-eyed skull and crossbones with wings (see also plates 9, top, and 13).

PLATE 7 This somewhat compressed death's-head with wings may be the work of

a member of the Lamson family of Charlestown (see also plates 5, 10, top, and 12, top; and note to plate 5).

PLATE 8 The two death's-heads in the designs at top and center have forked nostrils (see also plate 9, bottom). Bottom: Spencer, Mass. A skeleton in full view reclines in the detail at bottom.

PLATE 9 Death's-heads with wings. Note resemblance of design at top to plates 6 and 13; and design at bottom to plate 8, top and center.

PLATE 10 A winged death's-head and leafy motifs adorn the stone at top which may be the work of a member of the Lamson family of Charlestown (see also plates 5, 7, and 12, top; and note to plate 5). Bottom: Marblehead, Mass. (1757). This design is distinctive for its stark arrangement of symbols. It is also a rare example of a skull carved in profile. The hourglass, scythe, and crossbones are graphic symbols of mortality.

PLATE 11 East Woodstock, Conn. Death's-head with wings.

PLATE 12 A shell-like ornament is suspended above the skull in the stone at top which may be the work of a member of the Lamson family of Charlestown (see also plates 5, 7, and 10, top; and note to plate 5). The curly-headed angel with wings in the bottom design is close to portraiture in the expressive down lines around the mouth. The head is flanked by crudely incised flowers.

PLATE 13 Death's-head with wings (see also plates 6 and 9, top).

PLATE 14 Oxford, N. H. The anonymous cutter of the stone has been called the "Hook and Eye man" (see Forbes, *op. cit.*, pp. 101-2) from his way of carving noses and eyes. Other evidences of his work are to be found in the Connecticut Valley. The crown adorning the skull is probably intended as a symbol of the soul's victory over death.

PLATE 15 Angels' heads. The head in the top design with its smooth hair is close to portraiture (see also plate 69), while the head in the stone at bottom (1778) is much more stylized.

PLATE 16 Angels' heads.

PLATE 17 Angels' heads executed with naive facial details in the outlines of the geometric style. The stone in the top design is dated 1796.

PLATE 18 Angels' heads. Top: Wales, Mass. (1791.) A crown adorns the head (see also plate 32, bottom). Bottom: East Woodstock, Conn.

PLATE 19 Canterbury, Conn. Square-jowled face with rope-like hair (see also plate 63) and pastoral collar representing the vocation of the deceased. The ornamental grapevines bordering the stone symbolize the rewards of Heaven and are also an emblem of Christ.

PLATE 20 Angels' heads. The head in the top design is dated 1824. The head at bottom, dated 1756, is surrounded by a nimbus.

PLATE 21 Angel's head.

PLATE 22 Sturbridge, Mass. (1778). Angel's head adorned with crown (see also plates 25, top, and 52). Note elaborate scrollwork and eight-pointed star, perhaps a Masonic symbol of nature's obedience to God.

PLATE 23 The head at top is unusual for its tightly coiled outline of hair. Bottom: Woodstock, Conn. Angel's head with crudely incised facial details.

PLATE 24 Woodstock, Conn. Implish-looking angel's head.

PLATE 25 Angels' heads. The square stone at top is similar in execution to that of plate 22 (see also plate 52 for a similarly styled head). The angel's head at bottom resembles that of plate 30.

PLATE 26 Angel's head out of which is growing an oak leaf, perhaps intended as a symbol of the strength of faith.

PLATE 27 Angels' heads. Note leaf arrangement in stone at top. Bottom: East Woodstock, Conn. (1775).

PLATE 28 Angels' heads. Top: Salem, Mass. (1773). A single asphodel, traditionally a symbol of death, is incised on the stone at bottom.

PLATE 29 Angels' heads mark the burial place of two brothers.

PLATE 30 Angel's head (see also plate 25, bottom).

PLATE 31 Angel's head with crudely incised flowers.

PLATE 32 The naively detailed angel's head at top is an example of the geometric style of carving. Bottom: Wales, Mass. This design is adorned with a crown (see plate 18, top, for a similar crown design) and initials of the deceased. Note the cleft chin and abstract simplicity of the wings.

PLATE 33 Head with fan-shaped wings above which is an ivy vine, perhaps intended as a symbol of immortality.

PLATE 34 Unusually stylized figure, dated 1754, with distinctive wings. The border is a composite arrangement of floral motifs (see also plate 44).

PLATE 35 Angels' heads, one more skeletal, the other more cherubic. The head in the top design is distinctive for its pompadour hair and unfeathered wings. The stone at bottom may be the work of Captain John Bull (1734-1808) of Newport, Rhode Island (see Forbes, *op. cit.*, p. 97).

PLATE 36 Angel's head. A thistle emerges from the scroll relief at the base of the stone.

PLATE 37 Sturbridge, Mass. Curly-locked angel's head. The crudely incised grape-vine border is a traditional symbol of Christ and of the fruits of Heaven.

PLATE 38 Death's-head with wings above which is either a palm, symbolizing the soul's victory over death, or an oak leaf.

PLATE 39 Angels' heads executed in the geometric style. The stone at top is dated 1795. An unfeathered wing arrangement is at bottom.

PLATE 40 Elongated angels' heads with curiously flattened jowls. The stone at bottom is dated 1768.

PLATE 41 Provincetown, Mass. Above this angel's head, which is close to portraiture, are mourning drapes.

PLATE 42 Angel's head.

PLATE 43 Angels' heads, both of which are close to portraiture.

PLATE 44 South Worthington, Mass. Unusually stylized head with odd wings (see also plate 179, bottom, and plate 34).

PLATE 45 Angel's head. The words "Memento mori" are inscribed on an ornamental ribbon. This headstone is distinctive for its pillared arch construction with simple Tuscan columns, an example of the influence of architectural motifs of the Federal period upon mortuary sculpture.

PLATE 46 Top and bottom: Bennington, Vt. The stone at top (1788) displays a profusion of floral motifs, symbolic of the rewards of Heaven, dominated by an angel's head (see also plates 165 and 170). The bottom tablet, somewhat less ornate, shows two angels' heads. This stone is decorated with ferns and asphodels. Two hearts with crosses inscribed within are at its base.

PLATE 47 An angel's head is shown at top. This stone is ornamented with an acanthus scroll border. At bottom (1708) is a portrait flanked by a scythe and hourglass. Scrollwork borders the stone.

PLATE 48 At top is an angel's head mounted on a pedestal. The bottom design shows an angel's head atop a pedestal flanked by two funereal urns. An hourglass is centered between ceremonial ribbons on which the words "My glass is run" are inscribed.

PLATE 49 Angel's head.

PLATE 50 Top: Concord, Mass. Interesting use of scroll pediment into which a skull and crossbones and two portraits are incised. This architectural treatment is reminiscent of the more elaborate doorways of the Connecticut River Valley. Note the fluted columns with their composite capitals. Bottom: Warren, Mass. In the distinctive way in which the figure is carved—the low forehead, the long nose formed by continuing the eyebrows down, the straight-lined mouth, the unusually rounded shoulders with small neck—and the characteristic crossing of the *A's* in the inscription, this stone appears to be the work of William Young (1711-1795), the "thistle-carver of Tatnuck" (see Forbes, *op. cit.*, p. 83). (See also plates 57, top, 58, top, 62 top, and 169.)

PLATE 51 Moon-faced head of young girl garlanded with ribbons.

PLATE 52 Head adorned with crown and flanked by coiled wings (see also plates 22 and 25, top). This stone is distinctive for its geometric simplicity.

PLATE 53 Sturbridge, Mass. (1780). Portrait of wife of town's first settler. Head adorned with crown amid scrollwork.

PLATE 54 The head in the top design is enclosed in a circle which is possibly intended as a nimbus. Bottom: Uxbridge, Mass.

PLATE 55 Hubbardston, Mass. An attempt to represent the pastoral vocation of the deceased. Figure standing before a lectern beneath an archway. A rudimentary willow tree is bent ceremoniously over the figure. Stately Tuscan columns support the pediment.

PLATE 56 Wales, Mass. Portrait of youth whose death was the result of falling into a well. Crudely carved cypress trees, traditional symbols of death, adorn the stone.

PLATE 57 Forbes (op. cit., p. 83) describes one stone by William Young of Tatnuck as bearing a three-storied adaptation of the thistle. The stone at top is similar in many respects to the one reproduced by Mrs. Forbes and may very well be an example of his work (see also plates 50, bottom, 58, top, 62, top, 169; and notes to plate 50). Bottom: Wilbraham, Mass. (1785). Two portraits in profile between which is an hourglass adorned with a crown (see also plates 66 and 68).

PLATE 58 The stone at top may also be the work of William Young (see plates 50, bottom, 57, top, 62, top, 169; and notes to plates 50 and 57). At bottom is a head above a sun flanked by two cypress trees. The sun may represent either the end of life (in which case it would be setting) or the resurrection of the soul after death (in which case it would be rising). Note the supporting columns at the sides, typical of construction during the Federal period.

PLATE 59 At top is a head with pigtails. Bottom: North Brookfield, Mass. A graphic portrayal of death by the use of the full skeleton and open coffin with body in it. Vines decorate the borders of the stone.

PLATE 60 (1796). Columns support an arch, typical of Federal period construction, on which are arranged funereal urns and adaptations of a willow tree. The flames rising from the urns are emblems of the soul rising from its mortal ashes.

PLATE 61 Deerfield, Mass. Mother and infant in coffin.

PLATE 62 The stone at top (1752) bears the typical characteristics of the work of William Young of Tatnuck (see also plates 50, bottom, 57, top, 58, top, and 169; and notes to plate 50). Bottom: Crudely executed head in the geometric style.

PLATE 63 Woodstock, Conn. Square-jowled angels' heads (see also plate 19).

PLATE 64 Jaffrey, N. H. Figure niched beneath willow tree.

PLATE 65 A collection of heads from various stones with some attempts at portraiture.

PLATE 66 Longmeadow, Mass. Profile portrait amid scrollwork somewhat similar in execution to plates 57, bottom, and 68.

PLATE 67 Cameo portrait surrounded by geometric designs.

PLATE 68 West Woodstock, Conn. Profile portrait amid scrollwork (see also plates 57, bottom, and 66).

PLATE 69 Head amid leaf arrangement (see also plate 15, top). Note the funereal urns at the base of the stone out of which grow vines.

PLATE 70 At top (1797) is a naively detailed angel's head whose eyes are dreamily directed upwards to the motto "Death Overcomes All." Bottom: Paxton, Mass. (1769). Portrait of a Congregational minister before a lectern adorned with ceremonial tassels.

PLATE 71 Addison, Vt. Head above which are mourning drapes. The fan-shaped patterns on this stone were popular motifs in mortuary art. The two webbed designs flanking the head resemble bats' wings, while the details beneath look like suns.

PLATE 72 Niched figure with nimbus amid scrollwork.

PLATE 73 An angel's head is shown in the design at top. Bottom: Canterbury, Conn. (1775). Three curly-headed faces, a crown, and two fan-shaped designs adorn this stone. This pediment is similar to one of the two sons of John Trumbull (1794) reproduced by Forbes (*op. cit.*, p. 108) and attributed to the hand of John Walden (d. 1807) of Windham, Conn., whose work shows the stylistic influence of the Manning family of Connecticut.

PLATE 74 A collection of similarly carved heads. The middle one is flanked by two trees.

PLATE 75 The willow tree and urn became popular motifs of mortuary sculpture at the turn of the nineteenth century, and were evidence of an increasing tendency toward sentimentalization in gravestone art of that century. Urns, of course, were also fashionable accessories to buildings of the Federal period. In the design at top the willow signifies mourning and death. Two suns represent the resurrection of the soul after death.

PLATE 76 Woman leaning on urn weeping. This is typical of watercolor and embroidered mourning scenes so commonly executed by female seminary students during the Federal period. A chain of geometric designs decorates the base of the stone.

PLATE 77 The single flower within the urn seen at top bears resemblance to a rose with the possible significance that the soul attains its most perfect state after death. Note the checkered pattern of the urn at bottom.

PLATE 78 Conventionalized designs of willows and urn.

PLATE 79 Willow and urn resting on a brick tomb which in turn is supported by arch construction.

PLATE 80 Fan-shaped patterns in the design at top (1819) flank conventional representations of a willow and urn. Ornamental border work is at bottom.

PLATE 81 Funereal urns flanked by willow trees. Note the flame which rises from the urn at bottom (see note to plate 60).

PLATE 82 Westport, Conn. The initials of the deceased girl are carved on the urn.

PLATE 83 Ware Center, Mass. A willow and urn stand beneath an arch into which stylized willow branches appear to be carved. The checkered pattern of the keystone may have Masonic significance as a symbol of the variegated moments of pleasure and pain, prosperity and adversity in human life. Elaborate construction of the tombstone is typical of the Federal period. Note signature of stonecutter—"Martin Woods" of "Whately"—at base of

stone. This practice of signing stones might prove to have been more common if it were possible to see that part of the stone which has sunk into the earth over the years (see, for example, plate 115). (There have been several stones unearthed near Hampton, Conn. which reveal the prices paid for them, another practice that might have been common.)

PLATE 105 Top: East Washington, N. H. (1836). Two stars, beneath which are fan-shaped patterns, flank a conventionally depicted urn. At bottom, a stylized willow tree and two somber obelisks are arranged in a tryptich effect.

PLATE 106 Bottom: East Washington, N. H. The urn is framed by a Gothic arch.

PLATE 107 Conventionalized designs of urns.

PLATE 108 Top: New Ipswich, N. H. (1820). Urn base is executed in floral design (for a similarly designed pediment see plate 116). Bottom: Hillsboro, N. H. (1840). Giant leaves flank the urn (see also plate 98, bottom).

PLATE 109 Hillsboro, N. H. Note leaves emanating from urn and stars just above.

PLATE 110 East Washington, N. H. (1840). A panel effect is created by geometric designs and urn.

PLATE 111 Stylized willow trees. Bottom: West Woodstock, Conn. (1805).

PLATE 112 Sharon, N. H. Construction of stone typical of Federal period. The swag ornaments on this slab are also found on the panels of fireplace mantels during this period.

PLATE 113 Another example of mortuary design during the Federal period.

PLATE 114 Conventionally executed urns.

PLATE 115 Warren, Mass. The stone was carved by Beza Soule (1750-1835) of Brookfield, Mass. Soule came from a family of stonecutters who did much work in the Worcester county of Massachusetts.

PLATE 116 Jaffrey, N. H. Note elaborate leaf ornamentation which contrasts with the solemnity of the willow and urn (see also plate 108, top, for a similarly executed pediment).

PLATE 117 Two rosettes flank the urn. Fan-shaped motifs are at the base of the stone.

PLATE 118 Provincetown, Mass. Obelisk-shaped stone with urn and willow.

PLATE 119 Conventionally executed willow and urn.

PLATE 120 A brick wall supports the traditional willow and urn in a cameo design which in turn is set upon scrollwork.

PLATE 121 The willow drapes a body encased in a coffin.

PLATE 122 Conventionally executed willow tree.

PLATE 123 The willow and urn are supported by elaborate pillared arch construction.

PLATE 124 Fan-shaped motifs prominently adorn this stone. Note the flames emanating from the urn (see note to plate 60).

PLATE 125 Details from various stones. The center design is similar to incised geometric motifs found on early blanket chests.

PLATE 126 Footstone with geometric decorations. This slab is unusual in that it lacks a date.

PLATE 127 Detail of a column supporting the all-seeing eye, a Masonic symbol.

PLATE 128 An abstract representation of a sunburst, probably symbolic of the soul's resurrection.

PLATE 129 Ceremonial drapes gaudily adorn this stone. Note the fan-shaped designs in the corners.

PLATE 130 Details of ornamental borders.

PLATE 131 Jaffrey, N. H. Interesting for its elongated finial motifs and the stately tassel suspended from the center of the arched top of the stone. The tassel is a motif commonly found in this southern area of New Hampshire (see also plate 158).

PLATE 132 This most extreme refinement of the geometrically styled head is another example of work done by a member of the Worcester family of Harvard, Mass. (see also plates 1 and 3).

PLATE 133 Uxbridge, Mass. (See plate 137, bottom.)

PLATE 134 A footstone on which heart-shaped designs are carved.

PLATE 159　Crudely executed angel's head.

PLATE 160　Salem, Mass. Angel's head.

PLATE 161　Thompson, Conn. Angel's head. The grapevine border at the sides brings to mind the parable of the vineyards.

PLATE 162　Sharon, N. H. This head is a realistic attempt at colonial portraiture (see also plate 168).

PLATE 163　Foster, R. I. Stylized angel's head (see also plate 175, bottom).

PLATE 164　Boston, Mass. Stone shows an attempt at colonial portraiture.

PLATE 165　Bennington, Vt. Stylized angel's head surrounded by a profusion of floral motifs (see also plates 46, top, and 170).

PLATE 166　Top: Hampton, Conn. Crude but realistic portrait of a woman in colonial cap and dress. Bottom: Two finials flank an hourglass above which is carved a head (see also plate 179).

PLATE 167　Bolton, Mass. A realistic attempt at portraiture and execution of colonial dress.

PLATE 168　North Sudbury, Mass. Four urns with flames emanating from two of them (see note to plate 60) flank a portrait (see plate 162).

PLATE 169　Sutton, Mass. This broad-shouldered figure may be the work of William Young, the "thistle-carver of Tatnuck" (see also plates 50, bottom, 57, top, 58, top, and top plate 50). Forbes (*op. cit.*, p. 83) notes that on Young's stones male figures were depicted by a conventional representation of a wig.

PLATE 170　Bennington, Vt. Angel's head dominated by luxurious floral motifs (see also plates 46, top, and 165).

PLATE 171　Canterbury, Conn. Geometrically executed head with almond-shaped eyes.

PLATE 172　Mendon, Mass. Stern-looking portrait.

PLATE 173　Union, Conn. Moon-shaped head with wings amid geometric motifs.

PLATE 174　Top: Boston, Mass. Cherubic angel's head. Bottom: Woodstock, Conn. Stylized angel's head.

PLATE 175　Top: Boston, Mass. A crown, intended either as an emblem of deity or as a symbol of the victory of the soul over death, is flanked by two cherubic angels' heads. Bottom: Foster, R. I. Impassive-looking angel's head (see also plate 163, bottom).

PLATE 176　Boston, Mass. A realistic attempt at colonial portraiture.

PLATE 177　Crudely executed angels' heads.

PLATE 178　Thompson, Conn. Head flanked by geometric motifs and vine border.

PLATE 179　Top: Two finial projections frame a portrait (see also plate 166, bottom). Bottom: South Worthington, Mass. Unusually stylized head with odd wings (see also plate 44).

PLATE 180　Top: Stylized angel's head. Bottom: Boston, Mass. Note the two-headed profile portraiture and the eight-pointed stars.

PLATE 181　Boston, Mass. Unusual full figure portrayal of Father Time.

PLATE 182　Floral motifs dominated by angel's head.

PLATE 183　Funereal urn surrounded by branch motif.

PLATE 184　Boston, Mass. In addition to the familiar pick and shovel, coffin and crossbones, tree and sun, a profusion of Masonic symbols dominates this stone (for an explanation, see note to plate 151). The crescent, along with the stars, is symbolic of nature's obedience to God.

PLATE 185　Twin trees in mortuary sculpture were meant to represent the so-called marriage trees which were often planted to flank the entrance of the newly-weds' residence. In this instance, the fallen tree symbolizes the death of the wife (see also plate 188).

My glass is run

Dover Books on Art

VITRUVIUS: TEN BOOKS ON ARCHITECTURE. The most influential book in the history of architecture. 1st century A.D. Roman classic has influenced such men as Bramante, Palladio, Michelangelo, up to present. Classic principles of design, harmony, etc. Fascinating reading. Definitive English translation by Professor H. Morgan, Harvard. 344pp. 5⅜ x 8.

20645-9 Paperbound $3.00

HAWTHORNE ON PAINTING. Vivid re-creation, from students' notes, of instructions by Charles Hawthorne at Cape Cod School of Art. Essays, epigrammatic comments on color, form, seeing, techniques, etc. "Excellent," Time. 100pp. 5⅜ x 8.

20653-X Paperbound $1.25

THE HANDBOOK OF PLANT AND FLORAL ORNAMENT, *R. G. Hatton.* 1200 line illustrations, from medieval, Renaissance herbals, of flowering or fruiting plants: garden flowers, wild flowers, medicinal plants, poisons, industrial plants, etc. A unique compilation that probably could not be matched in any library in the world. Formerly "The Craftsman's Plant-Book." Also full text on uses, history as ornament, etc. 548pp. 6⅛ x 9¼.

20649-1 Paperbound $4.50

DECORATIVE ALPHABETS AND INITIALS, Alexander Nesbitt. 91 complete alphabets, over 3900 ornamental initials, from Middle Ages, Renaissance printing, baroque, rococo, and modern sources. Individual items copyright free, for use in commercial art, crafts, design, packaging, etc. 123 full-page plates. 3924 initials. 129pp. 7¾ x 10¾. 20544-4 Paperbound $2.75

METHODS AND MATERIALS OF THE GREAT SCHOOLS AND MASTERS, Sir Charles Eastlake. (Formerly titled "Materials for a History of Oil Painting.") Vast, authentic reconstruction of secret techniques of the masters, recreated from ancient manuscripts, contemporary accounts, analysis of paintings, etc. Oils, fresco, tempera, varnishes, encaustics. Both Flemish and Italian schools, also British and French. One of great works for art historians, critics; inexhaustible mine of suggestions, information for practicing artists. Total of 1025pp. 5⅜ x 8.

20718-8, 20719-6 Two volume set, Paperbound $7.00

BYZANTINE ART AND ARCHAEOLOGY, O.M. Dalton. Still most thorough work in English on Byzantine art forms throughout ancient and medieval world. Analyzes hundreds of pieces, covers sculpture, painting, mosaic, jewelry, textiles, architecture, etc. Historical development; specific examples; iconology and ideas; symbolism. A treasure-trove of material about one of most important art traditions, will supplement and expand any other book in area. Bibliography of over 2500 items. 457 illustrations. 747pp. 6⅛ x 9¼. 20776-5 Clothbound $8.50

THE HUMAN FIGURE, J. H. Vanderpoel. Not just a picture book, but a complete course by a famous figure artist. Extensive text, illustrated by 430 pencil and charcoal drawings of both male and female anatomy. 2nd enlarged edition. Foreword. 430 illus. 143pp. 6⅛ x 9¼. 20432-4 Paperbound $1.50

*AN ATLAS OF ANIMAL ANATOMY FOR ARTISTS, W. Ellen-
berger, H. Baum, H. Dittrich.* The largest, richest animal anatomy
for artists in English. Form, musculature, tendons, bone struc-
ture, expression, detailed cross sections of head, other features,
of the horse, lion, dog, cat, deer, seal, kangaroo, cow, bull, goat,
monkey, hare, many other animals. "Highly recommended,"
DESIGN. Second, revised, enlarged edition with new plates from
Cuvier, Stubbs, etc. 288 illustrations. 153pp. 11⅜ x 9.

20082-5 Paperbound $3.00

*ANIMAL DRAWING: ANATOMY AND ACTION FOR
ARTISTS, C. R. Knight.* 158 studies, with full accompanying
text, of such animals as the gorilla, bear, bison, dromedary,
camel, vulture, pelican, iguana, shark, etc., by one of the greatest
modern masters of animal drawing. Innumerable tips on how to
get life expression into your work. "An excellent reference work,"
SAN FRANCISCO CHRONICLE. 158 illustrations. 156pp.
10½ x 8½. 20426-X Paperbound $3.00

*ARCHITECTURAL AND PERSPECTIVE DESIGNS, Giuseppe
Galli Bibiena.* 50 imaginative scenic drawings of Giuseppe Galli
Bibiena, principal theatrical engineer and architect to the
Viennese court of Charles VI. Aside from its interest to art his-
torians, students, and art lovers, there is a whole Baroque world
of material in this book for the commercial artist. Portrait of
Charles VI by Martin de Meytens. 1 allegorical plate. 50 addi-
tional plates. New introduction. vi + 103pp. 10⅛ x 13¼.

21263-7 Paperbound $2.50

HANDBOOK OF DESIGNS AND DEVICES, C. P. Hornung. A
remarkable working collection of 1836 basic designs and varia-
tions, all copyright-free. Variations of circle, line, cross, dia-
mond, swastika, star, scroll, shield, many more. Notes on sym-
bolism. "A necessity to every designer who would be original
without having to labor heavily," ARTIST AND ADVERTISER.
204 plates. 240pp. 5⅜ x 8. 20125-2 Paperbound $2.00

CHINESE HOUSEHOLD FURNITURE, G. N. Kates. A sum-
mary of virtually everything that is known about authentic
Chinese furniture before it was contaminated by the influence
of the West. The text covers history of styles, materials used,
principles of design and craftsmanship, and furniture arrange-
ment—all fully illustrated. xiii + 190pp. 5⅝ x 8½.

20958-X Paperbound $2.00

*DECORATIVE ART OF THE SOUTHWESTERN INDIANS,
D. S. Sides.* 300 black and white reproductions from one of the
most beautiful art traditions of the primitive world, ranging
from the geometric art of the Great Pueblo period of the 13th
century to modern folk art. Motives from basketry, beadwork,
Zuni masks, Hopi kachina dolls, Navajo sand pictures and
blankets, and ceramic ware. Unusual and imaginative designs
will inspire craftsmen in all media, and commercial artists may
reproduce any of them without permission or payment. xviii +
101pp. 5⅝ x 8⅜. 20139-2 Paperbound $1.50

ART ANATOMY, Dr. William Rimmer. One of the few books on art anatomy that are themselves works of art, this is a faithful reproduction (rearranged for handy use) of the extremely rare masterpiece of the famous 19th century anatomist, sculptor, and art teacher. Beautiful, clear line drawings show every part of the body—bony structure, muscles, features, etc. Unusual are the sections on falling bodies, foreshortenings, muscles in tension, grotesque personalities, and Rimmer's remarkable interpretation of emotions and personalities as expressed by facial features. It will supplement every other book on art anatomy you are likely to have. Reproduced clearer than the lithographic original (which sells for $500 on up on the rare book market.) Over 1,200 illustrations. xiii + 153pp. $7\frac{3}{4}$ x $10\frac{3}{4}$.

20908-3 Paperbound $2.50

THE CRAFTSMAN'S HANDBOOK, Cennino Cennini. The finest English translation of IL LIBRO DELL' ARTE, the 15th century introduction to art technique that is both a mirror of Quatrocento life and a source of many useful but nearly forgotten facets of the painter's art. 4 illustrations. xxvii + 142pp. D. V. Thompson, translator. $5\frac{3}{8}$ x 8.

20054-X Paperbound $2.00

THE BROWN DECADES, Lewis Mumford. A picture of the "buried renaissance" of the post-Civil War period, and the founding of modern architecture (Sullivan, Richardson, Root, Roebling), landscape development (Marsh, Olmstead, Eliot), and the graphic arts (Homer, Eakins, Ryder). 2nd revised, enlarged edition. Bibliography. 12 illustrations. xiv + 266 pp. $5\frac{3}{8}$ x 8.

20200-3 Paperbound $2.00

THE STYLES OF ORNAMENT, A. Speltz. The largest collection of line ornament in print, with 3750 numbered illustrations arranged chronologically from Egypt, Assyria, Greeks, Romans, Etruscans, through Medieval, Renaissance, 18th century, and Victorian. No permissions, no fees needed to use or reproduce illustrations. 400 plates with 3750 illustrations. Bibliography. Index. 640pp. 6 x 9.

20577-6 Paperbound $3.75

THE ART OF ETCHING, E. S. Lumsden. Every step of the etching process from essential materials to completed proof is carefully and clearly explained, with 24 annotated plates exemplifying every technique and approach discussed. The book also features a rich survey of the art, with 105 annotated plates by masters. Invaluable for beginner to advanced etcher. 374pp. $5\frac{3}{8}$ x 8.

20049-3 Paperbound $3.00

OF THE JUST SHAPING OF LETTERS, Albrecht Dürer. This remarkable volume reveals Albrecht Dürer's rules for the geometric construction of Roman capitals and the formation of Gothic lower case and capital letters, complete with construction diagrams and directions. Of considerable practical interest to the contemporary illustrator, artist, and designer. Translated from the Latin text of the edition of 1535 by R. T. Nichol. Numerous letterform designs, construction diagrams, illustrations. iv + 43pp. $7\frac{7}{8}$ x $10\frac{3}{4}$.

21306-4 Paperbound $2.00

GRAPHIC WORLDS OF PETER BRUEGEL THE ELDER,
H. A. Klein. 64 of the finest etchings and engravings made from
the drawings of the Flemish master Peter Bruegel. Every aspect
of the artist's diversified style and subject matter is represented,
with notes providing biographical and other background in-
formation. Excellent reproductions on opaque stock with nothing
on reverse side. 63 engravings, 1 woodcut. Bibliography. xviii +
289pp. 11⅜ x 8¼. 21132-0 Paperbound $3.50

THE COMPLETE WOODCUTS OF ALBRECHT DURER,
edited by Dr. Willi Kurth. Albrecht Dürer was a master in vari-
ous media, but it was in woodcut design that his creative genius
reached its highest expression. Here are all of his extant wood-
cuts, a collection of over 300 great works, many of which are
not available elsewhere. An indispensable work for the art his-
torian and critic and all art lovers. 346 plates. Index. 285pp.
8½ x 12¼. 21097-9 Paperbound $3.00

GRAPHIC REPRODUCTION IN PRINTING, H. Curwen. A
behind-the-scenes account of the various processes of graphic
reproduction—relief, intaglio, stenciling, lithography, line
methods, continuous tone methods, photogravure, collotype—
and the advantages and limitations of each. Invaluable for all
artists, advertising art directors, commercial designers, adver-
tisers, publishers, and all art lovers who buy prints as a hobby.
137 illustrations, including 13 full-page plates, 10 in color. xvi +
171pp. 5¼ x 8½. 20512-6 Clothbound $7.50

WILD FOWL DECOYS, Joel Barber. Antique dealers, collectors,
craftsmen, hunters, readers of Americana, etc. will find this the
only thorough and reliable guide on the market today to this
unique folk art. It contains the history, cultural significance, re-
gional design variations; unusual decoy lore; working plans for
constructing decoys; and loads of illustrations. 140 full-page
plates, 4 in color. 14 additional plates of drawings and plans by
the author. xxvii + 156pp. 7⅞ x 10¾. 20011-6 Paperbound $3.50

1800 WOODCUTS BY THOMAS BEWICK AND HIS SCHOOL.
This is the largest collection of first-rate pictorial woodcuts in
print—an indispensable part of the working library of every
commercial artist, art director, production designer, packaging
artist, craftsman, manufacturer, librarian, art collector, and
artist. And best of all, when you buy your copy of Bewick, you
buy the rights to reproduce individual illustrations—no permis-
sion needed, no acknowledgments, no clearance fees! Classified
index. Bibliography and sources. xiv + 246pp. 9 x 12.
20766-8 Paperbound $4.00

THE SCRIPT LETTER, Tommy Thompson. Prepared by a noted
authority, this is a thorough, straightforward course of instruc-
tion with advice on virtually every facet of the art of script
lettering. Also a brief history of lettering with examples from
early copy books and illustrations from present day advertising
and packaging. Copiously illustrated. Bibliography. 128pp.
6½ x 9⅛. 21311-0 Paperbound $1.25

VASARI ON TECHNIQUE, G. Vasari. Pupil of Michelangelo, outstanding biographer of Renaissance artists reveals technical methods of his day. Marble, bronze, fresco painting, mosaics, engraving, stained glass, rustic ware, etc. Only English translation, extensively annotated by G. Baldwin Brown. 18 plates. 342pp. 5⅜ x 8. 20717-X Paperbound $2.75

FOOT-HIGH LETTERS: A GUIDE TO LETTERING, M. Price. 28 15½ x 22½" plates, give classic Roman alphabet, one foot high per letter, plus 9 other 2" high letter forms for each letter. 16 page syllabus. Ideal for lettering classes, home study. 28 plates in box. 20238-9 $6.00

A HANDBOOK OF WEAVES, G. H. Oelsner. Most complete book of weaves, fully explained, differentiated, illustrated. Plain weaves, irregular, double-stitched, filling satins; derivative, basket, rib weaves; steep, broken, herringbone, twills, lace, tricot, many others. Translated, revised by S. S. Dale; supplement on analysis of weaves. Bible for all handweavers. 1875 illustrations. 410pp. 6⅛ x 9¼. 20209-7 Clothbound $7.50

JAPANESE HOMES AND THEIR SURROUNDINGS, E. S. Morse. Classic describes, analyses, illustrates all aspects of traditional Japanese home, from plan and structure to appointments, furniture, etc. Published in 1886, before Japanese architecture was contaminated by Western, this is strikingly modern in beautiful, functional approach to living. Indispensable to every architect, interior decorator, designer. 307 illustrations. Glossary. 410pp. 5⅝ x 8⅜. 20746-3 Paperbound $2.25

THE DRAWINGS OF HEINRICH KLEY. Uncut publication of long-sought-after sketchbooks of satiric, ironic iconoclast. Remarkable fantasy, weird symbolism, brilliant technique make Kley a shocking experience to layman, endless source of ideas, techniques for artist. 200 drawings, original size, captions translated. Introduction. 136pp. 6 x 9. 20024-8 Paperbound $2.00

COSTUMES OF THE ANCIENTS, Thomas Hope. Beautiful, clear, sharp line drawings of Greek and Roman figures in full costume, by noted artist and antiquary of early 19th century. Dress, armor, divinities, masks, etc. Invaluable sourcebook for costumers, designers, first-rate picture file for illustrators, commercial artists. Introductory text by Hope. 300 plates. 6 x 9.
20021-3 Paperbound $2.00

EPOCHS OF CHINESE AND JAPANESE ART, E. Fenollosa. Classic study of pre-20th century Oriental art, revealing, as does no other book, the important interrelationships between the art of China and Japan and their history and sociology. Illustrations include ancient bronzes, Buddhist paintings by Kobo Daishi, scroll paintings by Toba Sojo, prints by Nobusane, screens by Korin, woodcuts by Hokusai, Koryusai, Utamaro, Hiroshige and scores of other pieces by Chinese and Japanese masters. Biographical preface. Notes. Index. 242 illustrations. Total of lii + 439pp. plus 174 plates. 5⅝ x 8¼.
20364-6, 20265-4 Two-volume set, Paperbound $5.00

LANDSCAPE GARDENING IN JAPAN, Josiah Conder. A detailed picture of Japanese gardening techniques and ideas, the artistic principles incorporated in the Japanese garden, and the religious and ethical concepts at the heart of those principles. Preface. 92 illustrations, plus all 40 full-page plates from the Supplement. Index. xv + 299pp. 8⅜ x 11¼.

21216-5 Paperbound $3.50

DESIGN AND FIGURE CARVING, E. J. Tangerman. "Anyone who can peel a potato can carve," states the author, and in this unusual book he shows you how, covering every stage in detail from very simple exercises working up to museum-quality pieces. Terrific aid for hobbyists, arts and crafts counselors, teachers, those who wish to make reproductions for the commercial market. Appendix: How to Enlarge a Design. Brief bibliography. Index. 1298 figures. x + 289pp. 5⅜ x 8½.

21209-2 Paperbound $2.00

THE STANDARD BOOK OF QUILT MAKING AND COLLECTING, M. Ickis. Even if you are a beginner, you will soon find yourself quilting like an expert, by following these clearly drawn patterns, photographs, and step-by-step instructions. Learn how to plan the quilt, to select the pattern to harmonize with the design and color of the room, to choose materials. Over 40 full-size patterns. Index. 483 illustrations. One color plate. xi + 276pp. 6¾ x 9½. 20582-7 Paperbound $2.50

LOST EXAMPLES OF COLONIAL ARCHITECTURE, J. M. Howells. This book offers a unique guided tour through America's architectural past, all of which is either no longer in existence or so changed that its original beauty has been destroyed. More than 275 clear photos of old churches, dwelling houses, public buildings, business structures, etc. 245 plates, containing 281 photos and 9 drawings, floorplans, etc. New Index. xvii + 248pp. 7⅞ x 10¾. 21143-6 Paperbound $3.00

A HISTORY OF COSTUME, Carl Köhler. The most reliable and authentic account of the development of dress from ancient times through the 19th century. Based on actual pieces of clothing that have survived, using paintings, statues and other reproductions only where originals no longer exist. Hundreds of illustrations, including detailed patterns for many articles. Highly useful for theatre and movie directors, fashion designers, illustrators, teachers. Edited and augmented by Emma von Sichart. Translated by Alexander K. Dallas. 594 illustrations. 464pp. 5⅛ x 7⅛.

21030-8 Paperbound $3.00

Dover publishes books on commercial art, art history, crafts, design, art classics; also books on music, literature, science, mathematics, puzzles and entertainments, chess, engineering, biology, philosophy, psychology, languages, history, and other fields. For free circulars write to Dept. DA, Dover Publications, Inc., 180 Varick St., New York, N.Y. 10014.